Lloyd and Jennifer Laing
have published widely on Celtic art
and archaeology in Britain and the United States, both in
collaboration and separately. Lloyd Laing is Senior Lecturer
in Archaeology at the University
of Nottingham.

WORLD OF ART

This famous series
provides the widest available
range of illustrated books on art in all its aspects.
If you would like to receive a complete list
of titles in print please write to:
THAMES AND HUDSON
30 Bloomsbury Street, London WC1B 3QP
In the United States please write to:
THAMES AND HUDSON INC.
500 Fifth Avenue, New York, New York 10110

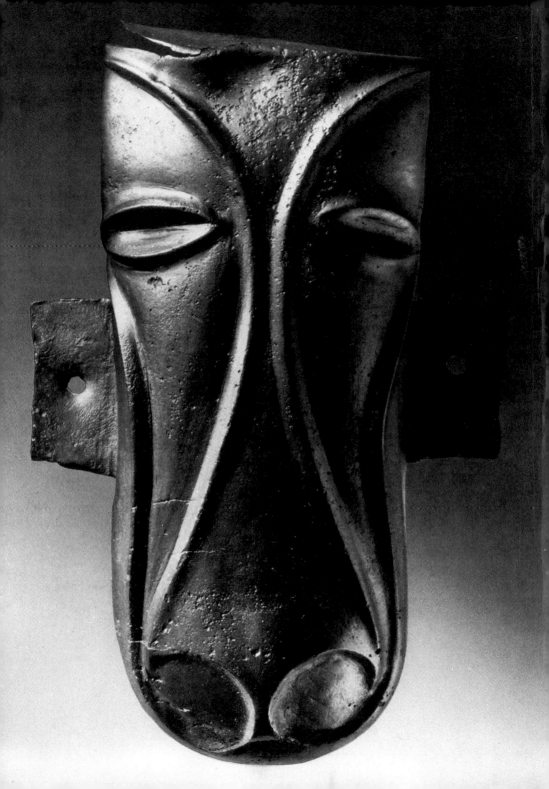

ART OF
THE CELTS

Lloyd and Jennifer Laing

212 illustrations, 22 in color

Thames and Hudson

1 FRONTISPIECE
Sheet-bronze horse-head mount, 10.9 cm
($4\frac{3}{8}$ in) high, found near Stanwick, England,
mid to late first century AD (see p. 126)

© 1992 Thames and Hudson Ltd, London

First published in the United States in 1992 by
Thames and Hudson Inc., 500 Fifth Avenue,
New York, New York 10110

Library of Congress Catalog Card Number 91–66018

Printed and bound in Singapore by C.S. Graphics

Contents

Preface

In commonly accepted usage, the term 'Celtic art' is applied both to the art produced in Europe between the fifth century BC and the first century AD by Iron Age peoples who are usually labelled 'Celts', and the art produced in Britain and Ireland between the fifth and the twelfth centuries AD, outside the areas of Anglo-Saxon settlement. This book is concerned with both these artistic traditions, and discusses what connections, if any, there may be between the two. It is also concerned with the revival of early Christian Celtic art as a form of ornament, particularly in the nineteenth and twentieth centuries.

Celtic art differs from classical art, and by extension most Western art since the Renaissance, in that it is not concerned either with the imitation of nature or with an ideal of beauty. At all times the Celtic artist avoided the straight line, and only occasionally showed a concern for symmetry. The art appears to be primarily ornamental, but contained in the complex patterns are frequently to be found examples of symbolism, which can be, where we understand them, very complex. Although Celtic artists were aware of the uses of 'white space' and restraint in the selection of areas to be ornamented, generally speaking Celtic art displays a *horror vacui* and a delight in the infill of the field with ornamental details. Although a few sculptures show that the Celtic artist could employ his skills in the production of larger works of art, he was at his best when decorating metalwork and manuscripts where limited surfaces offered opportunities for detailed work in miniature.

We would particularly like to thank Jeffrey May for reading and commenting on the script, to its great advantage.

<div align="right">

L.L.
J.L.

</div>

Introduction

The word 'Celt' is derived from the Greek name for barbarians living in temperate Europe – *Keltoi*. The term first was employed in the sixth century BC, and was used to refer to people living north of the Alps and on the Upper Danube.

The cultural concept of 'Celts' was given stronger definition in the seventeenth century – Celts were seen to be speakers of a group of related languages which subsequent research showed to be Indo-European. There is not, and never has been, such a thing as a Celtic 'race', a Celtic 'nation' or a Celtic 'empire'. The nearest to group identity that Celts ever came was probably the sense of belonging to a particular tribe, clan or (in post-Roman centuries) kingdom.

If we take our definition of 'Celt' as 'Celtic speaker', we can regard areas of Britain as being 'Celtic' from the fifth to the twelfth centuries AD. We can be fairly confident too that Iron Age Britain and Ireland and the areas in which La Tène culture (see below) can be found on the Continent were also 'Celtic', insofar as a form or forms of the Celtic languages were being spoken in the areas in which they prevailed. Whether the whole population spoke Celtic is another matter, and how far back it is possible to argue that a form of Celtic may have been spoken in Europe is another problem still. In this, however, the study of place-names can be useful, for in areas where Celtic place-names occur it is probably reasonable to infer that Celtic languages were spoken at least at some period in the region's past, and a study of the form of the place-names can help to provide some kind of general date. For some, such as Colin Renfrew, Celtic evolved out of an earlier Indo-European language introduced by the first farmers in Europe before 4000 BC. He believes that Celts, and with them Celtic culture in archaeological terms, evolved in parallel in different areas. However, archaeologists cannot dig up spoken languages, and without documentary evidence it is not possible to determine what languages were spoken by whom in prehistory.

Following on from the classical and linguistic definition of 'Celts', archaeologists have come to use the term to describe the Iron Age

peoples of large areas of central and western Europe. Although there are wide regional variations among these archaeologically-defined Celts, a number of artifact types seem widely dispersed among them, and 'Celtic art' has been seen as another widespread attribute of the Celts as so defined.

Even if some of its elements can be detected earlier, Celtic art does not emerge clearly until the fifth century BC when it is found among peoples sharing elements of what archaeologists have defined as Iron Age La Tène culture, named traditionally after a site in Switzerland. For many archaeologists, Celtic culture cannot be recognized before this date, but for others it has been seen reasonable to include the previous Hallstatt D culture (c. 600–500 BC), named after a site in Austria, or even Hallstatt C (700–600 BC), as representing an early form of Celtic society.

CELTIC ART

Celtic is a term applied to art in a diversity of styles. Many of the elements associated are not 'Celtic' at all, but adapted from other artistic repertoires and subtly modified. Its most outstanding characteristic is its eclecticism and variety. Symmetrical over–and–under ribbon interlace pattern, for example, is commonly thought of as the most Celtic of ornamental devices, but arrived relatively late in the Celtic world (around the later sixth century AD) when it was already in use in the continental Germanic artist's pattern book. Its origin is both Mediterranean and civilized. At various times, Celtic art has borrowed or adapted other elements from classical Greek, Oriental, Roman and Viking art.

It is this very variety that has caused questions about whether 'Celtic art' exists as a single entity. Some scholars argue that it might be better to speak of 'La Tène art', 'Pictish art', 'Early Christian Irish art' or 'insular Iron Age art' rather than group them together. Yet paradoxically this in a sense obscures rather than clarifies. Many people who buy modern examples of 'Celtic' jewellery or tea towels ornamented with designs from the Book of Kells have a very clear idea in their own minds of what 'Celtic art' comprises. In essence it is an art in which naturalism in the classical sense is largely absent, and in which pattern predominates. It is an art which delights in curvilinear forms, in intertwining lines, in ornament which is often ambiguous. It is an art in which similar motifs – triskeles, trumpets, scrolls and palmettes – abound. The immediate inspiration for this or that motif

8

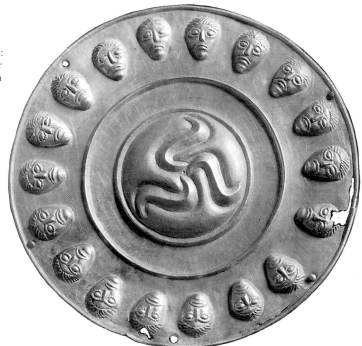

2 Two of the most enduring of Celtic motifs: the three-legged wheel or *triskele* and the mask with staring eyes and downturned mouth, on a silver disc from Villa Vecchia, Italy, first century BC

may be seen to vary in succeeding periods and in different areas, but the visual impact remains very much the same, whether one is looking at an Iron Age shield boss or the ornament on a 'carpet page' in an early medieval Gospel Book.

As with all traditions of art, Celtic art produces anomalies. What is one to make of such naturalistic representations as the ox-heads which formed bucket escutcheons from Felmersham-on-Ouse (Bedford-shire), or the figural ornament on the Cross of Muiredach at Monasterboice, Co. Louth, for instance? Neither displays any of the types of curvilinear ornament that we have just defined as characteristic of Celtic art – naturalism is here apparent, as well as, in the case of the Monasterboice sculpture, a kind of late Antique classicism which betrays strongly the Mediterranean parentage of the imagery. Yet even here there are subtle elements that bespeak the Celtic artist's confidence with the wandering line. The Celtic feel for form is evident in the curves of the Felmersham ox-heads' profiles, and in the stylization of their curved, elongated horns. Similarly, on the Cross of Muiredach the figural work is combined with panels of linear ornament. Viewed from a distance, the figures seem to dissolve into patterns of high relief bosses.

4
3

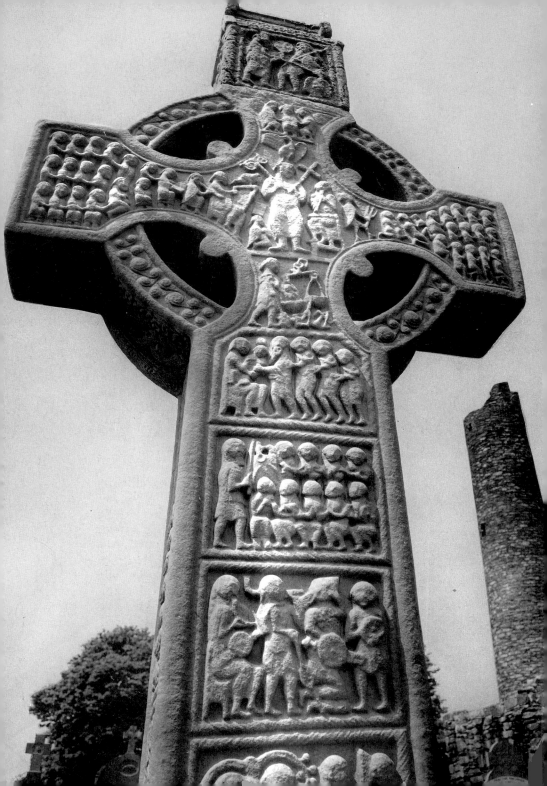

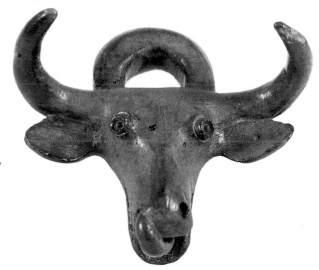

3 (left) Cross of Muiredach, Monasterboice, Co. Louth, Ireland, ninth or tenth century AD, with figural carving that from a distance resembles an abstract pattern of bosses

4 (right) A cow licking her nose, 4.2 cm (1½ in) high, forming the escutcheon of a bucket, probably a milk-pail, from Felmersham-on-Ouse, Bedfordshire, England, first century AD. The head is sympathetically observed, but note the stylization of the horns

It is tempting to try to avoid such definitions of a Celtic art 'style' and describe Celtic art simply as 'art produced by Celts'. This is too simplistic to be workable, for are the works in totally different traditions produced in Celtic-speaking areas to be included? If they were, the art of Ceri Richards would be 'Celtic' since it was produced by a Welshman, and Louis le Brocquy's paintings would be 'Celtic' because they were executed in Ireland. While some might argue that there are 'Celtic' elements in some at least of the works of these artists, many might well dispute it, and none would claim they were artists who worked in the same tradition as the creators of the early ninth-century Book of Kells. Not all art produced in Celtic lands, then, is Celtic art.

In essence, there are three rather than two 'traditions' of Celtic art. The first, continental La Tène art, started in the fifth century BC and continued until around the time of Caesar's conquest of Gaul in the first century BC. This art drew on native, classical and oriental sources (the last possibly derived second-hand from the Mediterranean) to produce a diversity of distinct but related styles. Although there is a certain amount of sculpture in stone and wood, most of the La Tène continental art that has come down to us was fashioned in metal, using a variety of techniques. Commonest is casting, but this can be combined with engraving, punching, tracing and scorping (grooving the metal with an implement known as a 'scorper'). Compasses were on occasion used in laying out designs. Bronze was the commonest metal employed, but gold, silver and even iron was on occasion

ornamented. Coral or glass were sometimes used to enhance the natural surface of the metal. Ground was sometimes cut away to form openwork.

The second tradition is in some measure dependent on and derivative of the first, and comprises the La Tène art produced in Britain and Ireland from the fifth or fourth century BC until the Roman conquest by Claudius in AD 43 (or somewhat later in areas outside Roman control). Many of the elements of this 'insular' La Tène art are shared in common with the continent, but the creations are mostly distinctive and represent regional styles of the La Tène tradition. The materials and substances employed are much the same, but British craftsmen showed a particular liking for basket patterns for infilling ground, and for enamelwork.

The third tradition of Celtic art is that which flourished in Ireland and to a lesser extent Britain between the fifth and twelfth centuries AD. This art borrows heavily from Roman motifs and it is a debated point as to what extent it owes a debt to La Tène art at all. From modest beginnings in later Roman Britain it was transmitted to Ireland in the fifth century and from the sixth flourished on Irish soil. Except by the Picts and Scots of northern Scotland, little Celtic art of note seems to have been produced in Britain after the seventh century. Of this 'Dark Age' Celtic art, most that has survived is in metal and stone, though a few rare pieces of woodwork show that this too was ornamented. A new medium however came to the fore – the illuminated manuscript. The range of ornamental techniques of the Iron Age artist was greatly extended by his post-Roman counterpart: gold filigree and granular work and the technique of cloisonné inlaying were developed in response to similar techniques employed by contemporary Germanic artists, while die-stamped foils and new materials such as niello (a black silver sulphide paste) were added to the repertoire.

The Norman penetration of Celtic Britain and Ireland seems to have led to the disappearance of Celtic art in the thirteenth century. Although elements of a Celtic tradition can be detected from time to time thereafter, it was not until the conscious revival of Celtic art in the nineteenth century that it became popular again. The factors behind its revival, particularly in Ireland, were originally partly at least political, but it rapidly appealed as an ornamental form to those who had little or no concern for issues of nationalism, and to judge by the proliferation of objects decorated in Celtic style, it has not yet outlived its vogue.

In the past one of the chief obstacles to an appreciation of Celtic art has been the way in which art-historical thinking has developed. Until this century there has been a deep-rooted belief, which stems ultimately from Greek philosophical writings, that art is concerned with two objectives, the imitation of nature and the search for the ideal. It is clearly true that Celtic art has no interest in the accurate representation of nature, and whatever ideal it may aspire to, it is not one which would be recognized by a Greek philosopher or his Renaissance inheritor. At the base of much art-historical thinking has been the belief, developed particularly by Winckelmann in the eighteenth century, that Greek art represents the pinnacle of artistic achievement, against which all other art must be measured. This view has had its legacy even among those who have devoted themselves to the study of Celtic art.

E.T. Leeds, an authority on Anglo-Saxon as well as Celtic art, in 1933 wrote of the Celts with scant sympathy: 'Throughout their artistic history it is impossible to detect those natural powers of accurate observation, the lack of which must constitute an eternal bar to entry into the higher spheres of art. Their treatment of the classical palmettes proves that they were endowed with little appreciation of the natural world in which they moved' (*Celtic Ornament in the British Isles*, 1933, 36).

More recent thinking would regard Leeds as having misunderstood the nature of Celtic art, which cannot be evaluated in classical terms. An appreciation of the natural world, to take but one example, cannot necessarily be equated with the desire to copy it slavishly rather than reinterpret it.

Even the Early Celtic art specialist, Paul Jacobsthal, who was himself a distinguished classical archaeologist who acknowledged that the art was 'full of contrasts . . . full of paradoxes, restless, puzzlingly ambiguous', also claimed 'how narrow is the repertory of Early Celtic imagery! It is confined to huge menhir-like statues in stone, to a few busts or miniature doll-like men, and to a multitude of heads, either primitive or strongly stylized, adorning metal objects' (*Early Celtic Art*, 1944, 1).

At almost any period, the Celtic world was fraught with petty warfare. The destruction of property, human life, artifacts and relationships was so common that rebelling against the 'Establishment' would have seemed inexplicable and irrelevant to any Celtic artist: there was, after all, no Establishment, as the modern world

understands it, against which to rebel. In addition, religious belief reinforced a respect and fear of the gods and militated towards acceptance of events. Not surprisingly, some of the fundamental values in Celtic art cannot be expected to excite sympathy from all twentieth-century artists or art critics. There is, nevertheless, a growing awareness that 'barbarian' art has a direct relevance to twentieth-century art. Although it might have at first sight nothing in common, a concern for form and light effects, and a transcending of physical limitations in ways that have often been misunderstood and wrongly interpreted as a lack of draughtsmanship or other technical ability, are shared by both Celtic and twentieth-century art.

Non-classical art is set apart from many other forms in that we have almost no written or spoken words to guide us into understanding the intent of the artist, the effect on the audience of the time, the prevailing ideologies of the society, or the view of art in that society. As a result, most commentators have hesitated to discuss 'barbarian' art, preferring the safety of prosaic descriptions and discussion of the archaeological contexts. It is not until after the Roman period that information is certain enough for us to distinguish schools or styles and sometimes even individual artists with sufficient confidence for the discussions to conform even approximately to the models we expect in traditional art history.

The dearth of written evidence about the Iron Age Celts has led many commentators to baulk at attempting to equate the art with any possible beliefs. We are often reduced to rather tenuous negative evidence. Nevertheless, even if we cannot know for sure what the artist's intention was, some interpretations at the extremes of the conceptual field open to us, are valid: for example, we can be nearly totally certain that the figure from Corbridge was not intended to represent 'joy personified'.

136

EVALUATING CELTIC ART

A number of factors are important in evaluating Celtic art. Though not peculiar to it, they are fundamental to all its manifestations, pagan and Christian, early and late.

A notable feature is the scale on which Celtic artists often worked. The intricacy and the small scale of manuscript or metalwork has caused considerable discussion. It must be assumed that the function of such art was not public display to the largest number of people. In many cases the function was probably magical – intricate designs can

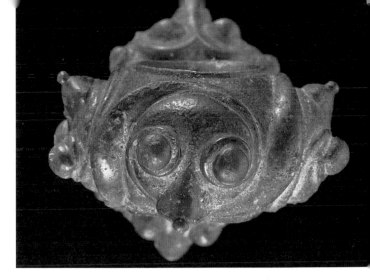

5 Bronze chariot mount found near Paris, third century BC

be found for example on the backs of brooches which were clearly not intended for public display.

While Celtic artists may seem to be reaching out to the viewer in depicting the most charming of animals, or exciting a smile with their tricks in what has been termed the 'Cheshire Style' (p. 62), in much religious or cultic art the viewer is not encouraged to develop any sense of intimacy with the artifact. The creation of a barrier between the audience and the art is also found in classical art, but it is expressed in different forms: for example in the use of idealized or colossal human guises for the gods. Whilst the classical artist may well successfully impress on us that we as mere mortals can have little in common with deities, the Celtic artist is in addition capable of instilling real fear and foreboding in the onlooker.

The fact that we do not understand all the symbolism in Celtic art does not make the study of it, or the appreciation of it, less valid. The modern viewer gains from classical art without knowing the precise mythological meanings which would have been apparent to its originators.

A feature that seems to have caused the Celts endless fascination is known as transformation. The classical writers commented on this, and Caesar's observations about the Druid belief in the transmigration of souls is probably the result of his misunderstanding the Celtic concern with shape-changing.

For example, a design that appears totally abstract from one angle can become a face when viewed from another. Abstract shapes on closer scrutiny can become horns, eyes or beaks.

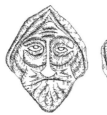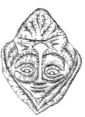

6 Reversible face, male or female depending upon which way up it is viewed, from a gold leaf fragment from Bad Dürkheim, Germany, late fifth or early fourth century BC

A classic example of one form of transformation is apparent in a human mask which appears on an openwork gold leaf fragment from Bad Dürkheim in the Rhineland. Here the head can be turned round to represent an alternative picture – one way up it shows a sad old man, the other way up it depicts a happy young women, neatly combining several antitheses in one image. This 'shape-changing', as Megaw has termed it, is an important element in the earliest La Tène Celtic art. By their mutability, the designs assumed a magical importance.

RELIGION, MAGIC AND CELTIC ART

In Iron Age and early medieval Europe, both the barbarian and the civilized world put considerable emphasis on the proper respect for death and deities, on both a personal and a collective level. The association of art objects and expressions of artistic endeavour with religion and with funeral rites illustrates their central importance to Celtic culture. These manifestations are thrown into greater prominence by the fact that at times the Celts displayed an appreciation of the more mundane aspects of life, embracing on occasion a notable sense of humour in their art.

The question of belief is of vital importance in studying art of any period or culture. One of the features that is often used to distinguish art from craft is the presence of ideals associated with its aims and purposes: art is held to convey something beyond the fact that it is a competently executed piece of work suitable for its purpose. This definition holds true for an idealized statue of Zeus sculpted from marble in 56 BC, the delicate intricacy of the 'Tara' brooch and the photograph of a white line drawn across a remote area of the world and displayed by the artist in a modern gallery.

For the greater part of their existence the Celts were pagan, Christianity being introduced to them in the fourth and fifth centuries. Even after Christianity was introduced, the subject matter is sometimes almost as difficult to interpret as the evidence for pagan periods.

16

The sources for Celtic pagan religion are spare and unreliable, limited to a few classical authors who appear to have based their texts mostly on that of the Stoic philosopher Poseidonius. Even the Druids have been described in a distorted fashion not only by Julius Caesar, who is well known to have presented a biased view in order to enhance his own exploits, but also through 'Druidomania', a peculiarly British disorder of eighteenth century and later romantic intellectual circles.

The matter is complicated by the fact that the Celts became literate concurrently with their absorption of things Roman including religion and art, so that most written evidence we do have does not necessarily relate to 'pure' Celtic society.

In consequence, although we have firstly a considerable number of objects displaying strange and indecipherable scenes that must surely be of religious or mythological origin, secondly a large number of Gallo-Roman and Romano-British sculptures of which the function is almost certainly religious, and thirdly, written evidence for four hundred or so different named deities, it is difficult to evaluate pagan Celtic religion with certainty.

A number of features are self-evident, however. The large number of different deities point to a different arrangement of the Celtic pantheon from that of the classical world. It is likely, for example, that most natural features, such as springs, rivers or mountains, were invested with their particular deity: a belief held in common with many cultures which emphasize the 'unity' of the natural world and seek to bridge the gap between this and human existence through the medium of multitudinous supernatural beings. Such an arrangement can be traced into the Roman period where a large number of Celtic divinities can be found equated in inscriptions with classical beings, who presumably were held to possess attributes in common.

Another feature of pagan Celtic art was an emphasis on fertility, death and regeneration. A number of deities are assumed from the literature to possess particular attributes – one of the most celebrated examples is Cernunnos, the stag-horned god. At times it is felt 87 appropriate to suggest that particular effigies or other depictions relate to those documented figures, but it is rare to be certain outside the Roman period.

Of magical significance are the ubiquitous *triskeles*. Three was a magic number – later Welsh poems were composed in groups of three (Triads), and some deities were represented in groups of three. Some such significance must account for the constant repetition of the

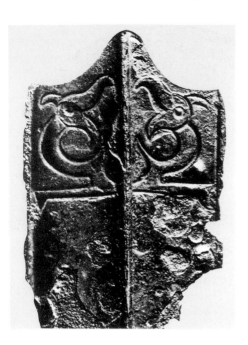
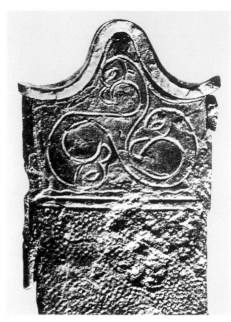

complex *triskele* of trumpet patterns that appears on hanging bowl escutcheons in the Christian period, and on a variety of other objects of widely differing function.

On occasion, pairs may similarly be symbolic. Some La Tène swords have pairs of s-dragons facing one another on their scabbards. Clearly these were symbols intended to protect the user or give his sword strength.

If the exact original meaning of the symbolism is lost to us, it is still clear that Celtic art was not mere ornament but part of a belief system of Celtic society. The designs were magical, and we might guess that the artists responsible for them were no mere craftsmen. In Early Christian Ireland the artists enjoyed the same sort of status as poets. Like the poets, the artists were a product of a conservative society, and in contrast to artists of our own time set great store by the maintenance of tradition.

THE STORY OF THE CELTS

The subject of Celtic art is inextricably bound up with the story of the Celtic peoples.

7 (far left) Confronted s-dragon-pair engraved on a La Tène sword scabbard from Kosd, Hungary

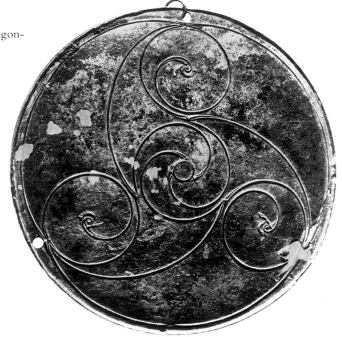

8,9 Detail of scabbard (left) from Obermenzing, Germany, dating from *c*. 200 BC, with a *triskele* of bird-heads, anticipating the elegant Irish Bann disc bird heads (right) of perhaps the second century AD

Prehistorians have distinguished a late Bronze Age culture in central and eastern Europe known from their typical burial rites as the 'Urnfields'. When the scheme was devised, it was believed that the last two phases of the Urnfield culture were fully iron-using, and they were termed Hallstatt A and B. The European Iron Age, and with it, conventionally, Celtic culture, can now be seen as commencing in the succeeding C and D divisions of Hallstatt culture, which has been named after a site in the Austrian Salzkammergut. Widespread iron-working made its appearance around 700 BC.

The succeeding culture is known in archaeology as La Tène, after the type site in Switzerland. Conventionally, La Tène is divided in France into divisions designated La Tène I to III. La Tène I has been seen as lasting from the earlier fifth century BC to around the mid-third century BC, the succeeding La Tène II phase continuing until the late second century BC when La Tène III continues until the Roman conquest. In Germany the terms La Tène A to D are used instead of I to III, La Tène I being equated with Germany's La Tène A and B. During the La Tène phase Celts are found far afield – documentary evidence attests their presence in Galatia (Turkey) and La Tène artifacts have been found in the far north of Britain. During this

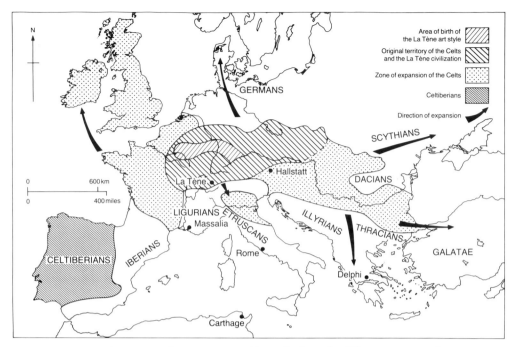

10 The regions of Europe occupied by Celts from the fifth century BC to the Roman conquest of the first century AD

period they came into contact not only with the local populations of the areas they inhabited but also with the colonies of Carthage and Greece, and of more lasting significance, Rome. The development of the Celts could not be and was not uniform – each region was open to influence from its neighbours to a greater or lesser degree.

In the third century BC when Rome began to expand, Celtic development was considerably modified. But Celtic culture continued to flourish in western and central Europe until the conquest of Gaul by Julius Caesar, whereupon many Gauls appear to have taken to Roman-style life with some enthusiasm. Convincing evidence for a flourishing art in the old traditions has not been forthcoming, though some Gallo-Roman art displays a Celtic vigour.

In Britain, unconquered until the invasion of Claudius in AD 43, a Celtic cultural substratum persisted longer, but tracing Celtic art through the Roman period is a complex business and the divide between 'Romano-Celtic' and 'Roman provincial' can be difficult to determine, if indeed it is meaningful to try.

20

During the period of Roman occupation in Britain, there is evidence for political re-groupings outside the frontiers of Britannia, and the emergence of new élites. In the period after the withdrawal of the Roman legions, we can trace the development of kingdoms based on these élites. From the fourth century onwards Christianity was adopted by the Celts, and both the Church and the rulers of the new kingdoms provided the necessary patronage for the resurgence of Celtic art. The immediate models may have been drawn from Romano-British art and the Christian art of the Mediterranean, but the interpretation was Celtic, just as it remained Celtic despite the subsequent impact of Anglo-Saxon then Viking art styles.

Celtic culture, and with it Celtic art, endured until the Anglo-Norman advance into Britain and Ireland, after which it seems to have largely lapsed, to re-emerge in 'revivals' in post-medieval centuries.

In surveying Celtic art from its earliest to its latest phases, the evidence and areas of study change according to the historico-political development. The influence of civilizations is heavily apparent from the start — the artists of Hallstatt and Le Tène displayed a smooth ability to absorb and adapt 'alien' motif and concepts, and their successors, under Roman domination, displayed a variety of responses to the new artistic challenges. Only in Ireland and the north of Britain can we find an unbroken development of society relatively free from intervention.

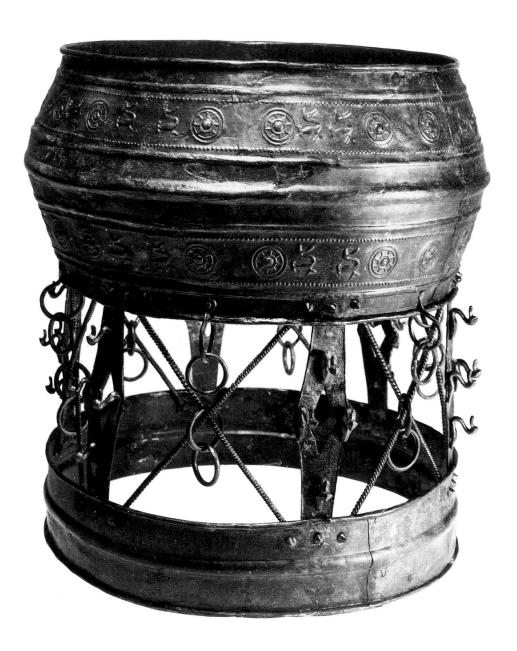

The beginnings of Celtic art

Before the emergence of true Celtic art in the fifth century BC, with the La Tène culture, forerunners of some of the elements of La Tène art can be discerned in Bronze Age and Hallstatt Iron Age Europe. Craftsmen and artists applied geometric curvilinear patterns to decorate swords, horse bits, figurines and discs. A common ornamental theme is the cycle of the farming calendar. In the early Bronze Age in Hungary, for example, figurines were being produced of domestic animals (horse, pig, sheep and dog), and wild creatures such as boar and bear. By the middle Bronze Age (fifteenth and fourteenth centuries BC) artists were experimenting with three-dimensional representations of the human figure, creating strange creatures that are half-men, half-bird, and pots shaped like birds with human faces. The new naturalism may have been prompted by contact with the civilized Mediterranean world. In the birdmen we can perhaps see the beginnings of the love of transformations so typical of the Celts.

Outstanding in Urnfield art are two bronze vessels shaped like birds that have been found in the Carpathians. The first, from Csicser, is not sure whether it is a bird or cow, as it displays horns as well as a beak. The second, from an unknown provenance in Hungary, is quite confident that it is a bird with ribbed body representing feathers, an elegant swan's neck and gently uptilted beak.

12

11 (left) Beaten bronze vessel 36 cm (14 in) high from grave 507 at Hallstatt, Austria. Waterbirds swim up the supports, and more birds interspaced with wheels appear on the vessel's body. Both birds and wheels are solar cult symbols. Hallstatt C, probably late seventh century BC

12 (right) Bronze vessel in the shape of a duck from Hungary, late second or early first millenium BC. The streamlined shape of head and neck prefigures much of later Celtic animal art

Apart from this animal art, later Bronze Age art in Europe included the decoration of bronze and gold objects with patterns of concentric circles, zig-zags, triangles and lines.

HALLSTATT ART

The economic development that led to the next significant phase of the Celtic artists's repertoire took place in the area around southern Germany where the later phases of the Urnfield culture evolved into the 'Hallstatt' culture, named after a site in western Austria. It was during the phase archaeologists term Hallstatt C (700 to 600 BC) that iron became more common, and for convenience a division can be set between Bronze Age and Iron Age. However, it is a strange fact that although in the archaeological literature this tends to be heralded as a major breakthrough, it was a long time before ironworking had real impact on the population. The skills required in ironworking were different from those needed in fashioning bronze objects, and not easily acquired by bronzesmiths. In consequence ironworking remained the province of an élite, and was not immediately widespread.

The people of Hallstatt themselves would certainly have regarded salt rather than iron as their most important commodity, since it was the salt mines that formed the basis of their prosperity. No settlement has been found, all our evidence coming from either the mines themselves, chance finds, or graves.

13 The greatest extent of the Hallstatt cultural province, shown by the tinted area, with locations mentioned in the text

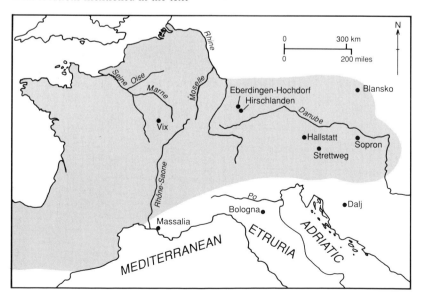

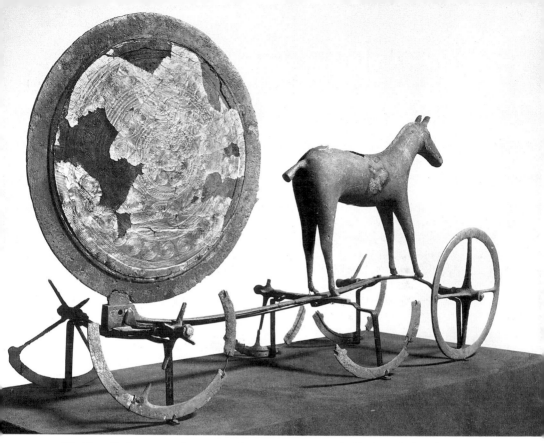

14 The Trundholm sun car, from a peat bog in Denmark, probably deposited in the twelfth century BC. The four-spoked wheels suggest an ancestry in vehicles from Egypt and Mycenaean Greece, but the circular ornament of the sun disc is typical of Bronze Age Europe

It is notable that many of the richer graves contain possible imports, which both facilitate dating and shed light on trade contacts, and concomitantly on the developing taste of the Hallstatt Celts.

As might be expected from this background of trade, some of the major features of Hallstatt art are not exclusive to it. For example, curvilinear ornament, which had been widespread over much of earlier Bronze Age Europe, can be seen on the goldwork produced in Ireland or on the bronzework of Scandinavia, which includes such a sophisticated piece of casting as the Trundholm sun car, with its gilded 14 sun disc on a vehicle pulled by a simplified but elegant pony. The symbolic meaning of the piece is now lost to us, although the religious

significance of the sun in Bronze Age belief has been established beyond dispute through study of such sites as Stonehenge, and by recent work on Celtic religion.

Hallstatt artists are notable for developing motifs and styles more exclusively their own. Outstanding examples of these are stylized birds, particularly waterfowl, which appear on a variety of objects from the cemetery at Hallstatt for example, and also in late Bronze Age Ireland where they adorn a 'flesh hook' (possibly a goad?) from Dunaverney Bog, Co. Antrim. On the latter were displayed a procession of swans and cygnets which confront two ravens. It is notable that both these birds are 'sacred' in later Celtic mythology. Whether they were held in such esteem at this period or whether they gained later sanctification is unknown. The long period of their use in artistic representations is indicative of symbolic importance, and possibly more practical use too.

At Hallstatt, ducks appear swimmimg up the supports of a bronze container, which also is further embossed with ducks and wheels on its side. This vessel must surely have served some cultic purpose. The waterfowl for example may represent an association with water cults favoured in later times by the Celts, while the wheels appear to be a Hallstatt version of the sun discs of earlier times.

Representations of other animals come from further graves at Hallstatt. A horse and rider adorn the back of one bronze axe, while there are representations of cattle from other graves. A splendid bowl from grave 671 is surmounted by a cow and a calf – the mother stands on a platform projecting over the interior of the bowl, while her baby clambers up the side of the escutcheon. This and other vessels from Hallstatt are also decorated with geometric linear ornament which acts as a balance to the figures, which are notable for having a plastic quality, as though made from clay. The calf in particular displays a dynamic stylization mixed with a certain fluidity of line which produces a feeling of life and movement. This feature may have been partly the natural outcome of using the *cire perdue* technique (whereby a wax model was cased in clay to make the mould).

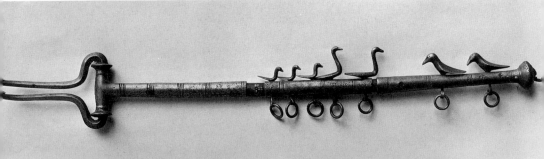

17 Bronze bull, 10.1 cm (3⅞ in) high, found in Býčí skála cave, Blansko, Czechoslovakia – so strikingly stylized and accomplished that it suggests an Eastern nomadic import. The eyes were originally iron-inlaid, and inlays on forehead and shoulders suggest brandmarks. Hallstatt D, probably sixth century BC

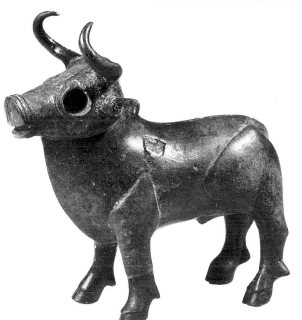

16 A calf clambers up a bowl-side in the wake of its mother (length 14.4 cm, 3½ in), a charming depiction of animals vital for Celtic livelihood. Beads also found in Hallstatt grave 671 suggest that it was a woman's. Hallstatt D, sixth century BC

15 (far left) Swans and ravens on a ritual bronze 'flesh-hook' or goad from Dunaverney Bog, Co. Antrim, northern Ireland, probably eighth century BC. Swans are solar symbols in later Celtic belief, ravens or crows associated with battle

By far the finest rendering of an animal in Hallstatt art however is that of a bull with curling horns, round staring eyes, open mouth and raised head as if bellowing, from Blansko, Czechoslovakia. So competent is the workmanship that some scholars have suggested that it is an import. Although the inspiration may ultimately have been eastern, many of the features of this particular piece are in keeping with Hallstatt traditions.

Some of the forces at work in Hallstatt art are apparent in the finds from the rich burial at Eberdingen-Hochdorf in West Germany, excavated between 1978 and 1979. Inside the massive mound was a chamber with an upholstered sofa or bed, the back of which was decorated with warriors standing on wagons and with three pairs of warriors brandishing swords and shields. This stood on eight supports, each in the form of a woman, of which six were clamped to small wheels or castors. These unusual items give the superficial appearance of monocyclists, the feet gripping the castor wheel at its hub and elongated arms upstretched and turned outwards to accept the weight of the bed. Additional support was gained by infilling the space between head and bed with a potlike object, increasing the appearance of a circus juggler balancing a vase on its head.

Despite this superficially light-hearted likeness, there is nothing undignified in these figures, which resemble miniature classical

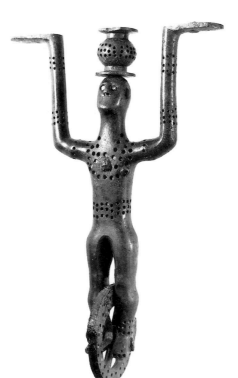

18 'Monocyclist' castor-figure, 35 cm (13¾ in) high, from the Eberdingen-Hochdorf couch (Ill. 19)

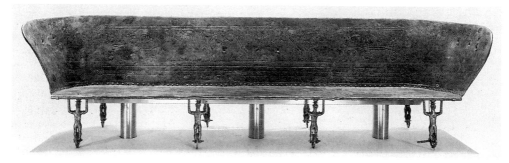

19 The bronze couch from Eberdingen-Hochdorf, Germany, on which the body of a chief was laid for burial. Hallstatt D, datable to around 530 BC

caryatids of many decades later. The treatment is not naturalistic, but verges on what in modern art would be termed 'primitive'. The body is clearly formed, with athletically-developed calves and thighs. The face is upturned, with open-work eyes and well chiselled nose, but no mouth. The effect is of dignity and solemnity. We could read many things into the lack of mouth, but whatever the intention the effect is to render words and speech unimportant – surely a universal observation in the face of death. It is the treatment of neck and head with the unnecessary tilt to the head looking towards its burden, that takes these figures out of the realm of 'crude modelling' into an area where the only explanation for them lies in an intellectual effort to express concepts of human existence connected with the fundamental and solemn matter of death. There is nothing ungainly about the line of the neck, the way the face looks upwards with uncanny similarities to the *orans* figures of Christian art, centuries later. The figures are firmly rooted in methods used in several civilizations to give proper respect to the dead, or to death itself. This has to be seen as a deliberate turning away from the natural, living world in order to invoke more spiritual matters.

The burden borne by these figures was the body of a man aged approximately forty years. He had been laid to rest with a gold torc, gold brooches and bracelet, belt plate and dagger, both overlaid with gold, and wearing shoes also adorned with gold overlay. An imported cauldron, once probably filled with mead, to judge by traces of honey, had been placed on a wooden stand. Three lions had been soldered to the rim, and a fourth lion was a local copy of the others and has the snub snout of the Blansko bull. It is notably a better casting than the other three. This has been seen as Celtic work, but whatever the truth it is of a lower quality artistically than the other three.

29

The chieftain of Eberdingen-Hochdorf was laid to rest wearing a birchbark 'coolie' hat. Just such a hat appears surmounting a statue 20,21 from Hirschlanden, also in Germany. Carved from local stone, it depicts a man, naked save for a belt into which his dagger has been fitted. His shoulders are hunched, his legs are sturdy, but his arms are crossed in what can be seen as a threatening posture, but which looks to modern eyes to be a gesture of insecurity oddly at variance with the rest of his body language. He once stood over a barrow – no doubt representing the dead warrior beneath. He has been seen as Greek, but more probably the prototype was Italian. He is barbarian, and an isolated forerunner of the sculptures that were to come later.

There is growing evidence for contacts between the Mediterranean and the Hallstatt culture from about 600 to 500 BC. This is especially apparent in new centres of power outside Hallstatt itself, for these depended on their control of trade routes for their supremacy.

20,21 Ithyphallic stone statue, 1.5 metres (5 feet) tall, from a barrow at Hirschlanden, Leonberg, Germany, Hallstatt D phase, late sixth or early fifth century BC. The figure's warrior status is suggested by a torc (neckring) and dagger in the belt

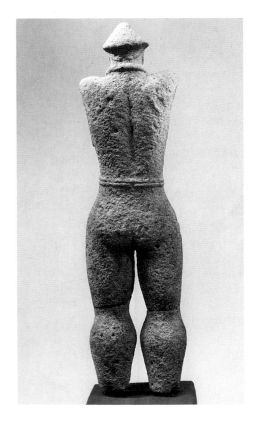 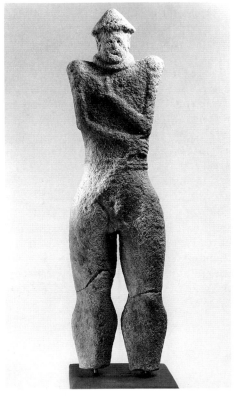

Indeed, the new centres of power are not noticeably near mineral resources, nor are they noted for manufacturing. Instead they were located at key positions on the Danube and Rhône on routes which eventually led to the Greek colonies of the Mediterranean, especially Massalia (Marseilles). As such they reflect an important change in economic or political focus which in turn had a tremendous impact on the development of taste, and eventually on the artist's repertoire itself.

Imports from the Mediterranean have been found in the timber-lined graves typical of the period. Significant among these are the various requisites for drinking wine – a liquor not made by the Celts themselves. Bronze beaked wine flagons and Attic Black-figure cups, as well as gold objects, all attest the power and wealth of the society which could support not only the acquisition of such riches, but their interment in the ground.

A scatter of other similar finds can be plotted along this trade route of which undoubtedly the most famous is the burial at Vix, in southern France. This grave (probably of a woman) came to light in 1953. The wheels had been detached from a wagon and propped up against the walls of the chamber. The vehicle was then used as a bier – a style characteristic of the culture.

Around the head was a 24 ct (480 g) gold torc with terminals in the 22
form of lions' claws gripping balls and flanked by winged, 'orientalizing' horses (similar to Pegasus). This may have been the product of a Graeco-Etruscan workshop, but, because there is nothing like it from the classical world, it may have been designed specially to cater for 'barbarian' taste, or be an actual Celtic product.

Two Attic Black Figure cups (both dated to between 525 and 500 BC), a bronze beaked flagon, two imported bronze pans, bracelets, circlets of amber beads, and Hallstatt brooches were included in the assemblage. Even more spectacular however, is a vast cauldron or *krater*.

The Vix *Krater* is a bronze wine-mixing vessel, which is unusual for 23
a number of reasons. It had probably been assembled in France, having been made in a Greek workshop in pieces which were marked with Greek lettering to facilitate assembly. It is also a matter of some curiosity that a Celtic notable should either accept as a gift, or obtain through trade, a vessel for blending a liquor which the Celts themselves did not produce. Whether it was used for its intended purpose, or whether adapted to the local beer, or simply admired as a symbol of the civilized world, is at present unknown.

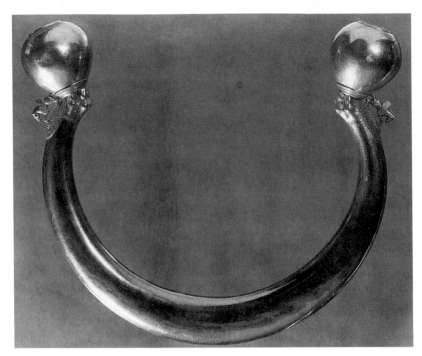

22,23 Hollow gold torc (above) from a 'princess's' burial at Vix, Côte d'Azur, France, Hallstatt D, late sixth century BC. Winged horses like the Greek Pegasus spring from the terminal balls, their curved wings typical of the Greek 'orientalizing' style. The Vix *Krater* (right), is the bronze wine-mixing bowl found in the same grave, ornamented with processions of infantrymen and charioteers

Whatever its use, the *krater* was undoubtedly impressive: 1.64 m (6ft 4in) high and weighing 208.6 Kg (468 lb), it is decorated with a low-relief frieze on which foot soldiers alternate with charioteers driving quadrigas (four-horse chariots). The lugs display Medusa heads, and the lid is adorned with a free-standing female figure.

Greek contacts are not only apparent through imported material goods, but caused modifications to 'pure' Celtic taste. From the barrows grouped around the hillforts near Sopron, Hungary, have come a series of pots decorated with stylized figures, mostly engaged in domestic activities such as weaving. The figures, with their triangular dresses and accompanying matchstick animals, look very much like the kind of figures that appear on Greek pottery of the Geometric period, such as the eighth-century Dipylon Vase from the Kerameikos cemetery in Athens.

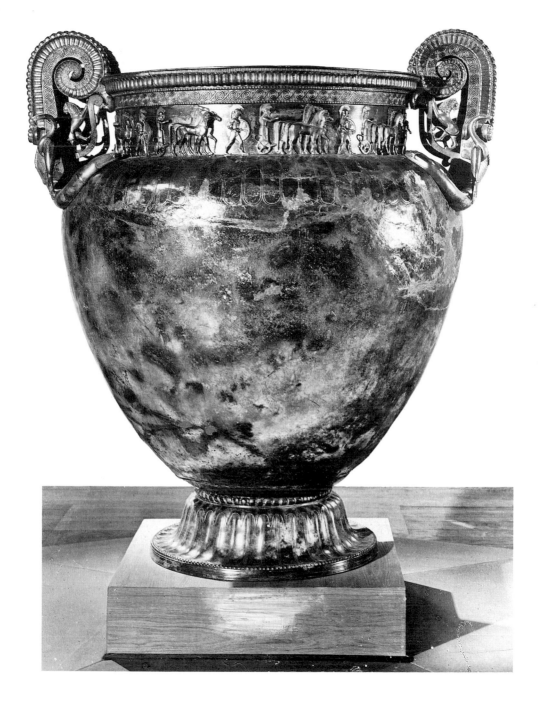

Through the medium of Greece, the Celtic world was exposed to influences from much farther east, in particular from Persia. The Greek world itself was not cut off from outside influence, indeed the Geometric style gave way to that known rather loosely as the 'orientalizing'. This style incorporated into the decorative scheme motifs such as winged horses, griffins, sphinxes and other monsters that no doubt contributed to the origins of such legends as those of Bellerophon and the Chimaera.

The orient also gave Greece a decorative repertoire including the lotus and the palmette – the former probably having originated in China, and thence having been transmitted via Persia. This art, exotic to Greece, was almost certainly disseminated through such media as the trading bases round the Mediterranean of which Al Mina in northern Syria, founded in the ninth century BC, is a good example.

The avenues by which oriental concepts reached Hallstatt and La Tène Europe have never been established with certainty. Some scholars for example have regarded the steppe nomads as the means of transmission. The Greek world knew them as Gimmirai (Cimmerians), who overran the early metalworking Persian kingdom of Urartu and who invaded Asia Minor and sacked Gordion. Some former nomads certainly settled down in the Crimea.

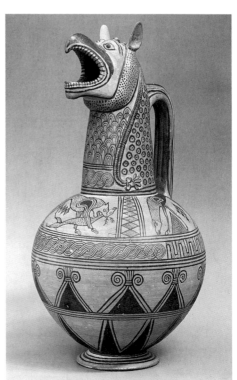

24 (right) Greek vase from Aegina, made in the Cyclades, displaying an 'oriental' motif: a griffin's head. Such Greek orientalizing art of the early seventh century BC is one source for the oriental elements in Celtic art

25,26 (far right) Four pottery *rhyta* or drinking horns from Dalj, Yugoslavia, of the seventh century BC. Resembling Persian vessels, they suggest another possible avenue by which Eastern influence could have reached the Celts

34

The picture is complex, and it is clear that 'Cimmerians' is a term that covers a number of groups with different origins. They do appear to have contributed to the spread of naturalistic animal art, although it is not possible to point to specifically 'nomad'-style animals in Europe. The Celtic interpretation of such art seems to have resulted in forms that are much less formal and rigid than those of their Greek counterparts. Given the known lifestyle of nomadic tribes, an indeterminate picture without cohesion or unity is precisely what would be expected in tracing the influences of such an intangible phenomenon as their style or taste.

However, if we look closely at Celtic art and artifacts of the Hallstatt period we can determine shadowy elements that can be claimed as coming from the orient through the nomads. One so influenced series of figures comes from Yugoslavia – a goat from Sisak and a stag from Surdak exemplify the best of this style. Also from Yugoslavia are four pottery *rhyta* or drinking horns found at Dalj, the 25,26
animals adorning them much in the style of the creatures from the cemetery at Hallstatt. These *rhyta* recall Iranian work, and there is growing evidence for contact with the East, particularly Phrygia, in the material assemblage from the Balkans in the seventh to sixth centuries B C.

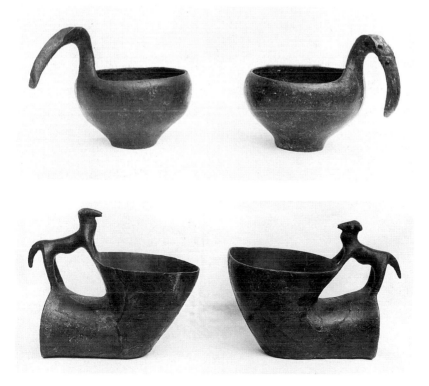

Most eloquent of such outside connections is the Strettweg cult wagon of Austria. Associated with pottery thought to be of the sixth century B C (but now lost), the four-wheeled bronze wagon bears a series of human figures, some mounted, round a central female figure balancing a dish on her head. There is evidence for cult wagons in later Greece – for example at Crannon in Thessaly – and the figures on this strange object are very close to Greek models. Nancy Sandars has gone so far as to suggest that it was made either by 'a Greek craftsman working to native orders or a native craftsman who had been to school in a Greek workshop'.

There is something about these figures that recalls the figurines with elongated and inelegant arms that can be produced in some malleable material rather than wood or metal, which suggests that the model was probably clay. Certainly the marked contrast between the precision of the inanimate parts of the object – the wagon itself – and the figures is noteworthy. The effect is to endow the crowd of figures with movement and life despite the lack of naturalism in their forms. Most of the figures are looking upwards, as were the females from the Eberdingen-Hochdorf burial, but the effect is quite different. The Strettweg figures have mouths, albeit closed, but the general effect, when added to the impression of movement is of noise and bustle, quite different from the silence at the Eberdingen-Hochdorf funeral.

This object is a fine example with which to illustrate the problems encountered when trying to evaluate art from a non-literate culture. Most of the commentary has of necessity to centre around the particular motifs or features which are similar to or different from those found in other cultures. By this means we can at least distinguish cultural exchange or even relative dating. However the art also offers 'messages' to any audience. The figures are placed standing or mounted, not sitting or prone. Their arms are in the air, or holding weapons. The expressions on the faces are solemn, with no attempt to convey joy, or anger or fear. The effect is very definitely close to awe or respect.

Another major influence on Hallstatt was *situla* art, which flourished around the head of the Adriatic. *Situlae* are bronze buckets, originally made in Bronze Age Europe. They were first fashioned in the twelfth century B C, and the earliest are sometimes ornamented with repoussé boss work depicting the sun-boat, a cross-in-circle with water fowl or the same cross-in-circle in a bird-ended boat. After such beginnings the buckets became plain, but around 600 B C small *situlae* appear furnished with lids and with all-over decoration in zones. The

figural work on these buckets is orientalizing, and the centres of production included Slovenia and Carinthia, the Alpine foothills and the area round Bologna and Este. Some of the *situlae* were used as cinerary urns, and are found in barrow burials. As well as the situlae other objects are found, notably scabbards and belts, decorated in the same style.

27 Strettweg cult wagon from Steiermark, Austria, 22.6 cm (9 in) high, one of the most remarkable objects to survive from prehistoric Europe. Warriors, axe-bearers and stags surround the nude female figure bearing an offering-dish on her head (shown restored). Found with a sixth-century BC burial, it could be earlier

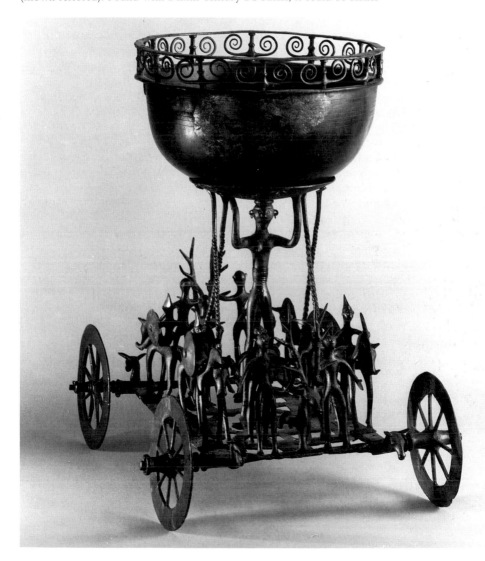

The subject matter of the *situlae* is basic to East Mediterranean art – processions of animals and men, musicians, and ceremonial occasions such as feasts. The earlier *situlae* favour animals, including the fantastic beasts of the orientalizing range. The immediate inspiration was probably Etruria, and thence the art passed into use among the Eastern Hallstatt patrons. Some *situlae* traversed the Alps to Hallstatt, where both *situlae* and lids occur as grave finds.

A few objects were traded across the Alps from Italy during the late Hallstatt phases. A magnificent example of such an item came to light when barrow-diggers opened the grave at Grächwil-Meilkirch in Switzerland in 1851. The grave produced the familiar array of pottery and brooches, the four-wheeled wagon adapted as a bier, and additionally, a large bronze jar that had been made in Italy in the first half of the sixth century BC. It is an outstanding piece of imported art made in Archaic Greek style, and reflecting taste at this time.

Significantly, especially in the light of later developments, where in the La Tène art of the fifth century BC Etruscan influence will be seen repeatedly, some of the objects that were traded across the Alps are decorated in a style associated with the Etruscans.

28 Detail of bronze scabbard from grave 994 in the Hallstatt cemetery, probably made on the Middle Rhine in the late fifth or early fourth century BC, and showing the influence of *situla* art on the Celts

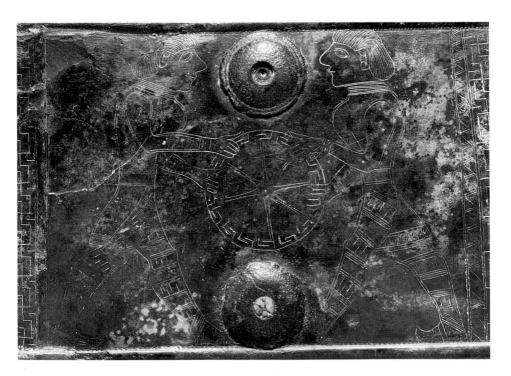

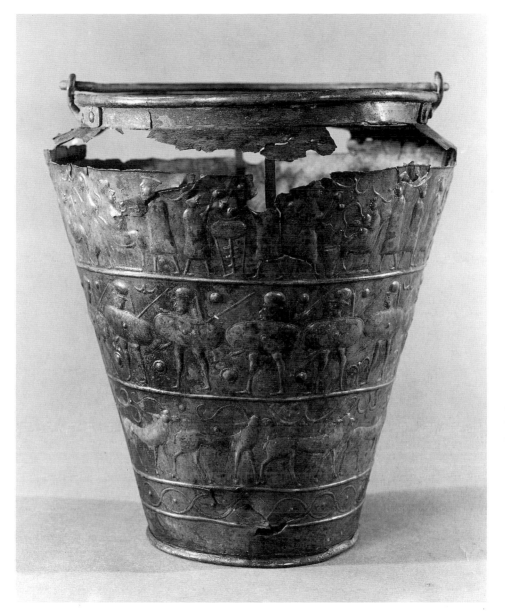

29 Bronze wine bucket or *situla* of the fifth century BC from the cemetery at Certosa, near Bologna, northern Italy. The friezes of figures and animals which decorate the bucket are probably of Etruscan inspiration, but the bucket-design itself belongs to the area at the head of the Adriatic, from which *situla* art probably reached the eastern Hallstatt world

La Tène art in Europe

The 'La Tène' culture is named after a site ('The Shallows') on Lake Neûchatel in Switzerland, but the richest artifacts have been found further north, in the Middle Rhine and Hunsrück-Eifel region. Although burials are known in the Bronze Age, this area was not archaeologically conspicuous in late Hallstatt times. La Tène society seems to have risen to prominence through trade, again with the Mediterranean world, but this time control may have been in the hands of Celts, not Greek or Italic entrepreneurs, and was conducted across the Alps and with the Etruscans. From the beginning of the fifth century BC Etruria seems to have been involved in a vigorous trade with the emerging centres of La Tène power on the river Mosel.

Early La Tène burials lack fine diplomatic gifts such as the Vix *Krater*, but wealthy Celts still favoured the accoutrements of wine-drinking, such as beaked flagons and *stamnoi* or bronze jars for wine, and pottery. Rich graves are a feature of Early La Tène; the archaeological assemblages point to a warrior aristocracy who were in a position to act as patrons for the developing art.

The classification of La Tène art has, since the 1940s, followed Paul Jacobsthal's scheme in distinguishing four 'styles', named 'Early', 'Waldalgesheim', 'Plastic' and 'Sword'. Initially the styles were thought to characterize a sequence in which 'Early' was succeeded by Waldalgesheim, which in turn was superseded by two contemporary styles, Plastic and Sword, but more recent research suggests that these groupings are meaningless chronologically, and elements of the Early and Waldalgesheim styles persist. They are also perhaps misleading since some of the best Waldalgesheim work is in effect 'plastic', that is, has relief modelling, while the finds from the Waldalgesheim grave are probably imports. Nor can the styles be said to be geographically meaningful, except perhaps in the case of the Sword Style, which has regional groupings, notably in Hungary and Switzerland.

The idea of 'styles' is in some measure derivative of Jacobsthal's classical background, and an attempt to break away from the labels was made by J.M. de Navarro, a British scholar (again from a classical

41

30 Gold torc from Waldalgesheim, Germany (see p. 58)

background). De Navarro used a numerical scheme in which Jacobsthal's sequence of four styles was replaced by a scheme of three, Style I being equated with 'Early', Style II with 'Waldalgesheim' and Style III with 'Plastic' and 'Sword'. Later researchers, such as Duval, have attempted alternative sequences, but Jacobsthal's terms still endure, and they have not yet been satisfactorily superseded.

EARLY LA TÈNE STYLE

From the earliest period, La Tène 'Celtic' art can be seen to be eclectic. As Rome adopted and adapted rather than destroyed much of the culture of the people she overran, so too did Celtic society. There was a wide range of motifs and symbolic repertory, though usually non-representational, non-naturalistic, and even abstract, which has led to Celtic art being seen at times as mere 'pattern'. Nowhere is this more apparent than in the zone between the Middle Rhine and the Hunsrück-Eifel, where a fine pool of works of art has traditionally (though not necessarily accurately) been categorized as the 'Early Style'. To modern eyes the art of this style is particularly pleasing since much of its success depends on its symmetry and in the repetition of motifs in all-over patterns. The basis of much of this ornament is vegetal and either classical or oriental.

Lotus flowers, palmettes and acanthus foliage were taken up by Early Celtic artists, robbed of their formalism and given a flowing character that is distinctively Celtic.

31 Celtic adaptation of the lotus-bud and palmette: top, from an Etruscan bronze wine vessel; centre, from a drinking horn from Eigenbilzen, Belgium; bottom, from a gold cup-mount from Schwarzenbach, Germany (after Frey, 1971)

42

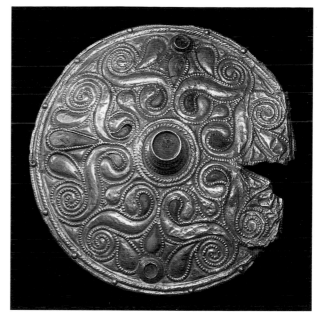

32 (right) Gold plated bronze disc, 100 cm (39½ in) diameter, from Auvers, France, with symmetrical ornament of paired lyre-scrolls typical of the Early Style. Bearded faces may be discerned in the pairs. Similar design elements (top) appear on the Swartzenbach bowl-mount (after Jacobsthal, 1944)

Jacobsthal recognized three sources of the Early Style: Hallstatt, classical and oriental. The Hallstatt contribution he claimed to be geometrical ornament and such motifs as Hallstatt ducks. He saw the classical ornament as derived from Etruria and Greece. The oriental, characterized by its animal designs, he regarded as probably filtered through a classical mesh, though he was less certain about the precise origins of this contribution than the others, and it is certainly the most enigmatic.

The bronze disc with gold plating from Auvers, France, provides an outstanding example of symmetry and classical plant-based ornament. It was probably made in the early fourth century BC when the Early Style was well established. It may have served as a lid for a bucket. Borders are provided in a kind of cable beading that resembles filigree work. Half palmettes form a continuous lyre pattern round the disc, which takes on the character of human faces. There is a central setting for an inlay, now lost, which was probably coral, a substance imported from the Mediterranean.

The use of sheet gold to decorate objects can be seen in a variety of contexts, for example in the decoration of flagons. In the same general style as the Auvers disc was a bowl deposited at Schwarzenbach in Germany. All that now survives of this object is the openwork sheet-gold which covered it.

11

32

31–2

43

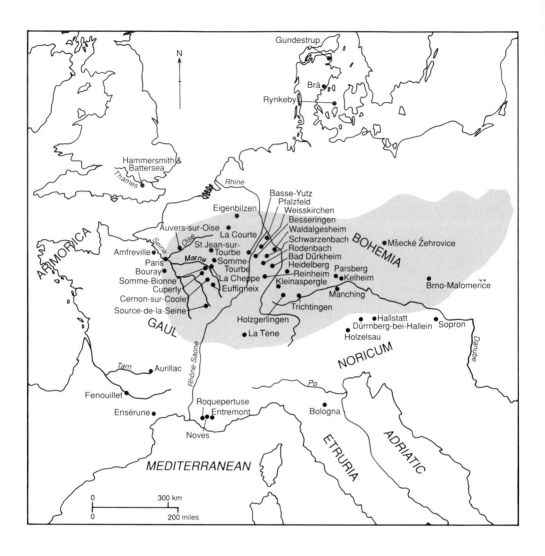

33 La Tène Europe, showing locations of major and representative finds. The tint indicates the original heartland of La Tène culture

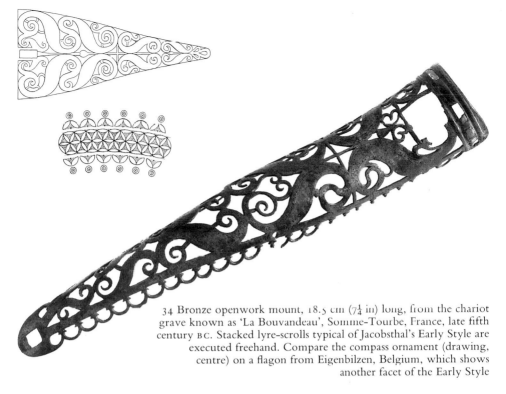

34 Bronze openwork mount, 18.5 cm ($7\frac{1}{4}$ in) long, from the chariot grave known as 'La Bouvandeau', Somme-Tourbe, France, late fifth century BC. Stacked lyre-scrolls typical of Jacobsthal's Early Style are executed freehand. Compare the compass ornament (drawing, centre) on a flagon from Eigenbilzen, Belgium, which shows another facet of the Early Style

The Auvers disc was probably drawn freehand, but compasses were definitely used in the production of other Early Style pieces, most notably on a flagon from Eigenbilzen, where the compass marks are detectable. An actual pair of Celtic compasses was found at Celles (Dept. Cantal) in France. The use of compasses can be seen in the finds from two graves at Weisskirchen in Germany. The practice may have originated in the Mediterranean, and was widely adopted in the Marne and Hunsrück-Eifel region for works in the Early Style, though it fell from popularity on the continent thereafter (it was however used later in Britain).

In eastern France chariot burials in the Marne region have yielded a different version of the vegetal style of work. Some of the Marne pieces have a modern look – take for example the 'hame' (a mounting for a chariot yoke) from the grave known as La Bouvandeau, of the late fifth century BC. The classical origin of the plant motifs fashioned in openwork is much less apparent on these than on Rhenish work, though the essence is a double three-leaved palmette.

34

45

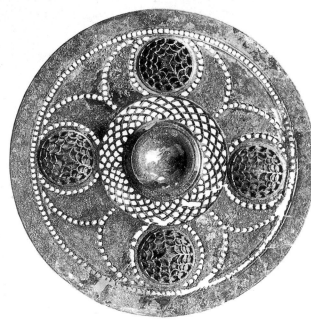

36 (right) Disc 24.5 cm (9½ in) diameter from Saint Jean-sur-Tourbe, Marne, France, late fifth or early fourth century BC. Stacked lyre-scrolls subtly merge with a 'running dog' pattern in the rich border, setting off the plain concentric circles. The ornament was originally inlaid with coral

35 Openwork disc 12.8 cm (5 in) diameter from Cuperly, Marne, France, late fifth or early fourth century BC. The compass design is based on three radii (right)

 The Marne has produced a series of compass-designed mounts. There is no hint of plant ornamentation here. An openwork disc, 35 originally enamelled, from Cuperly, has an arrangement of five roundels.

 The most accomplished of the Marne works must surely be the 36 discs from Saint Jean-sur-Tourbe. The abstract simplicity of the concentric circles (which, as with all such tricks, gives the impression of a wheel in constant movement as the eye glances over it), is set off by the openwork edging and central roundel. The swirling of the disc is held firmly between two 'frames', in what to the present writers at least appears to be a highly accomplished abstract of a wooden wheel – the openwork pattern representating the rings of the wood. Whether the disc had some representational purpose or is a purely abstract symbolic image, it is evidence of a highly sophisticated understanding of the effects of light and shade.

 The finds from the two graves at Weisskirchen and from that at Kleinaspergle, also in Germany, introduce other elements of Early Celtic art apart from the purely vegetal. The Kleinaspergle grave

46

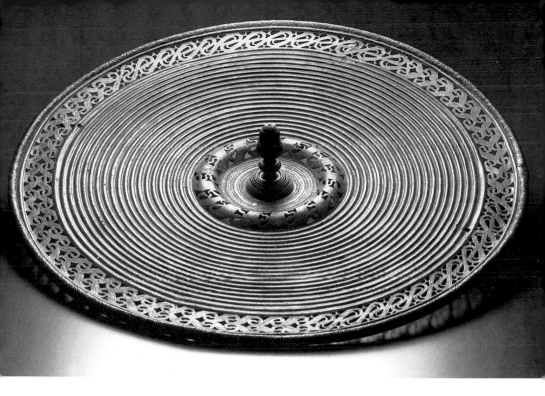

contained a pair of elaborately decorated gold drinking horns. The terminals take the form of the heads of a ram and a ewe, an idea of which might be of Persian inspiration, since armlets (and drinking horns) with animal terminals were popular there, though animal head terminals also have an ancestry in Europe. The burial also contained a wine flagon, closely modelled on an Etruscan prototype but with a bearded cartoon-like face on the escutcheon. The inspiration for the face can be presumed to be a classical Silenos, but the mask interpreted by Celtic hands turned out quite differently. With bulging eyes, puffed out cheeks, pointed ears and beard with symmetrical locks, it is neither human nor animal, though it has certain feline qualities. The handle spills out on to the rim of the flagon, and ends in a pair of similar faces, where on an Etruscan vessel there would have been lions.

37

The Weisskirchen grave finds extend the repertoire even further. As at Kleinaspergle, a similar face, this time human and bearded, adorned an escutcheon for the handle on an imported Etruscan *stamnos*. The face is moustachioed, and is essentially Celtic. From the same site has come a piece of sheet–gold on a base metal core decorated

with minute faces that might be mistaken for beading at first glance.

Although the Celtic face is distinctive – a frontal mask, with big eyes, solemn expression and frequently with moustache, it recurs in varying guises throughout the next fifteen hundred years to appear on Romanesque doorways in Ireland – never were faces more popular than in the 'Early' style of Celtic art. Jacobsthal had noted that the 'beasts and masks give the Early Style the stamp'.

The Weisskirchen gold-inlaid plaque is in complete contrast to, for example, the disc described above from Saint Jean-sur-Tourbe, yet it gives a similar impression of isolating itself from the viewer that is a feature of so much Celtic art. The general shape has been carefully composed in symmetry, with a clever juggling of shapes – a square, a cruciform interior, with so complex an edging that the basic design appears at first sight to be a rough circle with additional pieces at the sides. Within this geometrically conceived composition there is little restraint, however: lines twine round the central roundel catching the light in such a way that the eye is deceived into thinking the whole has been casually made. Within the overall pattern, human interest has been introduced in the form of four faces. They are rudimentary yet recognizably Celtic, and at the start of a long tradition that emphasizes the eyes and facial hair. Of course we cannot determine whether these

37 Handle escutcheon of a bronze flagon from Kleinaspergle, Germany, late fifth century BC. The bearded wine-god Silenos here acquires Celtic feline ears, staring eyes and an ornamental beard, quite at variance with the classical prototype

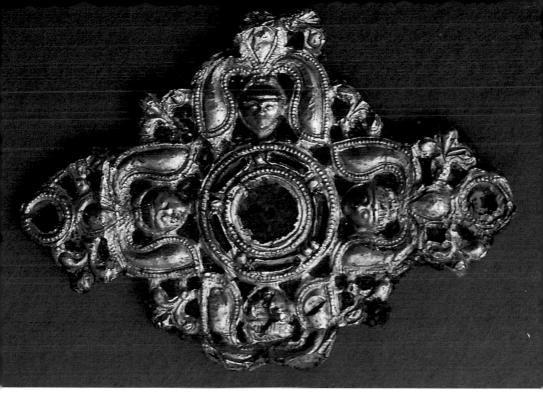

38 Masks predominate on a gold-inlaid bronze and iron plaque 8 cm (3 in) wide, found in a warrior grave at Weisskirchen, Germany, early fourth century BC

were meant to be real men, or gods, or allegorical figures, but artistically the effect is to make us continue to look at the piece. The eye moves constantly from one face to the other to compare – are they the same, in what way do they differ, are the shapes emerging at the crowns of their fringed heads meant to symbolize headgear? The item forces us to ask questions of it and frustrates us in not supplying the answers. Here again, we find the Celtic artist is conjuring up a feeling of movement by the use of relief which reflects light, constantly drawing attention to itself.

On a sheet-gold mount from Schwarzenbach the puffy cheeks, big eyes and rounded chin can be seen again, but here combined with another typical element, the 'leaf crown' of comma leaves. The leaf-crown occurs in various guises in the Early Style. Its meaning is lost to us, though some have postulated that it may be a mark of divinity.

49

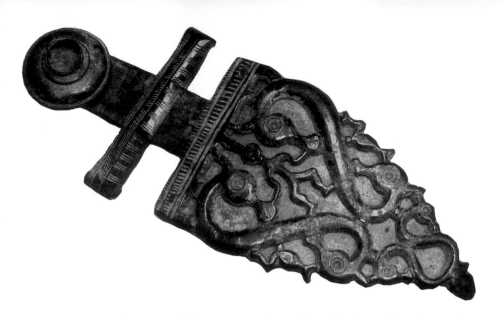

The oriental element in Early Style art has been the subject of some debate. Jacobsthal was unclear as to its origins, suspecting its transmission into Celtic art via that of the Royal Scyths. Nancy Sandars has assumed a more direct inspiration, but has not ruled out the possibility that some 'oriental looking' creatures, such as those on the Cuperly ornament and on a tracery mount from Bad Dürkheim, in the Rhineland, may owe a debt to a native northern source, the ancestors of which she has identified on razors made in the northern Bronze Age. These creatures are s-dragons, and are found in many contexts – they appear in pairs on later scabbards, they manifest themselves snaking round a pot from La Cheppe, Marne, and they appear in various milieux in both the Celtic and Germanic Dark Ages.

The more obviously orientalizing motifs such as griffins, ibex and suchlike, Sandars has accounted for by the advance of the Persian king Darius into Eastern Europe in the late sixth century BC. As she pointed out, Darius left his general Megabazus in Thrace, which the Persians held, at least in part, down to the time of Marathon in 480 BC. At this time Thracians served as mercenaries in the Persian army, and may well have taken back Persian treasures to Thrace. An Achaemenid Persian silver amphora with handles in the shape of a horned and winged lion was found at Duvanli near Plovdiv in a native burial, and from such a source, she believes, Achaemenid works might have travelled farther inland and west into Celtic Europe.

40

50

Other scholars have been less convinced of such direct inspiration. They have pointed out, for example, that there have been no Persian finds in the distribution area of Early Style Celtic art, which would be expected if the Sandars hypothesis were correct. Furthermore, all the motifs designated 'Persian' are to be found from the sixth century BC on orientalizing Etruscan art and in *situla* art, and it is from these areas rather than farther east that they have seen the 'oriental' influence being derived.

In addition, a few orientalizing pieces from the Greek world are known to have reached the Celts. Fine examples of these are the ivory sphinxes with amber faces from a late Hallstatt burial at Grafenbühl and a gold-leaf drinking horn mount from Weisskirchen on which sphinxes bear typically orientalizing sickle-shaped wings.

The picture would therefore seem to be complex, with several indirect routes of oriental influence possible. Whatever their origin, however, 'orientalizing' motifs abound in Early Style art. They appear for instance on a belt hook from Holzelsau in Austria. 39 Executed in openwork, a pair of the s-dragons confront one another while a full-length human figure standing between them touches their snouts. Water birds swim in the dragons' coils.

39 (above left) Belt hook 16 cm (6¼ in) long, from Holzelsau, Austria, early fourth century BC. S-dragons flank a figure touching their snouts, like an Eastern 'master of the animals'. This is the finest of a group of such belt fittings, probably made by the Celts south of the Alps, but found as far afield as the Marne

40 Pair of griffins on a bronze openwork mount 9.1 cm (3½ in) long, possibly a helmet cheek-piece, from Cuperly, Marne, France, late fifth or early fourth century BC

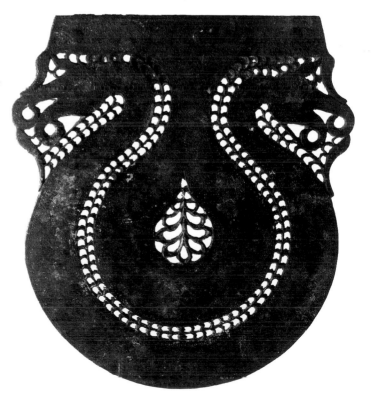

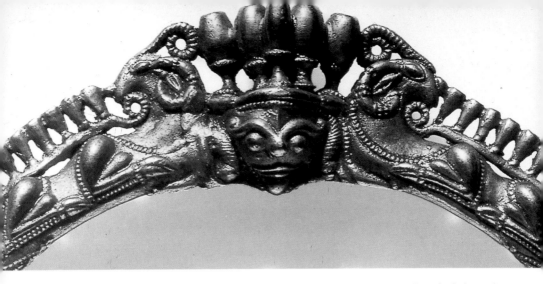

41 Detail of gold bracelet from Rodenbach, Germany, with central mask, 'balusters', and backward-looking ibex or rams. The masks and animals, said Jacobsthal, 'give the Early Style the stamp'

Perhaps the most attractive examples of 'orientalizing' Early Celtic art are to be found on a series of gold torcs and bracelets from the Middle Rhine and Switzerland. They begin with a find from a male secondary burial at Rodenbach, Germany, accompanied by Etruscan bronze vessels and an Attic pottery *kantharos* of the later fifth century BC. The gold bracelet has a central face with a strange crown of 'inverted bottles' or balusters, which also form an openwork crest round the heavily ornamented part of the ring. On either side of the face are crouched, backward-looking ibex (or rams?). Two further masks form the central studs between another pair of similarly backward-looking ibex. The treatment of the figures has a Scythian look about it, particularly in the deployment of the folded legs and backward-looking heads. This is a complicated piece of art. If symbolism was, as one expects, intended, then it is lost to us. The effect is regal, however, with considerable detail on those parts of the band that would have been in view, but plain where it might have touched the wearer's body. The use of beading accentuates the relief work, making maximum use of the light. With movement, this bracelet is likely to have attracted considerable attention to itself. It is interesting for not being symmetrical, though it is balanced. The lack of symmetry, as so often in any art, causes the eye to roam constantly over the object.

41

42 Mask on the escutcheon of the Dürrnberg flagon (see Ill. 49)

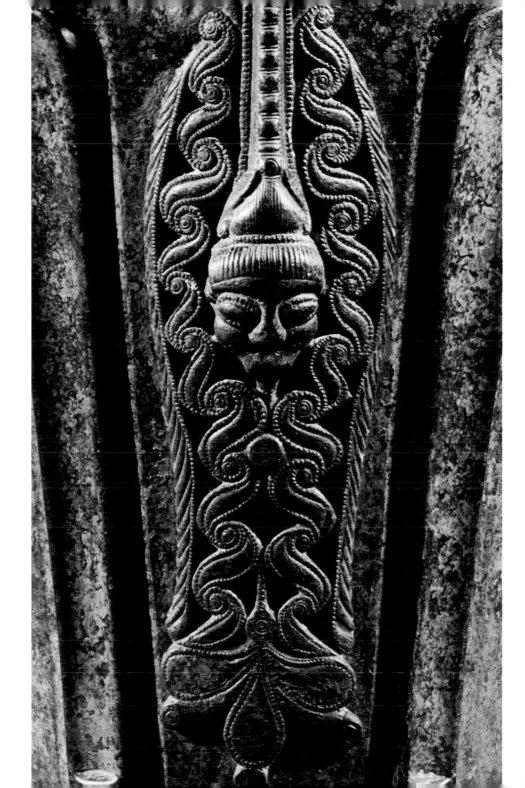

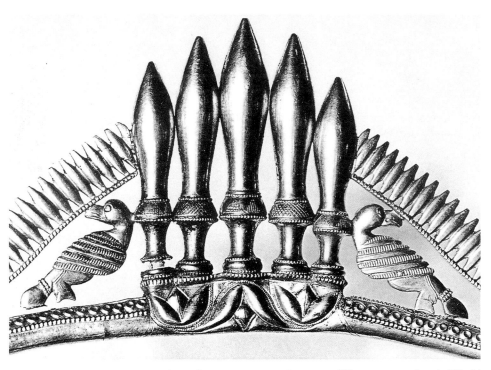

43 Detail of a gold torc from Besseringen, Germany, fifth century BC. Lost in World War II, the torc is only known from photographs

'Bottles' or balusters also ornamented a now-lost neckring or torc from Besseringen in Germany, this time from a woman's grave. The balusters are flanked by backward-looking birds, and three lotus buds form the platform from which they spring. Lack of symmetry is a main feature of the object. It is all the more noteworthy since the first impression of this torc is of total order. There is something almost heraldic about it, and it has been accomplished with considerable precision and skill. These items came from 'royal' graves and there is nothing casual or informal about them. Nor does the art convey the atmosphere of spirituality encountered in, for example, the funeral procession on the Strettweg wagon, or the female figures in the Eberdingen-Hochdorf grave. Quite apart from the fact that logic suggests that the wearing of bracelet and torc would be connected with a certain amount of pomp, their very form gives the sense of a human or social barrier being accentuated through the medium of art.

Both these rings may have been produced in the same area or even workshop that manufactured a sheet gold torc and armrings from a sumptuous burial, probably of a woman, at Reinheim, Germany. Again balusters are employed on these pieces, along with a type of beading encountered also at Besseringen and Rodenbach. On the armring are truncated (female?) figures, their arms folded over their stomachs. Birds of prey protect (or menace?) with outstretched wings.

45-7

Among the smaller products of the Celtic artists who flourished in the fifth and fourth centuries BC are a series of richly decorated brooches, often with coral inlays. One example may suffice. Found at Parsberg, Oberfalz, in Germany, and made of bronze, its foot displays a moustached cartoon face with round popping eyes. On the head of the brooch is another face with feline ears. This spreads out into two 'griffins' which look like Chinese dogs with curled hip and shoulder spirals, hooked beaks and ears, and hatched fur.

44

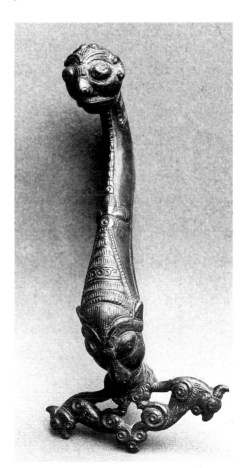

44 Bronze brooch 8.8 cm (3½ in) long, found in a barrow at Parsberg, Oberfalz, Germany, end of the fifth century BC. The uppermost Celtic face bears a lotus-bud-like 'caste mark' on the forehead, and the nostrils may have held enamel inlay

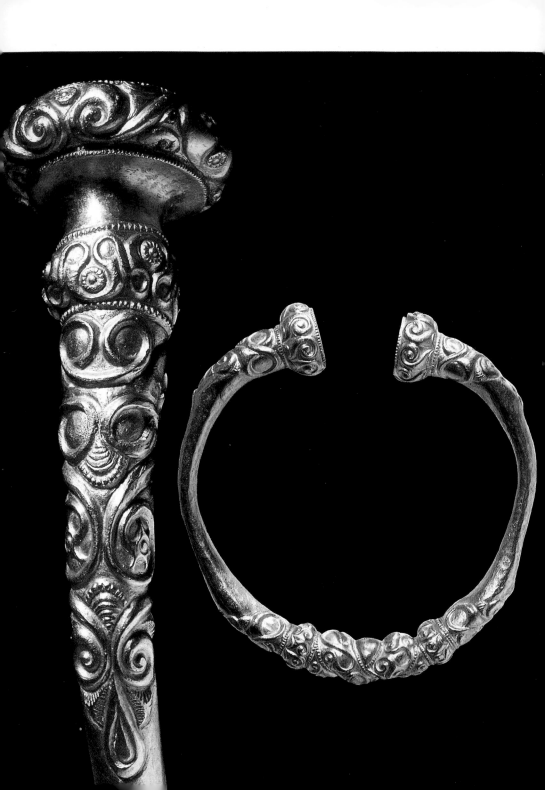

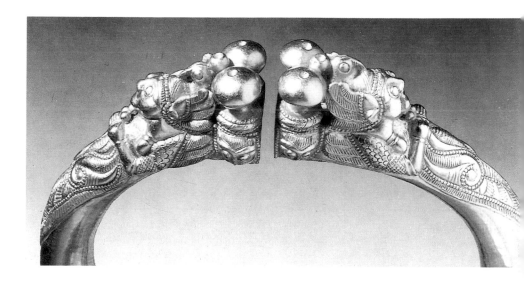

45–7 Gold torc (left) and details of armrings, the jewellery of a princess found at Rheinheim, Germany, mid-fourth century BC. They were discovered in 1956 in a wood-lined chamber under a mound, among more than two hundred items of jewellery, mostly beads, but also finger rings

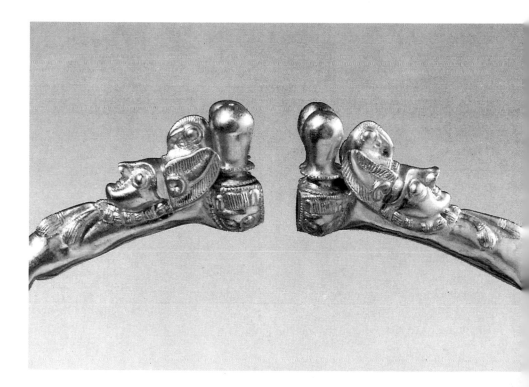

51 A pair of flagons from Basse-Yutz in France are notable first for their elegance, with slender, concave-sided profiles. The sides are left plain, apart from a line of engraving above the coral-inlaid foot which has symmetrical, interlace ornament. The handles are enchanting little dogs with almost impish appearance whose lower extremities fade into Celtic masks. A chain joins their jaws to the lids, which is crowned on one of them with a similar animal head. The flagons have enamelled spouts. The design on the spout is geometric, with a sprung palmette at its base. On the spout a tiny duck is balanced. These flagons belong probably to the early fourth century BC.

The flagons are delicately balanced between true understated elegance and excess. The almost stark lines of the body and neck are in sharp contrast to the handle, spout and foot-ring. These are definitely not everyday objects, though designed for the top to be seen best while being poured rather than when standing. They are objects to impress visitors perhaps, or to give pleasure to their owner during a feast.

49,50 The Dürrnberg flagon from Austria is altogether more sober. Arguably of superior workmanship, its slender, tapering profile is relieved by sunk repoussé panels with ribbing. The handle escutcheon

42 bears the all-important human mask, unbearded, but its crest takes the form of a crouching animal which rests its chin on a human head, gripped between its paws. The extremities of the handle attachment are created in the form of smaller animals, from whose jaws protrude the tails of their latest meal.

THE WALDALGESHEIM STYLE

A princess's burial from Waldalgesheim in Germany marks the beginning of a new episode in Celtic development and art. In the fourth century BC the La Tène Celts began expanding from their original homelands into Italy and Greece, and the effect of this social upheaval can be argued as giving rise to the 'second' style of art –

30,52 Jacobsthal's 'Waldalgesheim Style'. For Jacobsthal, this was the 'classic' phase of Early Celtic art – 'it overcomes archaism: the Eurasian features and the geometric patterns recede. By free use of Southern forms the Celts now elaborate a serviceable ornament, particularly a type of tendril which can be brought into any shape and serve any purpose of decoration' (Jacobsthal, 1944, 162).

48 The princess's belongings included a flagon decorated with engraved ornament in the Early Style. It has a handle escutcheon in the form of a head wearing a leaf crown: very expressive, it depicts an

48 Mask forming the handle escutcheon of a flagon found in a princess's grave at Waldalgesheim, Germany. Note the 'leaf crown', believed by some to be a mark of divinity, and the Early Style openwork ornament. Such ornament was already 'old fashioned' when the flagon was buried in the mid-fourth century BC

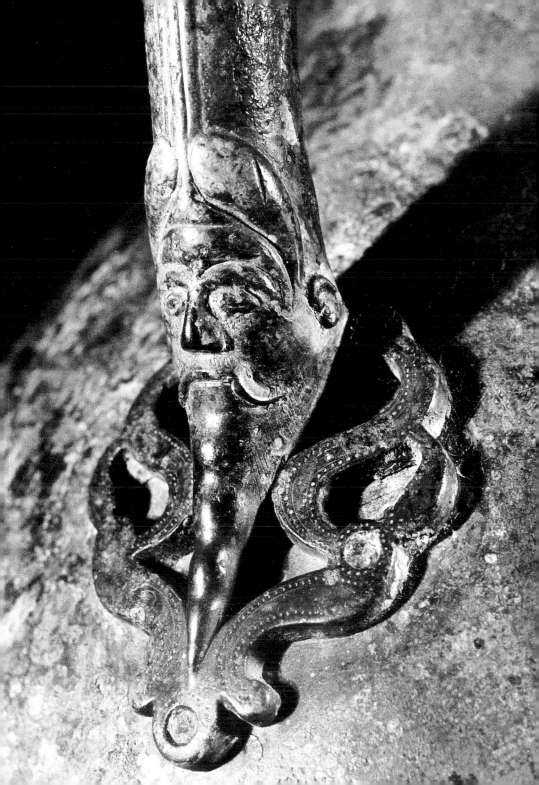

49–50 (right and below) Elegant, fluted flagon, 48.8 cm (19⅛ in) high, with Celtic monsters, found in a richly furnished grave at Dürrnberg, Austria, dating from the late fifth century BC. Notice the creature on the handle with a human head tucked beneath the chin, and the two monsters on the rim, where an Etruscan flagon would have had lions, with their victims' tails protruding from their mouths

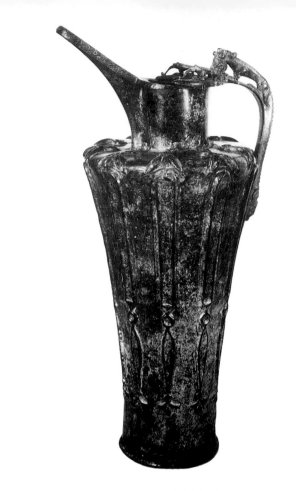

51 (far right) Pair of coral and enamel inlaid flagons 38.7 cm̀ (15 in) high from Basse-Yutz, Moselle, made in the Rhineland in the early fourth century BC, and among the finest of surviving products in the Early Style. Their models are Etruscan wine flagons, but the Celtic versions are more elegant. Notice the handle and rim creatures, and the tiny duck on the spout, poised as if to sail down the wine-flow

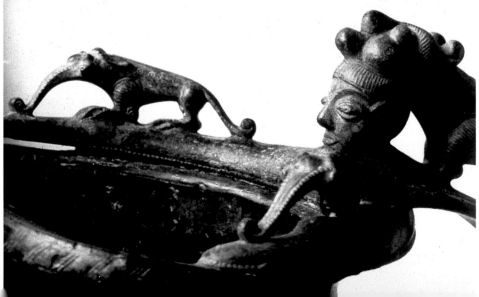

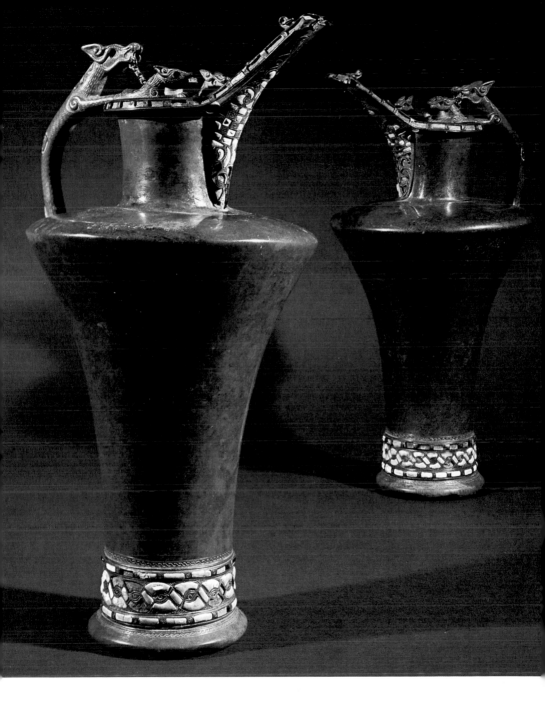

old man who appears, in the words of T.G.E. Powell, 'composed and well dined'. At the top of the handle is a ram's head, and the lid has a dumpy Celtic pony with hip spiral and shoulder patterns.

The leaf crown appears also on a pair of repoussé bronze plaques from the burial, with female faces and typical Waldalgesheim tendrils on their chests. Each raises an elegant hand in attitude of benefaction, and each wears a torc round her neck.

The objects which make Waldalgesheim a key discovery artistically are a group of gold torc and armlets. The torc and two of the three armlets have buffer ends. Human faces are incorporated into the design of running tendrils. Here they are unmistakably human, but elsewhere in Waldalgesheim art similar motifs are very ambiguous – are they faces, or simply an accident of ornament? Jacobsthal, who saw this ambiguity as a particular characteristic of his succeeding Plastic Style, termed this 'Cheshire' style, since the faces have a habit of vanishing as you look at them, as did the Cheshire Cat in Lewis Carroll's *Alice*.

The torc and two bracelets in the same style from the Waldalgesheim grave were probably made in the same workshop, but it is unlikely to have been located in the Middle Rhine, and the influence

52

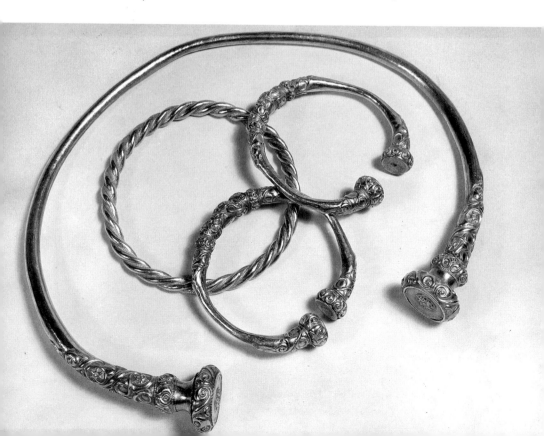

of the style current among the Celts of northern Italy is very apparent.

The burial has been dated by a south Italic *situla*, assigned to the late fourth century BC by many scholars, but which Zahlhaas has suggested, albeit controversially, is much earlier, around 370 BC.

The main feature of Waldalgesheim art is its use of vegetal patterns, employed with much less regard for symmetry and with much greater verve than before. Although human faces and animals appear, they are much less prominent. The style is also sometimes called the 'Mature' or 'Vegetal' style.

During the period in which Waldalgesheim Style was becoming fashionable, Celts settled in northern Italy. Some notable works in the Waldalgesheim Style have been found in Celtic cemeteries in Italy, and some may have been made there. Helmets, for example, illustrate well the development of the Waldalgesheim Style. These are cap-shaped, sometimes with cheek-pieces, and with a crest, or sometimes with a fitting for a plume. Some were possibly made in Italic workshops under Celtic influence, rather than by Celts, but on them the Waldalgesheim Style is clearly manifest. At Canosa in Apulia a burial vault for a local south Italian warrior contained an iron helmet of this type with repoussé bronze plates and with coral insets. Lyres, palmettes and half palmettes in friezes make up the ornament.

Marnian, rather than Italic, however, is the superb helmet of bronze decorated with gold repoussé plates and iron and enamel from Amfreville, Eure, in France. The Amfreville helmet has on its central 53 gold band a linked series of *triskeles*, made out of debased palmettes, and a lower iron openwork frieze with what is known as a 'running dog' pattern. A wave pattern, of the kind widespread in Greek art, forms the borders of the central band.

The Waldalgesheim Style can be seen on a number of other pieces. Many come from northern Italy, such as the bronze mounts, possibly for a flagon, reputedly from Comacchio. Shaped like commas with 54 trumpet ends, they are infilled with subtle Waldalgesheim tendrils, bordered by bands of very classical-looking ring-and-dot. The background for the tendrils is infilled with punched dots, and the whole design combines exuberance with restraint.

It is notable that the Waldalgesheim Style was not confined to metalwork, but also appears painted on pots from the Marne region. 55 These elegant vessels, modelled probably on metal prototypes, are perhaps the most successful of the several traditions of pots with Celtic designs found in the Iron Age.

52 Buffer-ended torc, diameter 19.9 cm (7⅞ in), and a group of armrings from the princess's grave at Waldalgesheim, mid-fourth century BC. Human masks still appear, but now the dominant design-element is a fleshy tendril pattern of swirling spirals in strong relief, with beaded borders, sometimes called 'Vegetal Style'

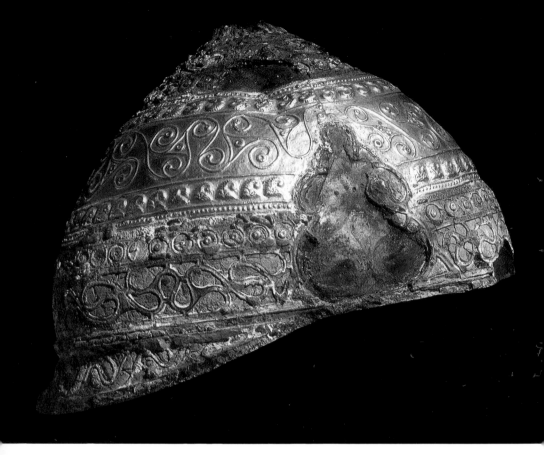

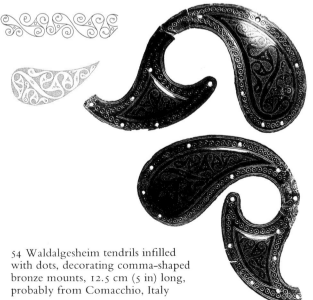

53 (above) 'Jockey cap' helmet of bronze and iron ornamented with gold leaf and enamel, from Amfreville, Eure, France. Waldalgesheim tendrils interlock on the central band in a *triskele*-like pattern. The wave-pattern edging the band is more 'old fashioned', making the helmet a work in a transitional style. It was perhaps made in northern Italy in the later fourth century. Far left: Waldalgesheim motifs (after Jacobsthal, 1944)

54 Waldalgesheim tendrils infilled with dots, decorating comma-shaped bronze mounts, 12.5 cm (5 in) long, probably from Comacchio, Italy

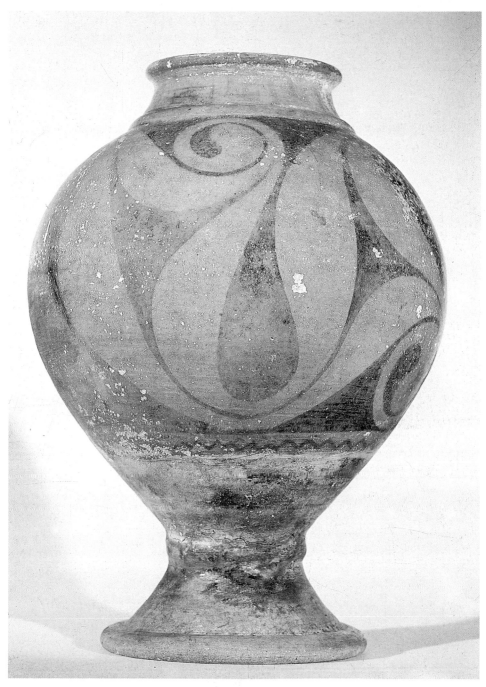

55 Pedestal-footed pot 35 cm (13¾ in) tall from Prunay, Marne, France, late fourth or
early third century BC. The Waldalgesheim spirals serve as a reminder that Celtic
ornament was not reserved for metalwork and stone

A remarkable bronze-plated tube-like chariot mount found 'near Paris' introduces new elements in Celtic art. Here, in contrast to the two-dimensional designs executed in relief that characterize Waldalgesheim art, we can see a work conceived three-dimensionally from the outset. This is Jacobsthal's 'Plastic Style'. Three faces are caught up in a running spiral – all are identical, but they alternate direction. They are represented in three-quarter profile, and are asymmetrical – both eyes appear closed, but one eye is much larger than the other. The relief is so high they seem almost free-standing. On the chin of each is a mole or wart (which was regarded, incidentally, centuries later by the Early Christian Irish as a mark of beauty). Our first reaction is to laugh at the grotesque faces, but the laugh is one which stems from unease. They are potent masks, not so much objects of good humour as suggestive of darker powers.

The Plastic Style represents an almost 'baroque' phase in Celtic art, flamboyant in its sometimes grotesque modelling. It is heavier and accordingly much more static than the style which preceded it. Developing in the early third century BC, it owed a debt to the Early Style and to the Waldalgesheim. From the Early Style it acquired a distinctive treatment of animal and human forms; from Waldalgesheim it acquired a disregard for symmetry. In the Plastic Style the creatures are themselves ornament – 'a style that is balanced between nature and solid geometry' in the words of Nancy Sandars. Bosses with spirals, whorls and voids are the essence of the decoration. Found in both East and West, it reaches its most extreme forms in central and eastern Europe.

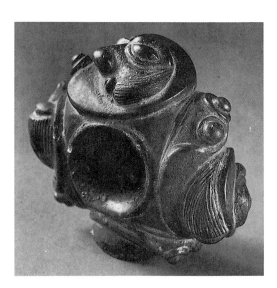

56 Chariot mount 8.5 cm (3¼ in) wide, found near Paris, early third century BC. 'Plastic Style' faces, large-eyed and mouthless, emerge from whorls and spirals

57 (above right) Gold armlet from Aurillac, Tarn, France, third century BC, one of the finest examples of jewellery in the Plastic Style

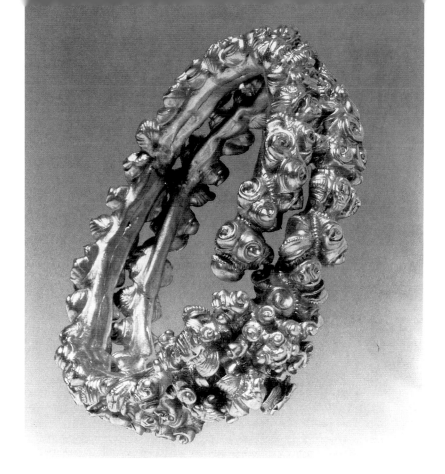

Although most Plastic Style work has a representational element, a few items are purely abstract. A gold armlet from Aurillac, Tarn, in France, weighs 191 g (6¾ oz), and is a mere 7.9 cm (3 in) across. Beading threads in and out of the relief work, which at first glance is vegetal and composed of twigs, nuts and berries; but this, however, is illusion: the ornament is strictly abstract, and based on curls and bosses.

Also from Tarn is a bronze bracelet or ankle ring with bosses and intertwining cabled lines. The background has been infilled with punched 'stipple' and *triskeles* join up the bosses, which probably imitate coral studs. There is a series of similar bracelets, examples of which have turned up in Greece and Turkey, attesting the far-flung travels of Celts at this period.

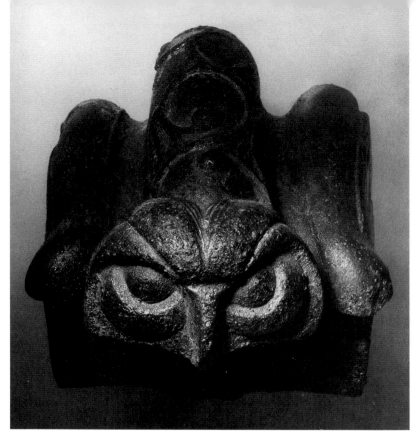

58 Owl's head, 4.2 cm (1⅔ in) high, on the escutcheon of a bronze cauldron from Brå, Jutland, Denmark

Figurative motifs are generally abundant in the Plastic Style. The 'Cheshire Cat' appears more frequently. On a spout of the late fourth or early third century BC from Dürrnberg in Austria can be seen the head of a long-jawed creature (possibly a misunderstood crocodile), back-to-back with a bull's head.

58 A owl's head menaces from the escutcheon of a cauldron from Brå in Jutland; behind its crest Waldalgesheim-derived plant ornament curls. The Brå cauldron, probably of the third century BC, is massive, about 2 m (6 ft 3 in) across and originally able to contain 600 litres (131 gallons). Flanking the drop loop handles are ox-head escutcheons of Eastern inspiration – the start of a long line of such creatures in Celtic art. Deliberately smashed up in antiquity, the Brå cauldron is one of several likely votive offerings, of which that from Gundestrup (p. 83)

68

is the most famous. Cauldrons had a special place in later Celtic literature – they figured prominently in the Celtic feast, and according to some stories had wonderful regenerative powers. Although like the Gundestrup cauldron the Brå cauldron was found in Scandinavia, it was produced much further south, perhaps in Bohemia.

Typical of the most extravagant manifestations of the Plastic Style are faces with protruding eyes but no mouths – a good example can be seen on the mount from near Paris already described.

Found with the chariot mount from near Paris was a lynch-pin for a chariot, with a bug-eyed face, again mouthless and with the eyes closed, but this time symmetrical and with hair that curls round into a boss. Closely related are a pair of lynch-pins with bronze heads and iron shanks from a burial at La Courte, Belgium, which have similar 59 hairstyles but this time beetling eyebrows above open eyes. The mouths are missing, and each has a pair of feline ears turning them from humans into half-animal hybrids.

Very remarkable are the objects from Brno-Maloměřice in 60–1 Czechoslovakia. One of the finest is a solid-cast bird with hooked beak, the body indicated by an openwork ring with lateral tendrils. It is exotic in character, with echoes of Luristan in Persia and of the art of the nomads of the eastern European Steppes. These pieces, and perhaps the Brå cauldron, were made in the territory of the Boii in Central Europe, as probably was the massive torc of silver with an iron core from Trichtingen in Germany. The hoop of the torc has 62 cable ornament, and the terminals are a pair of oxen, each wearing a torc. Such naturalistic animals, and the use of silver, were to play a greater part in the Celtic art of later centuries.

59 Bronze head of lynch-pin, 5 cm (2 in) wide, from La Courte, Belgium. Central horns are inlaid with Baltic amber. Apparently 'Plastic Style', the object was found in an Early La Tène cemetery dating from the fourth century BC

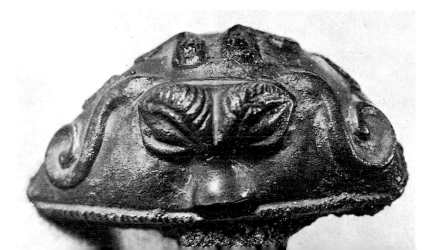

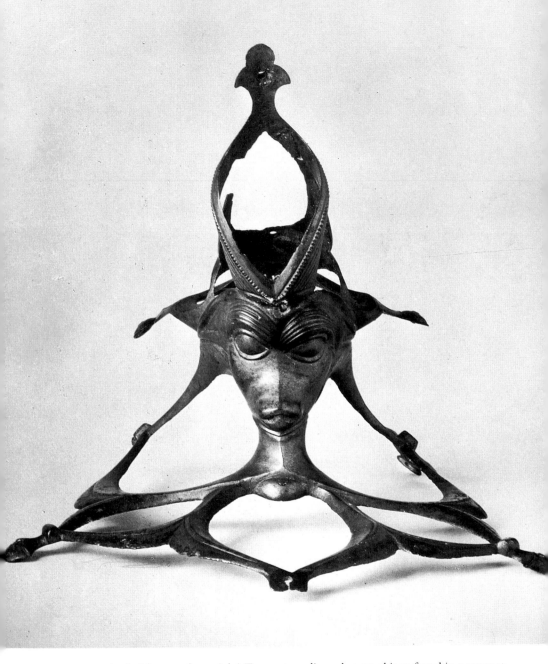

60–61 (above and top right) Two extraordinary bronze objects found in a grave at Brno-Maloměřice, Czechoslovakia, sometimes claimed as chariot fittings, but more probably flagon mounts. A bird-headed bossed ring 11.8 cm (4½ in) high is probably a handle. The openwork mount, 18 cm (7 in) high, is possibly for a spout. Today it looks like a modern sculpture, dominated by a terrifying animal mask. Both date from the early third century BC

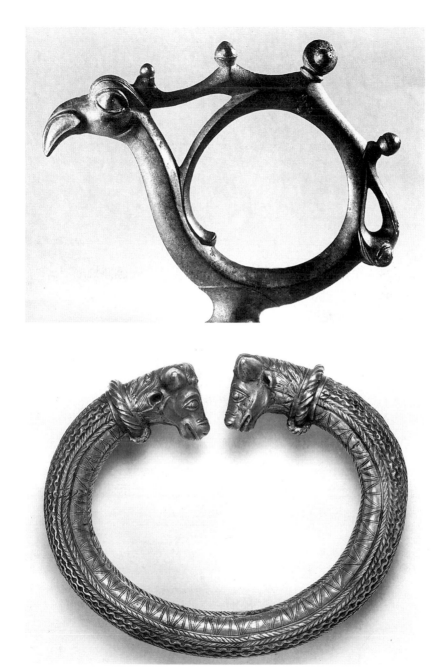

62 (above) Massive silver torc with iron core, 29.5 cm (11½ in) wide and weighing over 6 kg (13½ lb). It comes from Trichtingen, Germany, and is perhaps second century BC

63 An iron scabbard from Cernon-sur-Coole, in the Marne, introduces yet another element in the repertoire of Celtic styles. Here, instead of relief, the artist has turned to engraving to produce a rhythmic two-dimensional design. Discovered in 1892 with a cremation, the scabbard is ornamented on the back and has a balanced tendril pattern of Waldalgesheim origin on its suspension loop. The engraved decoration has been carried out with tracer, and has a beaked bird or griffin-head with spiral tip. The scabbard exemplifies the fourth tradition of Jacobsthal's scheme – the 'Sword Style', employed in the decoration of iron swords and scabbards. Their ornament is mainly engraved. Sword style products were fashioned by armourers, and their works are rarely found alongside Plastic Style pieces, which represent the mainstream of cast-bronzework in which animal and human forms abound. Sword Style art is more austere, and largely confined to abstract patterns.

Jacobsthal regarded the Sword Style as originating in Hungary in the fourth century BC, but many examples of the style have been found in Switzerland, including at La Tène itself. Many of them survive by having been committed to water, possibly as votive offerings – swords are often dredged from rivers.

63 Iron scabbard from Cernon-sur-Coole, Marne, France, late third or early second century BC

64 (above) Motifs from Bölcske-Madocsahegy, Tolna, Hungary, and from Batina, Yugoslavia (formerly Hungary)

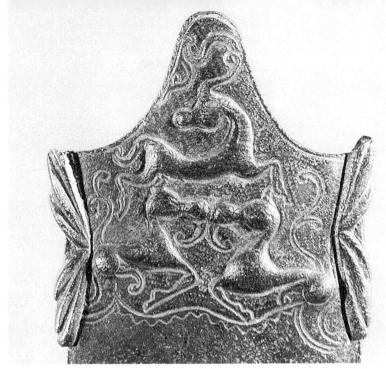

65 Lively deer ornament an iron scabbard from La Tène, Switzerland, of the second century BC (compare Ill. 121)

The ornamental schemes devised by the Sword Style artists originated in the Waldalgesheim Style, and employed variations of the acanthus patterns. They used these designs not just laterally, but diagonally, delighting in a lack of symmetry, with tendrils that spill out over the surface of the blades, or more usually, the scabbards that contained them. **64**

A feature of the Sword Style from the fourth century BC onwards are dragon pairs, fashioned out of a lyre scroll and given split ends which form gaping jaws with curling lappets. The dragon pair is a widespread motif. A variant form has the dragon body as a C-scroll, to which a tail has been added. Such dragons appear in Hungary, France and England.

In Switzerland the swordsmiths were more restrained in their decoration. Dragons appear, but on a scabbard from La Tène itself can be seen in relief a series of deer with folded legs that are a foretaste of the art of Celtic coins, or perhaps of the creatures that cavort on the Aylesford bucket from England, some years later. **65**

73

Celtic sculpture is to be found in stone and bronze, and more rarely, due to the accident of survival, in wood. The sculptor rarely worked in miniature, although the occasional figurine in glass or bronze is known.

Most sculptures show human heads – this is universal from the earliest times with which this chapter is concerned, through to the modern era (some heads reminiscent of Iron Age predecessors were still being made this century). Often they are roughly-hewn, as if once the general impression had been extracted from the block, the sculptor felt the work accomplished, and left it to speak for itself.

In general Celtic sculpture conveys the grim and the uncompromising. Many depictions of the human face or form are the images of gods or supernatural beings, and it is interesting that the information we do have about Celtic religion typifies the deities as forbidding or frightening. Not for the Celts (until Christianity arrived late in their story), the concept of a pantheon of benign beings or a God of Love.

66 Pillar, 1.48 metres (4 ft 8 in) tall, from Pfalzfeld, Germany, fifth or fourth century BC and among the earliest examples of Celtic sculpture in stone. Stacked s-scrolls and masks with leaf crowns are typical of the 'Early Style'. Originally the pillar was surmounted by a head, but this was already lost when it was recorded by a drawing in 1608–9

67 (right) Grim and forbidding, a stone 'Janus' figure 2.3 metres (7 ft 6 in) high from Holzgerlingen, Germany, probably sixth or fifth century BC. The head once bore a pair of 'horns', very likely a variant of the leaf crown (shown restored)

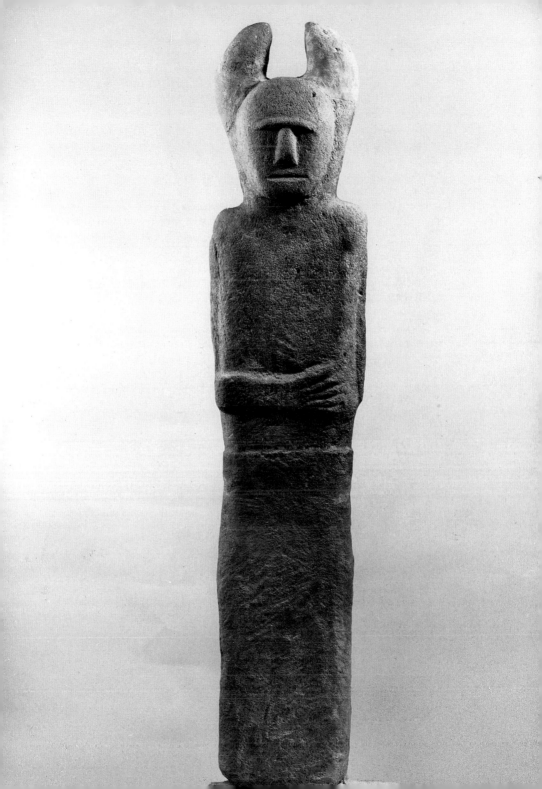

That the Celts may have learned of stone carving from Italy as early as Hallstatt times is suggested by the Hirschlanden statue described on p. 30. A few other stone sculptures take the story down into Early La Tène, of which perhaps the earliest is the truncated rectangular tapering pillar from Pfalzfeld in the Rhineland. On each side a face shaped like an inverted pear with ballooning leaf crown stares from a design taken from an Early Style repertoire. Cables frame each face, in the way they were to frame High Crosses in the Early Christian period, but here they are possibly derivative of Italian workshops. Such a pillar might have surmounted a barrow, like the Hirschlanden statue, or more probably was set up in a shrine, like a stone version of a sacred tree. The top is lost, but might have been surmounted by a head, similar to the sculptured example found at Heidelberg, Germany. The Heidelberg head was broken off below the nose, but is still fearsome of aspect. It bears a leaf crown and a furrowed brow which has been claimed to be some kind of caste mark, perhaps a tattoo. Celts are known from classical sources to have practised tattooing. A similar device appears on the faces on the Pfalzfeld pillar.

From Holzgerlingen, Germany, has been preserved for us a marvellous pillar which typifies the Celtic attitude to stone-carving that changed little with the millennia. The item is basically a stone shaft, the bottom half of which may have been set in the ground since it has only been roughly worked. The top half shows a 'human' figure from the waist up: a rudimentary arm crosses the stomach and a completely plain chest is surmounted by a simple head. The figure is similar to 'Janus' figures in the classical repertory, and is not one figure in the round, but two in relief, attached at the back and thus appearing to look both ways.

It is easy to find emotive words to describe this piece – it can be seen as lugubrious or solemn, remote or disturbing, as we will. One may try to 'read' it, to endow it with the characteristics of people known to one; but it is likely that it is the effigy of a deity, a symbol of the invisible dimension of existence, beyond everyday reality and human contacts.

Another sculpture comes from Germany and is represented by a solitary head from Mšecké-Žehrovice in Czechoslovakia, perhaps of the second century BC. It is a caricature of everyone's idea of a Celt. The character wears a buffer-ended torc round his neck and has fine twirling moustaches, small protruberant eyes and bushy eyebrows that end in scrolls. He was found in a sandpit near a shrine, broken in an otherwise empty pit.

68 Deservedly the most famous work of Celtic sculpture: a head 23.5 cm (9½ in) high, found near ritual enclosures at Mšecké-Žehrovice, near Prague, Czechoslovakia. The stylized moustache and eyebrows end in Celtic twirls, and the hair is arranged in a stiff, backswept style known to have been favoured by Celtic men in Roman times

The breaks in this damaged head make evaluation difficult since they complicate an otherwise simple shape. The piece differs markedly from that from Holzgerlingen in that there is more 'characterization'. We are tempted to guess that it represents a real person, with facial characteristics rendered as caricature, or stands for a 'hero' whose appearance was unknown.

The largest group of sculptures come from southern France, and were directly inspired by Greek sculpture in the colonies such as Massalia. In this part of southern Gaul a number of hilltop settlements grew up with elements derived from Greek colonial architecture, including defensive walls, bastions and grid-pattern street plans. A feature of those round the Rhône mouth is the possession of a native shrine, and one, at Entremont, seems to have been concerned with a head cult. Lying between two bastions of the city, the shrine probably post-dates the wall, erected in the third century BC, but pre-dates the Roman conquest of Provence in 125–20 BC.

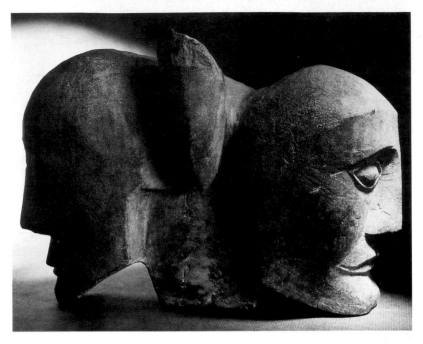

69,70 (above) Janus-like twin heads, 43 cm (17 in) high, from a Celto-Ligurian shrine at Roquepertuse, Bouches-du-Rhône, France (see right), probably third or second century BC

From Entremont has come a sculpture of a pile of 'severed' human heads, almost classical except for the formalized treatment of the hair. 69 Rather more interesting artistically is a Janus head from Roquepertuse, bald and with almond-shaped eyes and a grimace, and five larger-than-life figures who sat cross-legged like Buddhas. These like the other sculptures from Roqueperteuse were painted. Less accomplished and more obviously classically inspired is a low relief frieze of horse-heads from the same shrine. All probably date from after the fourth century BC.

Of uncertain date is the most grotesque of the southern Gaulish 71 sculptures, known as the 'Tarasque de Noves', from Bouches-du-Rhône – a snarling limestone monster from whose maw hangs a human arm and whose forepaws rest on a pair of bearded human heads which are in turn supported by its back paws. Ribs and muscles are heavily carved, and the eyes of the human heads are closed. They look like grotesques from a medieval church, but the whole is reminiscent of Roman sculptures of heads between the paws of a

78

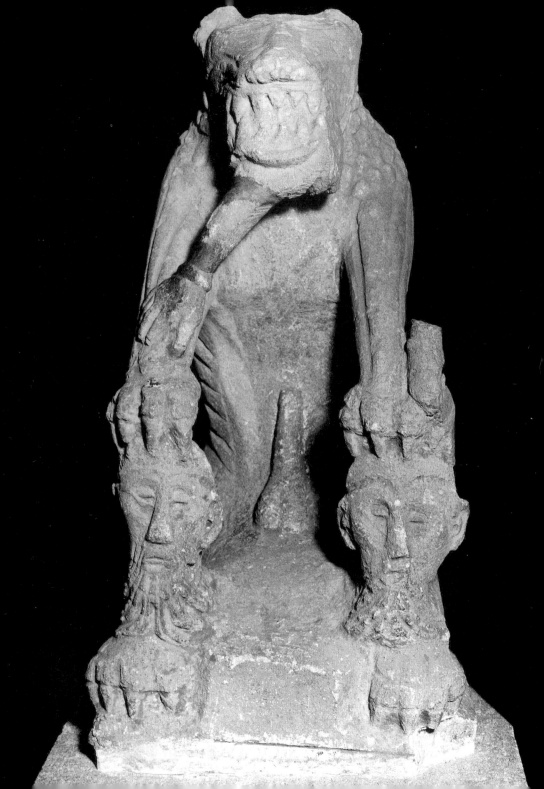

sphinx, which have been found, for example, in Colchester. The sculpture is however unlikely to pre-date the Roman conquest of Provence. The technical skill of the sculptor has been used to good effect here: the dangling arm being attached to both monster's head and to its foreleg to give support to the weight of the head. In turn the upper part of the stone body is supported through the heads.

A miniature masterpiece is the figurine from Euffigneix. A mere 30 cm (11¾ in) high, it is a pillar of smooth stone with a face on which the eyes are unusually indicated with both upper and lower lids. The wry expression is the result of accidental damage which has removed the bottom of the nose and mouth. A torc is fastened round the neck. On the otherwise featureless body there is one of the most spirited renderings of a boar with shoulder spiral that has come down to us from the Celtic past. A disembodied eye, complete with pupil, stares 72

71 (left) The 'Tarasque de Noves', a limestone monster 1.2 metres (3½ feet) high from the Bouches-du-Rhône region of France. The creature's paws rest on two human heads, and a human arm protrudes below its jaw. Usually assumed to belong to the same period as the other Celto-Ligurian sculptures, around the second century BC, it could be later

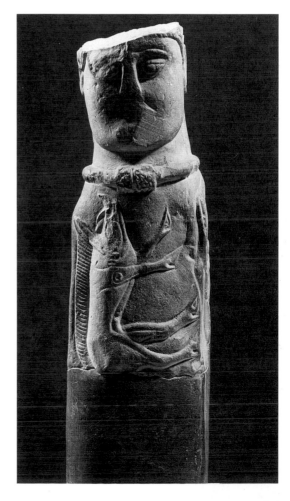

72 (right) Sandstone pillar-statue carved with a boar from Euffigneix, Haute-Marne, France. Although usually dated earlier, it could be Gallo-Roman

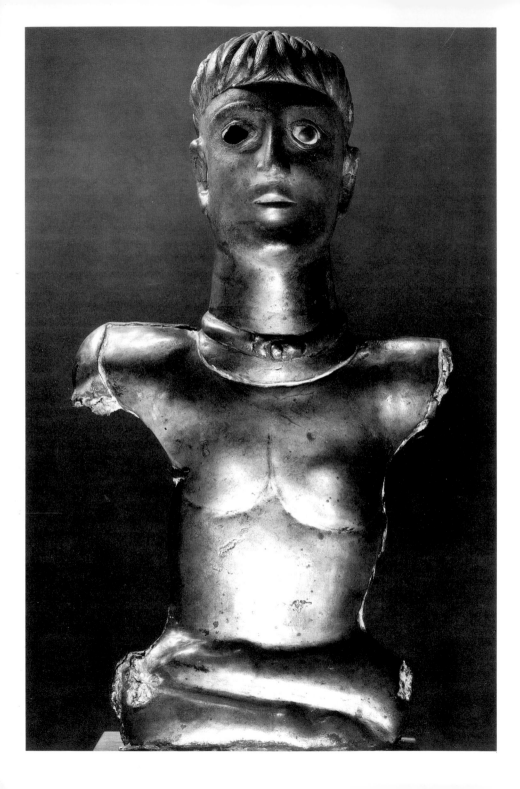

balefully from the side of the body. In low relief, this gives the impression of being the work of someone more in the habit of carving wood. Here is an instance in which very considerable attention has been given to detail. The symbols (which we do not now understand) were evidently the major importance of this work and their juxtaposition must have had significance. That we can no longer understand the language of its communication makes it a particularly frustrating work of art to modern eyes.

Some wooden sculptures have survived. The most famous are a group from Source-de-la-Seine, from a cult centre at the river's source. They are of varying quality, but show little sign of classical influence. One of the best shows a figure in a 'duffel' coat reminiscent of the *genii culculatii* (statue groups of three deities) of Roman Britain. With exaggeratedly large head and inturned toes, but no arms, he has a somewhat unconfident air. Another cult centre has been found at Source-de-la-Roche, where the votive deposit included several thousand figures, but despite Celtic details, such as a torc, the style is strongly classical and they were probably made in the first century AD under Roman influence. 74

A work in bronze may serve to round up the survey of early Celtic sculpture. From Gaul, it belongs to the last days of Celtic independence. It is a cross-legged figure in sheet bronze from Bouray, originally with inset glass eyes, one of which survives. His arms are missing, and he is oddly foreshortened, with tiny legs ending in what look like deer-hooves. Round his neck is a torc. There is something about the treatment of the hair that suggests Roman portraits of Augustus, and it is likely that it was made in the last years BC or early years AD. 73

CAULDRONS

Cauldrons, as already mentioned, were important objects in Celtic myth. The Gundestrup cauldron is one of the most eccentric creations of Celtic-related art. Made up from silver plates, it was deliberately dismantled and laid on a peat bog at Gundestrup, Jutland, where it was found in 1891. It was not made in Denmark, however. The plates are silver gilt, and include a dished base with central roundel. The iconography is extremely complex. On the basal disc (which is more accomplished and by another hand than the side plates), lies a bull, apparently dead. Above a figure brandishes a sword with which he has presumably carried out the sacrifice, and a dog, a lizard and a

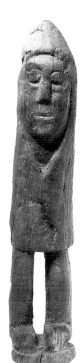

73 (left) Bronze figure 42 cm (18 in) high, dredged from the river Juine at Bouray, France

74 Wooden votive figure from Source-de-la-Seine, France, first century AD

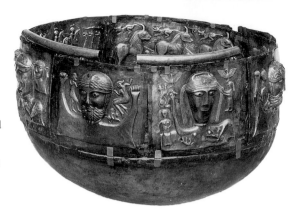

75–7 The 69 cm (27 in) diameter silver-gilt Gundestrup cauldron, found dismantled on a Danish peat bog. Much of the imagery, like the horned god and war trumpets, is found in the Celtic world, but the complex iconography probably belongs to a basic Indo–European tradition

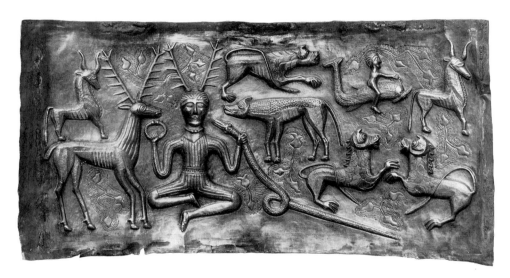

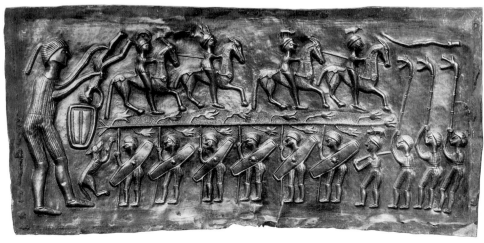

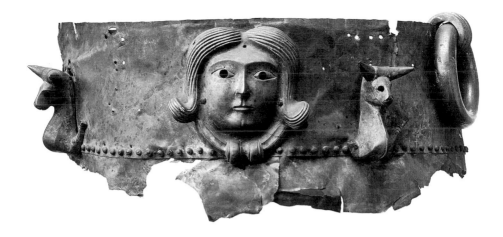

78 Fragment of bronze cauldron found at Rynkeby, Denmark, with female mask flanked by bulls. Made in Gaul, it shows similarities with some later Romano-British work (see Ill. 137)

further animal (possibly a dog) disport themselves amid a foliage pattern. The subject matter is close to the popular Persian representations of Mithras slaying the bull. The scenes on the side plates are no less enigmatic. Here is a squatting god with antlers, holding a snake and a torc. There is a boy riding a dolphin. Lions and ibex stand passively, as do griffins, elephants and leopards. A bearded god holds a wheel, attended by a figure with a horned helmet. Elsewhere there are processions of warriors, and a figure is lowered into a cauldron. 77

Many of the details on the Gundestrup cauldron are clearly Celtic, and arguments have been advanced that the episodes depicted can all be found in the Dark Age Irish Celtic epic, the *Táin bó Cuailgne*. Details of the work however link it to Dacian silver, and most authorities would accept that it was made somewhere in north Bulgaria or southern Romania. Details of the design, such as the griffins, have their counterparts on the Biatec coins. It possibly dates 84–5 from the second century BC.

Another cauldron, this time bronze and fragmentary, was also found in a Danish peat bog, at Rynkeby. A female mask with buffer 78 ended torc round its neck stares with empty eyes once inlaid with glass. Ox-heads flank her. The torc is a type that was current in France, and the treatment of the face recalls the figure from Bouray. Like it, the Rynkeby cauldron is Gallic and probably dates from the last years of the first century BC or the early years AD.

85

Another artistic form in which the metalsmith excelled was the miniature one of coin production. Both the idea of coinage, which originated with the Greeks of Asia Minor and which came to be an adjunct to urban-based trade, and the method of engraving dies, which stemmed from the ancient Near Eastern craft of seal- and gem-cutting, were totally alien to the Celts. The Celts became familiar with the use of coins from the Greeks, and began striking their own copies of Greek issues of Philip of Macedon in the later fourth century BC. Before the end of the second century there were local coinages in at least six regions in La Tène Europe. The classical origins of coinage however always dictated the Celtic approach to coin design.

79–80 Accordingly, the style of Celtic coins is distinct from other Celtic art, and more strongly influenced by classical ideals.

The artistic styles of Celtic coins have never been adequately studied, despite the considerable amount of research that has taken place on Celtic coinage in recent years. Yet there are hundreds of thousands of Celtic coins surviving from the continent, with individual hoards containing up to ten thousand coins or more. It is unlikely that these were used in regular trade: they were probably status objects used in gift exchange and diplomatic transactions, as well as offerings and possibly tributes. Except perhaps in Britain, only from the middle years of the first century BC, at the time of Caesar's conquest of Gaul, is there any real likelihood of a token coinage being used in normal trade. This coinage was cast in potin (a copper-tin alloy) and cast or struck in bronze. Prior to this Celtic coins were struck in gold and in silver.

A high proportion of Celtic coins are imitative of classical prototypes. The earliest are close copies, the later deviate increasingly from their models, and introduce new, Celtic elements.

In the numismatic literature coins are ascribed to particular Celtic tribes, the names of which are known at this point mostly from classical sources, so no longer need they be referred to by the abstract terms of the earlier period. However these designations are shorthand indications of the regions in which they have been found, and their attribution to particular tribes is often controversial. Coins were in some cases at least the issues of chiefs, and when inscriptions start to appear (copying Roman), it is the names of individuals, whether chiefs or moneyers, that are normally given. Occasionally coins may suggest they were struck by a tribe, such as those in the region of the Iceni in Britain, inscribed ECEN.

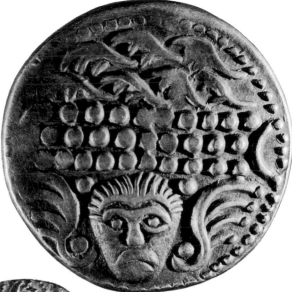

79–80 (above) Silver 'stater' issued by the Celts of the Danube, imitating silver tetradrachms of Philip II (the Great) of Macedon, first century BC. The Greek prototype is shown on the left, the Celtic copy on the right. Arad-Banat area. Third century BC

81 (right) Silver coin with a human mask flanked by what appears to be the last vestiges of the 'leaf crown'. Such coins circulated in the territory of the Taurisci, first century BC

82–3 (left) Gold coin inspired by the gold 'stater' of Philip II. The prototype had the head of Apollo on the obverse and a chariot on the reverse. The Celtic version, current in Armorica, renders the chariot as a centaur with a wheel. On the obverse, smaller heads appear to be attached to the main head by chains. Third to second century BC

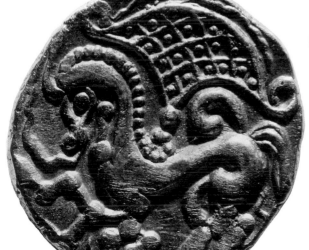
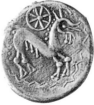

84–5 (above) Silver BIATEC coins from Czechoslovakia, one with a griffin on the reverse, another with two heads (of deities?) on the obverse. Mid-first century BC

86 (left) Fine gold coin from the region of the Parisii (round Paris), first half of first century BC

For our purposes, it will suffice to note a few distinctive stylistic groups. The first comprises the earliest series of Celtic coins – imitations of silver tetradrachms of Philip of Macedon issued by the eastern Celts in the Danube basin. The earliest are straight copies, but later versions of these (copying coins of Philip III and of the issues of the island of Thasos) are innovative. A coin of the Criciova type shows the head of Zeus with a very Celtic cheek-tattoo, while on another of the Ocnita-Carbunesti type the youth riding a pony on the reverse has turned into a wild Celtic horse-goddess with flying hair.

Of the eastern coins, however, the most interesting are those from southern Slovakia bearing the name BIATEC, modelled on Roman prototypes which date them to the middle of the first century BC. Biatec (who is otherwise unknown) put his name on the first issues, and he and his successors struck coins with strange mythological types

84–5 including griffins, harpies and centaurs probably taken from a long-obsolete orientalizing pattern book.

Of particular interest is a coin of East Noricum, with a throwback

81 type of a facing mask with wings which are clearly descended from a leaf crown.

In the west a series of silver coins in southern Gaul are imitations of first Greek then Roman coins. To the north of these coinages circulated a gold currency, which stretched from the Atlantic coast of France to Bohemia. In Bohemia the models were gold staters of Alexander the Great, though the issues of Philip V of Macedon were also formative. They span a period from c. 200 to c. 50 BC.

Further to the west, the model followed was the gold stater of Philip of Macedon. The artistic merit of these coins is variable, but the finest were produced in Armorica. Here, from the first, the horse which is the main element on the reverse has acquired a female rider.

82–3 Later, the horse sometimes becomes a centaur, and the head of 'Apollo' on the obverse acquires subsidiary heads, linked by chains.

Almost as fine are the coins struck in the area of the Parisii, who issued coins on broad flans (blanks) with graceful horses, the hollow

86 curve of their back filled with a 'parachute'-shape with curled ends.

Celtic coinage shows a wealth of traditional imagery, though in some cases the immediate models are Roman. Boars abound, with the occasional sow, accompanied by horses, eagles, bulls, wolves, bears, hares, ravens, crows, ducks, cocks, snakes and goats. Figures hold torcs and war trumpets; wheels, 'comets', trees and cauldrons appear; and, in the case of a coin struck in the name of one Arus Segusiasus, a figure stands beside what seems to be a crude wooden idol.

The challenge brought to the Celtic world by the domination of Rome was as great for the artist as for the general population, and in many ways it presents as great a challenge to us in our evaluation of the artistic products of the period. In Gaul and in Britain the dominant culture became artistically alien, with different aims and intentions.

The Celtic artist relatively suddenly became exposed to patrons who were keen to adopt Roman ways and required a totally different repertoire. While till the first century BC in Gaul and the first century AD in Britain, the Celtic world had been able to take of Rome or Greece what she required or admired, once she became subjugated the relationship changed. It is now when Rome overran most of the Celtic world that we find produced the strange and challenging pieces of Romano-Celtic or Gallo-Celtic work that were for so long dismissed as 'degenerate' Roman style.

137

For our purposes here, in attempting to make a start on evaluating Celtic art with relatively new insights, the most difficult challenge is certainly posed by those pieces that display both barbarian and classical features. However we may explain them as being made by a Celtic artist for a Roman audience, or a Roman-trained artisan for a Romanized patron, the fact remains that they with varying degrees of comfort demand to be judged by the canons of classical naturalism and realism and at the same time be viewed as the abstract and symbolic expression of the Celtic artist.

As we have seen, the Celts were long exposed to classical influence before Julius Caesar crossed the Alps and claimed Gaul on behalf of his State. Indeed, it is probable that they were able to accept and assimilate to such a remarkable degree the Romanizing influence on their artistic tradition simply because so much of their own repertoire had common roots with classical art. It can be argued that Celtic art proper was probably kept alive in Gaul during the Roman interlude: but it must have been in perishable materials that have rarely endured, and it is true that it had no chance of emerging intact at the end of the Roman period because by this time the Germanic elements that later became the Merovingian and Frankish kingdoms had become dominant. In fact, the amount of Celtic art from Gallo-Roman contexts is remarkably sparse, although the Gallo-Roman style of classically inspired pieces is highly distinctive, and commonly described by classical scholars in such terms as 'displaying a florid provincial exuberance'.

87 The bearded, horned, deer-hoofed Celtic deity, Cernunnos, in Roman times. Wearing a torc, he sits, cross-legged, in pride of place between the two Roman deities Apollo and Mercury, on a stone-carving from Rheims, France

There are characteristics of Gallo-Roman art that represent a native Celtic interpretation of classical subjects. Particularly interesting are the small bronze figurines which occur frequently throughout Gaul. Celtic probably is the ancestry of the small bronze horse from Aventicum, now in Geneva, or the racing hound from Moudon, with arabesque tail and snub snout. Equally Celtic is a seated bronze mother goddess that once formed a table leg from Martigny. Her head is out of proportion to her body, and her large eyes, quizzical mouth and highly formalized hair all betray a Celtic ancestry.

Formalized facing masks also appear in sculpture. Echoes of the masks of Roquepertuse and Enserune can be seen in the two stylized figures in a classical arcade from Arnesp. The eyes are almond-shaped voids, the mouth slits, the shoulders hunched, the bodies featureless and limbless.

Elsewhere in Gallo-Roman art can be seen the familiar Celtic subject matter of boars, cocks, bulls, bears and eagles, albeit used to classical purpose.

Perhaps the finest collection of Gallo-Roman art comes from Neuvy-en-Sullias (Loiret), and comprises a dancing girl, dancing man, juggler and musician. The little group obviously represents a party of travelling players. The girl is nude, displaying the same plastic quality encountered at Eberdingen-Hochdorf. Her arms are modelled crudely, the legs are out of proportion, with long thighs, short, rather matronly calves and tiny feet. In contrast, details of hair, face and ribs are sketched in carefully. As with many of these non-naturalistic figurines, the movement is thus expertly conveyed. The juggler waits for ever for a ball to come down. The figures are elongated and mannered, the treatment of the faces and hair very stylized, the proportions unnatural. They evoke a sub-culture in a Roman province that kept faith with its old traditions, despite a Roman overlay.

88

88 Bronze dancing girl 14 cm (5½ in) high from Neuvy-en-Sullias, France. A hoard of such figures, found on the left bank of the river Loire opposite a sanctuary at Fleury, was probably buried around the time of the Roman conquest. A name-stamp 's(c)uto' may indicate the maker

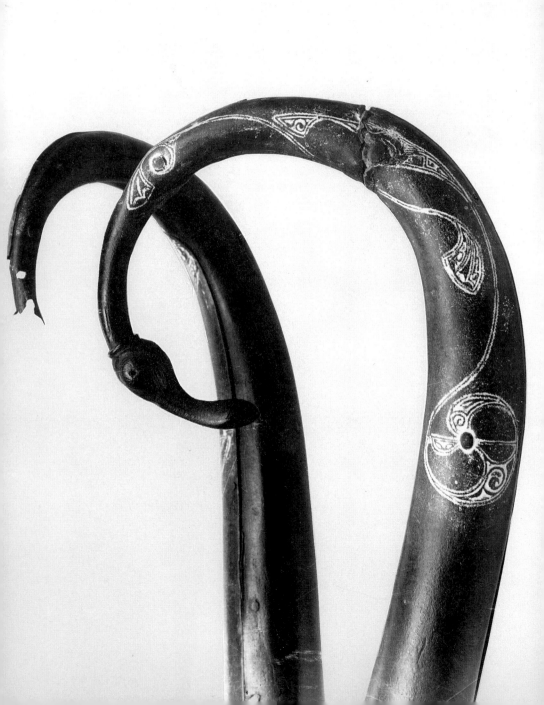

Art in Iron Age Britain and Ireland

Britain and Ireland lay on the very edge of the Hallstatt and Le Tène worlds. After the Roman conquest of Gaul, Celtic culture continued to flourish in Britain for nearly another century, until the conquest of England, Wales, and southern Scotland restricted free Celtic communications to the far north and Ireland.

The most recent research suggests that Celtic culture in later prehistoric Britain owes more to a gradual development of the language and other definitive features than to the invasions from the continent favoured by earlier archaeologists. It now seems most reasonable to accept that development from the Bronze Age onwards was gradual and continuous, responding to a lesser or greater degree to the continental influences.

Ireland has so far yielded no archaeological evidence whatsoever for large intrusive groups of Celtic continental immigrants, and there is a case for believing that the native Late Bronze Age culture continued with little change in many areas, gradually absorbing and creating 'Celtic' culture. Remarkably few 'La Tène' continental-style objects have been found in Ireland, and those few objects could be imports, or the possessions of a few rich immigrants.

Some people, however, may have arrived in mainland Britain. One such small group of settlers may have come from northern Gaul to eastern Yorkshire about 300 BC. They have been recognized by archaeologists from their distinctive habit of burying their dead in rustic equivalents of the La Tène chariot burials, although most of the graves date from a later time, when insular characteristics had begun to develop. The type site is Arras, Yorkshire, but more recently 90 related sites have been recognized at Wetwang Slack, Garton Slack and Garton Station in Yorkshire. It is extremely unlikely, however, that such a group could have had a widespread effect on the entire population, and their presence does not legitimize the more old-fashioned theories.

Among the possible immigrants from the continent, the 'Belgae' are the most often cited, since they have the distinction of being

93

89 The Torrs horns (see p. 102)

alluded to by Caesar, who wrote of people in Britain 'who came from Belgium'. 'Within living memory,' he recorded, 'Diviciacus, king of the Suessiones, controlled not only a large part of the Belgic country, but Britain as well.' Since the archaeological record apparently yielded continental coins of appropriate date, together with a new type of wheel-made pottery, and the rites of cremation in south-east England, a Belgic invasion documented by this archaeological material was for most of this century held to be an unassailable fact. Scholars in the 1930s felt that the Belgic settlement should be dated to around 75 BC, though later study pushed the date back to the late second century BC.

More recent research, however, disputes this view, and argues that the coins need not have been brought by settlers, and that the wheel-thrown pottery held to be early is probably later than Caesar. How extensive was the Belgic element in the population is still far from clear. One is tempted to suggest that there was only a handful of 'upper class' Belgae in Britain, intermingling with others of the élite, whose purpose or effect was to cause conflict on the eve of conquest in a way that is reflected, albeit dimly, in the classical writers and the local coinages.

Just as there is still considerable debate about how the Iron Age in Britain should be studied and viewed, a considerable divergence of opinion surrounds the problems of dating and grouping the examples of Iron Age art in Britain. Most of the key pieces have been found casually, unassociated with other archaeological material, and even those that have come from archaeological contexts may represent older objects which were buried or lost long after they were made. It is quite clear that although insular Celtic art shows many features that reflect continental trends, the overall character of the art is distinctive, just as insular Iron Age culture diverges from that of the continent. Accordingly, although specialists allow that influences from this or that continental style are apparent in particular insular pieces, there is no general agreement as to whether this should be interpreted as evidence for similar date, or a long survival of elements of continental styles after their heyday in mainland Europe.

There is a further problem in that insular Celtic art cannot easily be grouped into diagnostic 'schools', though this approach was attempted by Sir Cyril Fox in his pioneer *Pattern and Purpose* (1958) when he distinguished a series of British schools which he saw as commencing around 230 BC, following an earlier period when a number of imports provided the stimulus for native art. The very

insularity of British Iron Age art reinforces the argument that invasions in Iron Age Britain are difficult to recognize archaeologically.

Fox's chronology has been followed in general terms by other scholars, notably Vincent and Ruth Megaw, who have seen the beginnings of insular Celtic art as following the inspiration of continental Sword Style metalwork. Many writers have found this view hard to substantiate, since they have seen the influence of Waldalgesheim and even Early Style on a number of insular pieces such as the Wisbech Museum (Cambridge) scabbard-plate. Ian Stead has followed the numerical scheme first put forward by J.M. de Navarro, who equated the continental styles of Jacobsthal with a numerical sequence, adding two further insular styles to those found on the continent, Styles IV and V. Stead's sequence suggests that the first manifestations of Celtic art in Britain are to be placed, like their Early Style counterparts on the continent, in the fifth century BC. To the present writers, Stead's chronology, if not his division of insular art into five distinct styles, seems preferable to either Fox's or the Megaw's dating, for it seems difficult to accept that the insular Celts were producing works in styles that were already obsolete among their continental neighbours. It may also be wrong to assume that because British art cannot easily be related to the continental, it is therefore substantially later.

This flourishing of art in the Celtic style lasted only until southern Britain was Romanized after the conquest. By this time, the mid-first century AD, however, the traditions must have been sufficiently well established to be able to re-emerge after the end of Roman rule in the early fifth century AD.

With the present state of knowledge it is difficult to make a coherent pattern out of the evidence for Celtic insular art in the Roman period. It is possible to isolate a number of items which display strong Celtic features, but which seem to have come from Romano-British contexts. It is also possible to point to particular types of object (for example, hanging bowls) which start life in Roman Britain and then flourish after the Roman period.

The areas in which Celtic art might be expected to flourish during the Roman period – non-Romanized Ireland and northern Scotland, and the little-Romanized areas of Wales and Cornwall – are apparently almost devoid of artistic productions during the first to fourth centuries AD. However, these peoples (and many within the province of Roman Britain too, more passively) retained the religious

beliefs and farming way of life, the tribal and family-based culture, the essential outlook of the Iron Age Celt, and it should not be surprising that Celtic art apparently re-emerges in the archaeological record at the end of the Roman period. If we regard the art as the visible and tangible expression of things Celtic, and as a natural outcome of an entire way of life, then it is quite possible to allow that once the economic and physical restraints of Rome were removed, the Celts were able to develop once more where they had left off, especially outside Britannia: the Anglo-Saxons so rapidly became dominant in the old Roman province that an upsurge of 'Celtic' culture was not possible.

THE BEGINNINGS OF INSULAR CELTIC ART: STYLES I–III

Throughout its development, British and Irish Celtic art attained excellence in engraved linear ornament as opposed to high-relief modelling. This tradition was essentially abstract, and in the absence of obvious forerunners in Britain, it would be logical to suggest that it must have been inspired by imports. Unfortunately there are relatively few objects that can confidently be described as imported, and moreover, although a number of pieces do appear to be insular products in a continental idiom, there is dispute as to whether these display the 'Early' or the 'Waldalgesheim' styles.

91 Among the few possible imports are part of a flange and fragments of one (or possibly two) bowl lids, (originally identified as part of a bowl itself) from Cerrig-y-Drudion, Clwyd, north Wales. The central element of the engraved ornament on this intriguing fragment is a palmette flanked by lotus petals. The ultimate prototype for the design is to be found in classical Greece, but here it has been modified in a Celtic workshop, perhaps in Brittany (where a similar design can be seen on pottery). The Cerrig-y-Drudion flange, however, has an infilling of hatching, a device not found in Brittany but which became popular in later Iron Age insular Celtic art. The style is closely related to that of the Early Style of continental art (though some have seen it as closer to the Waldalgesheim), and thus suggests that this find belongs to the fourth or even fifth century BC. It came to light in a stone cist, and no associated finds are recorded.

A fragmentary bronze scabbard plate in Wisbech Museum, Cambridge, decorated with lines of lyre palmettes and a border with possibly even earlier, Hallstatt affinities, may have been inspired by an Early Style import.

96

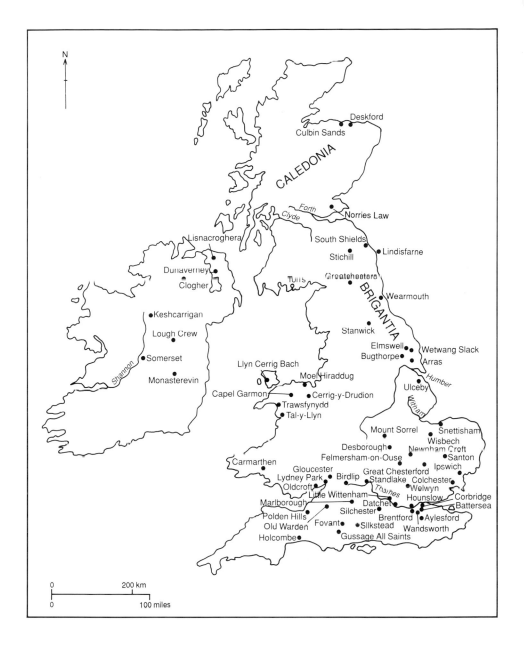

90 Location of finds of Iron Age Celtic art in Britain and Ireland

91 Fragments of a flanged bowl and lid from Cerrig-y-Drudion, Clwyd. Note the infilling with hatching, which came to characterize the British tradition of engraved fine ornament

95 The Standlake scabbard plates, found in Oxfordshire, reflect elements of the succeeding continental tradition, the Waldalgesheim or 'Vegetal' Style. The accompanying sword was dredged out of the Thames, to which it was perhaps consigned as a votive offering, and is of La Tène I type, indicating a date possibly as early as the late fourth or beginning of the third century BC. The scabbard chape too is in keeping with continental La Tène work. It is ornamented with a wave tendril on the lower plate and a relief pelta pattern within a similar tendril on the top. The hatched backgrounds may point to British origins. A similar, crudely executed design appears on the antler handle of a recently discovered rasp from Fiskerton, Lincolnshire.

 The development of engraving in Britain can be traced through a series of dagger-scabbards (with affinities to French La Tène I examples) from southern England. Two are of particular interest. The 92 first, from the Thames at Wandsworth, has an openwork chape decorated with concentric circles linked like running scrolls, and two bands of diamond patterns with hatched infilling down the length of the scabbard itself. It dates probably from the later fourth century BC. The second, from Minster Ditch, Oxford, has compass-drawn ornament, including a four-petal pattern and pelta. It is from such a tradition of engraved metalwork of the fourth century BC that the fully-fledged insular tradition emerged.

98

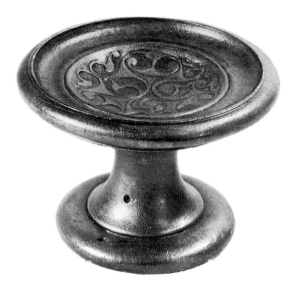

93 Bronze 'horn cap', 6.2 cm (2½ in) high, with 'Vegetal' tendrils, found in the Thames at Brentford, Middlesex

94 (below) Iron scabbard from Hammersmith with 'Sword Style' dragons

92 Wandsworth scabbard chape with linked roundels, a development from the stacked lyre scrolls of continental Early Style art

95 Bronze scabbard-mount from Standlake, Oxfordshire, with a repoussé palmette enclosing a pelta and 'Vegetal' tendrils

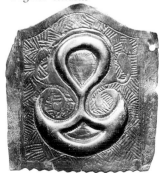

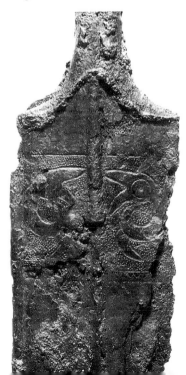

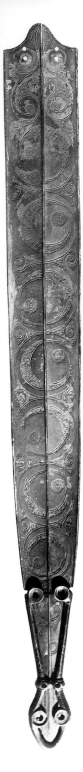

The Brentford 'horn cap' (possibly a hand-hold for a chariot) is very pleasing with its low relief and near-symmetrical ornament. Originally the ground was enamelled in red, but only a trace now remains. The red enamel, which some believe was not used until the eve of the Roman conquest, has led to suggestions that the cap was produced at that time, but it is difficult to find counterparts for its ornament from this period. Its fleshy tendrils are in the mainstream of Waldalgesheim design, but one cannot claim this as great art: here the piece has been competently and pleasingly decorated in traditional artistic style.

The Sword Style contributed to insular art of the third century BC. Most clearly inspired by Sword Style products are two iron scabbards, again from the Thames, decorated with a pair of confronted dragons. One, from Hammersmith, bears creatures with gaping jaws and huge eyes, and the ground is infilled with dots. Such dragon pairs, which may have had some kind of magical significance, are found quite widely in Europe in the third century BC.

STYLE IV IN BRITAIN AND IRELAND

Up to this point, the artistic styles apparent in Britain and Ireland have their counterparts on the continent, in the styles defined by J.M. de Navarro as I–III. The ornament next to be considered has no direct counterpart on the continent, though it shares elements of Sword Style design. It has therefore been designated as Style IV. Although some of its finest manifestations are on sword scabbards, it is also found on pieces with high-relief modelling. As in the continental Sword Style, engraved ornament arranged asymmetrically is a notable feature.

96 (far left) Bronze scabbard 42.8 cm (16$\frac{7}{8}$ in) long, from Lisnacroghera, Co. Antrim, third century BC, a fine example of the tendrils with hair-spring spirals that characterized the insular style

97 (left to right) Examples of British Iron Age ornament: Style I: Wisbech scabbard. Style II: Brentford 'horn cap'. Style IV: Witham shield and Wandsworth Round boss, Witham shield and scabbard (Style IV, after Stead, 1985)

Perhaps the earliest example of Style IV is a recently discovered iron scabbard (still containing its sword) from Fovant, Wiltshire, with tightly coiled spirals and hatched infilling. With its stylized pattern perhaps based on confronted dragons, it has elements that recall continental Sword Style work from Hungary.

64

A series of objects decorated with linear engraved patterns display a closely related style. All are 'high-status' objects: the panoply of important warriors, or perhaps, in the case of a bronze box found in a grave at Wetwang Slack, Yorkshire, high-ranking women. The 98 majority have been found in lakes or rivers, with one or two in graves. The designs are variously birds' heads, comma leaves with hair-spring spiral endings, all-over decoration and the combination of engraving with relief modelling. Some of these features, such as the tightly coiled spirals, are distinctively insular, others are also to be found on Sword Style products of the Middle Danube and Switzerland.

A selection of pieces can illustrate the linear engraved style, of which the largest group is of scabbards. Eight of these were found in or near the River Bann in Ireland, including a group found in or around a possible *crannóg* (lake dwelling) at Lisnacroghera, Co. 96 Antrim. The Bann scabbards are presumably the products of a school of northern Irish metalsmiths, and are characterized by running, all-over patterns of tendrils and s-curves, with hair-spring spirals. Compasses were employed in laying out some at least of the designs.

Related are objects from the cemetery at Wetwang Slack, Yorkshire, which include further scabbards and the bronze box of unknown function with a chain attached, mentioned above. The Wetwang Slack finds point to closer artistic links between Britain and Ireland than might have been supposed.

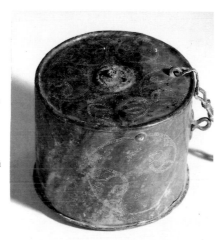

98 Bronze box with chain, 9 cm (3½ in) diameter, from Wetwang, Slack, Yorkshire, an unusual object related stylistically to the Lisnacroghera scabbard. Wetwang is one of a group of 'Arras culture' cemeteries with rectangular enclosures, and in some cases chariot burials, which suggest connections with the Marne, though the objects interred are usually British

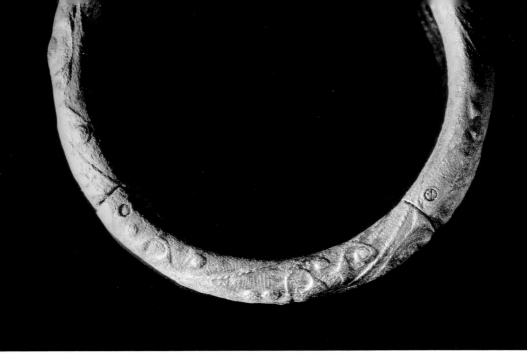

99 Bronze armlet from a chariot burial at Newnham Croft, Cambridgeshire, with tendril ornament and basketry hatching, possibly third century BC

Relief modelling appears on a unique pony cap from Torrs, Kirkcudbright, which is decorated in repoussé. To it has been attached a pair of horns with engraved ornament. Pony cap and horns do not necessarily belong together, but were found associated at the beginning of the nineteenth century in a peat bog, to which they had probably been consigned as a votive offering. Trumpet spirals with bird-heads adorn the cap; the horns, which may have been the terminals for drinking horns, if they were not in fact made for the cap, have engraved decoration which includes a facing human mask and bird heads which echo those of the pony cap. Both cap and horns were once in the collection of the novelist Sir Walter Scott.

The ornament on the pony cap shares features with an armlet from Newnham Croft, Cambridgeshire; the ornament on the horns is closer to Wetwang Slack and to the Irish scabbards. Both link up stylistically with a fine scabbard-mount on a sword found in the river Witham in Lincolnshire. High-relief modelling is combined with engraving in asymmetrical style.

100 Bronze pony cap from Torrs,
perhaps third century BC.
The larger holes are for the pony's ears

Three further objects complete the tally of masterpieces of the earliest Celtic art in Britain and Ireland. Two are complete shields, one a shield boss. Once again all were probably consigned to the rivers in which they were found as votive offerings.

The Witham shield which was dredged out of the river Witham in 1826 shows evidence of a varied history. Originally the metal facing must have been affixed to a wooden or leather backing. It had started out decorated with an appliqué, perhaps of leather or felt, of a spindly-legged boar which left an impression when it was prised off. More conspicuous now are the splendid central boss, midrib and bosses. Nothing comparable to the boar exists in Celtic art of this period, and the combination of high-relief modelling and engraved patterns with insets of coral make the whole composition distinctive. The engraving links the shield with the Irish scabbard plates and Witham scabbard-locket. Doleful equine (or bovine?) heads confront the viewer at each end of the central midrib; bird heads contribute to this Celtic menagerie.

101–3

103

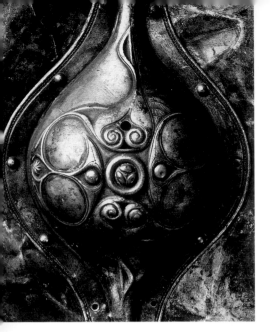
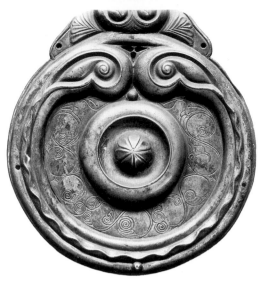

104–5 More sophisticated in design is the second shield. The Battersea shield from the river Thames is the very image of the shields carried by the 'Ancient Britons' of popular imagination. It too is the bronze facing for a wooden base, and its slender-waisted form and symmetrical arrangement of three roundels containing symmetrical patterns have led some to suggest a late date for it, as this has been seen as evidence for Roman influence. Red glass decorates the studs – analysis has suggested that this glass was of Mediterranean origin. High-relief modelling characterizes the ornament, which though at first sight abstract, soon reveals itself to contain a diversity of faces.

106 Such modelling also distinguishes a round shield boss from the Thames at Wandsworth. The Wandsworth round boss is ornamented with two birds of extremely stylized form (only their heads and beaks are clearly recognizable), interspersed with foliage patterns, executed in relief. The eyes of the birds were originally set with coral studs, and their 'wings' are engraved, as is the central dome which echoes the relief-modelling with engraved birds and foliage. With almost Art Nouveau-like flowing lines, the Wandsworth round boss is surely one of the most satisfying pieces of Early Celtic art in Britain. A similar combination of relief-modelled work and engraving appears on another shield boss from Wandsworth, this time long in profile and decorated with a rare human face.

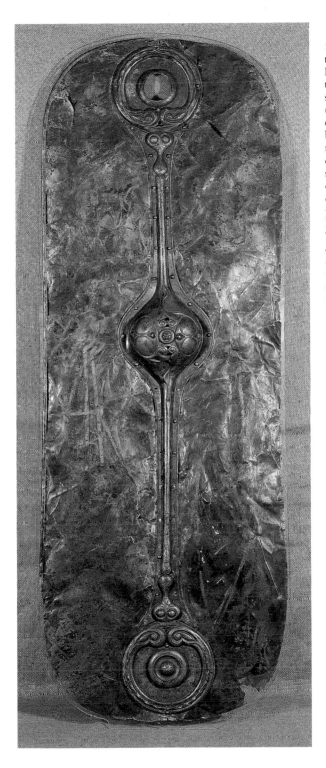

101–3 Bronze shield from the river Witham, Lincolnshire, possibly of the third century BC. The shield has a central boss (far left) and a roundel at each end (left) supported by a horse's head. The roundels bear engraved decoration of hair-spring spirals that link the ornament to the Torrs cap and horns, and perhaps also the Lisnacroghera scabbard. The repertoire of elements – British and continental – is so varied that it is almost impossible to locate the shield in time. Formed of two thin plates 113 cm (44½ in) long, joined at the midrib, and with a wood or leather backing, it was an object for parade or for a shrine, not for battle

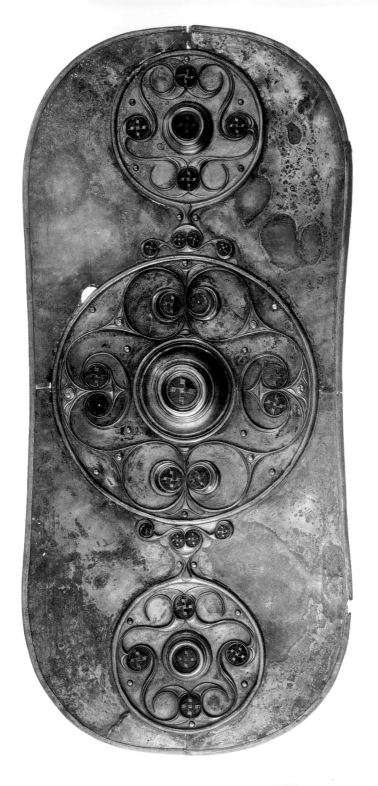

104 5 (left and above) The Battersea shield from the Thames in London. Probably the most famous work of British Iron Age art, the Battersea shield was made by a master whose work is otherwise unknown. The red enamel decoration is similar to that on the Basse-Yutz flagons (Ill. 51). Careful examination when the shield was dismantled in 1980 yielded no technical information as to date, but it may be third century BC. Measuring 77.5 cm (30½ in) long, like the Witham shield it was probably a votive or parade object, not for battle

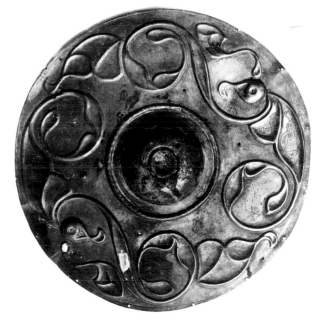

106 The round boss, diameter 33 cm (13 in), from the river Thames at Wandsworth. Relief modelling is combined with engraving closely comparable to that on the Torrs horns and Witham shield. Birds' heads are apparent in the design

STYLE V IN BRITAIN

The next style of ornament in Britain, what has been termed Style V, is without any continental parallel. Style V is clearly related to the proceeding Style IV, but the asymmetrical foliage-patterns seen on the engraved scabbards have given way to more symmetrical arrangements with basketry infilling, used to decorate mirrors and other items, while the relief modelling found on Style IV pieces takes new forms on a series of torcs and other items such as horse bit rings.

The beginnings of Style V are perhaps most readily traced in East Anglia, among the people who were known in later classical sources

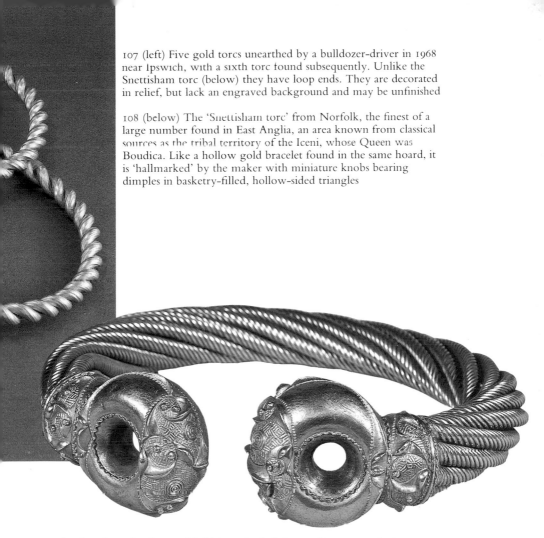

107 (left) Five gold torcs unearthed by a bulldozer-driver in 1968 near Ipswich, with a sixth torc found subsequently. Unlike the Snettisham torc (below) they have loop ends. They are decorated in relief, but lack an engraved background and may be unfinished

108 (below) The 'Snettisham torc' from Norfolk, the finest of a large number found in East Anglia, an area known from classical sources as the tribal territory of the Iceni, whose Queen was Boudica. Like a hollow gold bracelet found in the same hoard, it is 'hallmarked' by the maker with miniature knobs bearing dimples in basketry-filled, hollow-sided triangles

as the Iceni, and whose chief historical claim to fame was their queen, Boudica. Although archaeology has otherwise provided few clues to the wealth and importance of the Iceni prior to the Roman conquest, the sumptuous array of rich torcs (neckrings) from Iceni territory is sufficient to attest their importance. Chiefs probably owned the silver or gold torcs while their subjects made do with bronze. The Icenian torcs represent new artistic achievements, and the finest of them, the Snettisham torc, 20 cm ($7\frac{7}{8}$ in) diameter, is one of the outstanding treasures of prehistoric Britain.

108

109 Examples of Style V ornament: left, on the Bugthorpe scabbard; right, on the Holcombe mirror (after Stead, 1985)

Several rich hoards were found at Snettisham between 1948 and 1990. The Snettisham torc came to light in 1950 in Hoard E. Conveniently for archaeologists, a continental Celtic coin was enclosed in one of its terminals, and thus provided a rough date for its deposition, around the middle of the first century BC or slightly later. A worn example of that type of coin turned up in a hoard at Le Catillon, Grouville, Jersey. Also associated with the torc was a magnificent gold bracelet, probably by the same artist.

The Snettisham torc is made from electrum (an alloy of roughly two parts silver to three parts of gold) and the main body of it is formed of eight strands, each composed of eight wires, twisted into cables. The cables were then twisted clockwise and fitted into two hollow ring-terminals which were decorated with relief work and areas of hatching done with round-ended punch.

The pure gold Needwood Forest torc is simpler in design than the Snettisham example. The style links it to a hoard of six gold torcs found on a building site at Belstead, near Ipswich in Suffolk, five of which were found together in 1968. When found they were looped to one another, and may have formed a votive offering. These torcs are made from a multi-facetted bar, bent to form an elongated loop and twisted into the penannular torc-shape. The decoration was unfinished, but is very close stylistically to the Snettisham torc, perhaps indicating a production date for all these objects in the period *c*. 75–50 BC, as suggested by the Snettisham torc's coin.

107

A new group of hoards came to light near Snettisham in 1990. Probably the largest discovery of gold and silver treasure to be made in Britain in this century, the hoards comprised gold torcs, several gold and silver bracelets, and gold Celtic coins. The whole amounted to over fifty pieces of jewellery.

According to the Roman writer Cassius Dio, Boudica wore a gold neckring when she led a rebellion against the Romans in 61 AD.

The characteristics of the Snettisham style include cire perdue casting followed by chasing, basketry work, the fitting of the design to the shape, the use of slender commas and trumpet coils and of raised beads with three or four punched indentations. Similar features can be seen in the ornament on several quite different pieces, of which two are outstanding: the Waterloo Bridge helmet from the Thames, and 110 the Ulceby bit ring, from Ulceby-on-Humber.

Like the Battersea shield, the Waterloo Bridge helmet is frequently depicted in books, and its familiarity blunts our view of its artistic achievement. It is the Celtic warrior's headgear of popular imagination, with massive horns with knobbed ends and lateral loops, presumably to take some kind of streamers, or perhaps less colourfully a chin-strap. It is highly unlikely to have been worn, since the metal is thin and it would only fit a small head. It is more likely to have adorned some riverside wooden effigy. The ornament is loose, and spills out across the front lacking cohesion, though it displays the raised knobs with depressions that characterized Snettisham.

110 The Waterloo Bridge helmet, 18 cm (7 in) high, made of bronze with enamel inlay, and found in the Thames near Waterloo Bridge, London. Like the Battersea and Witham shields, the helmet is likely to have been for display, rather than war

111 Bronze mirror, 35 cm (13½ in) high, from Desborough, Northamptonshire, one of the very finest of the 'Style V' mirrors. An apparently symmetrical tripartite design harks back to Early Style lyre-scrolls. The voids are infilled with basketry ornament

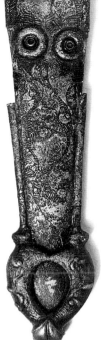

112–13 (left) Bronze-covered bit from Ulceby, Lincolnshire, probably made by a smith of the Iceni or Corieltauvi tribes in the first century BC. Elements of the Snettisham-Ipswich ornamental style include double knobs and basketry infilling. Similar relief ornament appears on the fish-faced Bugthorpe scabbard-chape (right). The ornament of the body of the scabbard is of a quite different type: evidence that Style V ornament was applied to warlike objects as well as to ladies' mirrors

The broken Ulceby bit ring, on the other hand, saw practical use directing a Celtic pony; decoration is confined to the terminal and the adjoining portion of the ring itself. It was found sometime before 1859 with another pair of broken snaffle bits, an electrum bracelet, two twisted-loop torcs and a twisted gold rod, of which two torcs survive in the Ashmolean Museum in Oxford, and are similar to examples from hoards B, C and D at Snettisham. 113

In a related style is the decoration on the chape of a bronze scabbard from Bugthorpe, East Yorkshire, and on the top of another scabbard from Little Wittenham, Oxfordshire, though the Little Wittenham 114 scabbard, despite its relief modelling, shows in its symmetry perhaps closer affinity to the series of 'Mirror Ornament' pieces described below. The Bugthorpe scabbard has the basketry-infilled ornament of the Mirror Style along its length, but the relief modelling of its chape, with its fishy face, has something in common with the Snettisham style.

If the relief modelling of the Snettisham Style represents one facet of Style V in Britain, a second facet can be seen in the engraved, symmetrical designs of the 'Mirror Style'. As the name suggests, this was used primarily to enhance mirror backs, though it is to be found on a variety of other objects too.

The idea of polished metal mirrors was one the Celts adopted from the classical world – the Etruscans were particularly fond of them. The essence of the mirror ornament is a hatched tripartite design, produced by a technique involving compasses and a tracer.

114 Technological study of a mirror found in excavation at Holcombe, Devon, in 1970 showed that the ornament was produced using compasses in an immensely complex manner involving numerous arcs and centre-points. Yet despite the intricacy of its construction, the design on the Holcombe mirror is not one produced by a mathematician following fixed geometrical rules. The first impression is of symmetry, with both halves following the same formula, but this is an illusion since there are slight differences just as a human face is not quite identical on both sides. A design of such subtlety requires very high intellectual and artistic skills, since the lack of symmetry was deliberately achieved by varying the compass layout.

One factor important to appreciating the design is the manner in which the mirror was held. The Holcombe mirror, like the better known Desborough (Northamptonshire) mirror, was evidently designed to be held with the handle upwards. The Great Chesterford (Essex) mirror seems to have been intended for holding at a slight

114 Detail of bronze mirror from Holcombe, Devon. The smiling cat's face appears when the handle is uppermost. Late first century BC or early first century AD

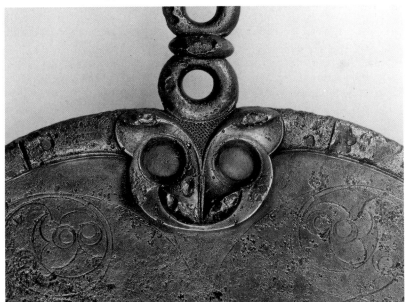

slant, again with the handle uppermost. Only positioned thus can the apparent symmetry of the designs be properly appreciated. In all probability the mirrors were held handle upwards by ladies' servants, and subsequently hung up on the wall by their handles, so that the designs on their backs could be seen to best advantage.

The use of compasses is a recurrent technique in Celtic art. It was used on the continent, as we have seen, in Early Style works, and was used around the early first century A D in both Scotland and Ireland for decorated bone-work. Later, in the Early Christian period, compasses were employed in laying out the designs of illuminated manuscripts.

The tooling techniques employed in engraving the mirrors also shows considerable expertise. The basketry on the Desborough mirror was produced with three strokes in each direction; that on the less accomplished Great Chesterford mirror uses six or seven strokes. In some cases the design is relatively simple, as for example on the Mayer mirror or the Aston (Hertfordshire) mirror, found in 1979. In the case of the latter, lack of technical expertise is probably one factor governing the simplicity of the design. Some mirrors, such as that from Great Chesterford, have lost apparent symmetry; that from Old Warden, Bedfordshire, is positively chaotic.

In the case of the Mayer mirror there are traces of the freehand sketching of the design before work began in earnest; in the case of the Great Chesterford mirror, conservation involved the removal of the handle and revealed experimental work beneath.

Held with the handle downwards, there is nothing apparently zoomorphic in the tripartite designs, but invert them and faces start to appear, particularly a cat-like face on the Aston mirror. This feature of the design is reflected in the handles – feline faces stare out from the Holcombe and Old Warden mirror handles. 114

Three mirrors, the Mayer, Great Chesterford and Birdlip examples, have a motif of a triangle in a circle, which has been seen as either a good-luck charm or, less certainly, a maker's mark.

The kind of basketry ornament found on the mirrors is also found on a *triskele*-ornamented shield mount from the hoard found at Tal-y-Llyn, Gwynedd, on a spearhead from the Thames at Datchet and on some scabbards.

The technological mastery of the foregoing pieces highlights the skills and techniques employed by Celtic smiths. Every piece of ornamental metalwork the Celts produced seems to have been an original: after casting they discarded the mould, and finished the work by hand.

We know something of the techniques employed by Iron Age smiths from the discoveries made at Gussage All Saints in Dorset, and the comparable site at Weelsby Avenue, Grimsby, by the river Humber, where excavation ended in 1990. Gussage All Saints is a fairly unremarkable Iron Age farmstead, typical of many to be found in southern England in the first century BC. Had it not been for the chance discovery of a pit filled, not with the usual broken postherds and bones, but with the debris of ornamental metalworking, it would have been assumed that no industry had been carried out on the site. The cache included moulds for making matched sets of horse and chariot fittings – fifty such sets were distinguished among the seven thousand mould-fragments.

The Gussage team of artists and craftsman relied on cire perdue casting; a wax model of the object was made then cast in clay and fired. The metal was then poured into the void left by the wax, and the mould smashed to remove the object. It was a technique that had been employed since almost the beginning of metal casting. The Gussage pit also contained some fine bone tools used in modelling the wax, as well as some corroded iron implements.

Many cast-bronze objects show signs of having had the intricate decoration added by engraving, which often shows a great mastery of difficult techniques. The methods used to decorate the mirror backs described above were particularly skillful.

Bronze-casting was combined with other skills. The Gussage pit also contained the refuse of iron-working; on occasions bronze was cast on to iron, or iron was covered in bronze, either by dipping or encasing in sheet metal.

In the Iron Age coral was imported from the Mediterranean for use in inlays. Probably imported too was the red glass or enamel used as a substitute. Pieces of this were softened by heating, then shaped, and either set in cells or fastened to the keyed base-plate with pins.

Just before the Roman period Celtic smiths in Britain were producing champlevé enamel work, in which powdered glass was put in a field cut away on the surface of the metal (or sometimes cast), and then heated in an oven to fuse it. Enamelling of this kind became a hallmark of Celtic smiths – Philostratus in the third century AD commented on it:

They say that the barbarians who live in the Ocean pour [these] colours on to heated bronze and that they adhere, and grow hard as stone, keeping the designs that are made in them.

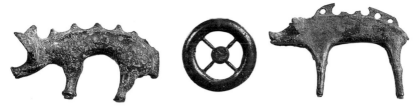

115 Bronze boars and a wheel, part of a group of offerings from a temple site at Hounslow, Middlesex, perhaps early first century AD

Celtic artists by the time of the Roman conquest had added other colours to the basic red, and continued to produce enamels throughout the Roman occupation.

In the last century of freedom from Rome the Celts in Britain began to make a miscellany of items which represent animals and human faces. The reasons for this are unknown, though it is tempting to see it as a response to the growing contacts with the classical world with its emphasis on human and animal naturalistic forms. Particularly charming are the miniature bronze pigs, of which three examples were found at Hounslow, Middlesex. With its appealing eyes, the best of the Hounslow pigs is almost pattable; all were found together, with two model dogs and a wheel, suggesting that they were votive offerings for a shrine, not toys or knick-knacks. 115

There are a series of such boar figurines from Iron Age and Roman Britain, and they serve as a reminder that animal representations were probably of religious significance. A less endearing boar's head forms the spout of a shallow lathe-turned bronze bowl found at Łęg Piekarski in Poland, where it must represent an export from Britain, and a similar bowl from Felmersham-on-Ouse has a fish-headed spout with an enamelled crest that looks Romano-British, and points to a date in the mid-first century AD, which would be compatible with the other bronzes from this find.

Celtic livelihood depended on cattle, and it is therefore not surprising that these ruminants figure in the last phases of independent Celtic art. Ox-heads of various forms were used to adorn buckets. They begin in the pre-Roman Iron Age, continue through the Roman period and probably survive into the fourth or fifth century AD. The latest of these bucket-animals appear on a complete vessel from Mount Sorrel, Leicestershire, where their combination with ring-and-dot ornament suggests a fourth-century AD milieu for their production. 4

117

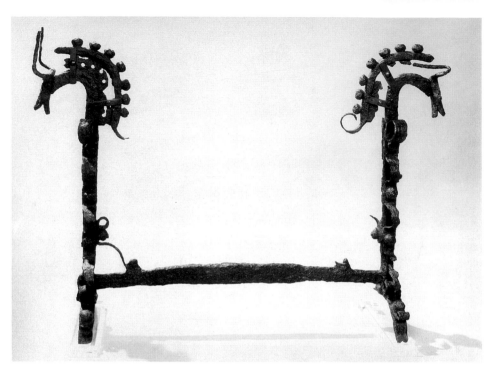

Oxen also figure on wrought-iron fire-dogs which held the spits
116 used to prepare banquets. The most ornate, from Capel Garmon in
Wales, are masterpieces of wrought ironwork, with curling locks and
supercilious expressions. Like some modern art, these objects are
stylized to the point where they offer no more than slender clues to the
relationship between their elements, and to their context. Similar if
less ornate examples are known from chieftains' burials, notably at
Welwyn in Hertfordshire, Stanfordbury in Bedfordshire and Mount
Bures in Essex, all of the late first century BC to first century AD.

Humans in any recognizable guise are still rare. A human head
118 adorns a shield mount from the Tal-y-Llyn, Gwynedd, hoard
deposited in the first century AD, and human masks appear instead of
119–20 oxen on a bucket from Aylesford, Kent, wearing haughty expressions
and plumed helmets. The eyes, without pupils, appear closed, as
though the figures are rapt in contemplation.

Less thoughtful are the warriors executed in repoussé work on a vat
117 from Marlborough, Wiltshire. The features of the Marlborough vat
faces are similar to those which appear on some Celtic coins found in
Britain between the time of Caesar and Claudius.

118

116 (left) Firedog from Capel Garmon, Wales

117 (below) Detail of head on a bronze mount 8.4 cm (3¼ in) high, from the Marlborough, Wiltshire, wooden vat

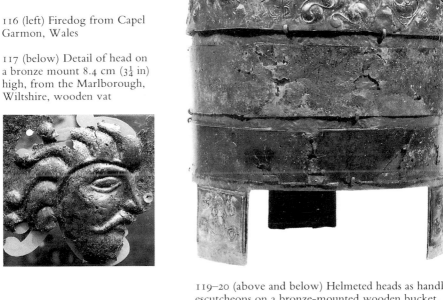

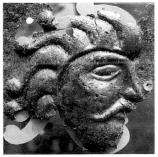

118 (above) Copper-zinc mount, 10.4 cm (4 in) wide, from Tal-y-Llyn, Gwynedd, Wales. Two bald, stylized heads balloon from a single neck, among tendrils. A Roman lock-plate dates the hoard, but the objects may be of various dates

119–20 (above and below) Helmeted heads as handle-escutcheons on a bronze-mounted wooden bucket, diameter 26.7 cm (10½ in), from a cremation burial at Aylesford, Kent, first century BC

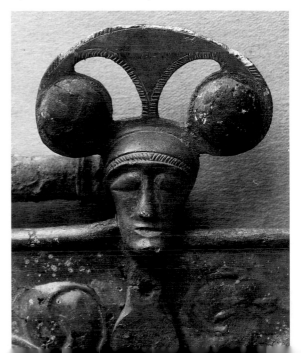

The Aylesford bucket mentioned above has a repoussé band round the rim with ornament composed of comma scrolls, a flower pattern and a pair of backward-looking graceful horses, which again have their counterparts in coinage. The type of bucket represented at Aylesford is associated, though not exclusively, with the continental Belgae, and it is arguably, along with the Marlborough vat, an import from the continent. The horses are superb, like the wild horses of the Carmargue, and make the visual short-hand of the chalk-cut Uffington White Horse, also assumed to be Iron Age (but possibly Anglo-Saxon), look like a cart-horse in comparison. Coins provide images of the entire spectrum of Celtic 'horsiness', from the stallions that pulled royal war chariots to the ponies used to teach children how to ride.

121 Frieze of wildly cavorting horses decorating the upper band of the Aylesford bucket (Ill. 119). 'Bucket' burial was a French phenomenon, and the bucket may have been made in Britain or in France

122–3 (right) The Trawsfynydd, Gwynedd, tankard, 14.3 cm (5½ in) high, and handle detail, first century AD

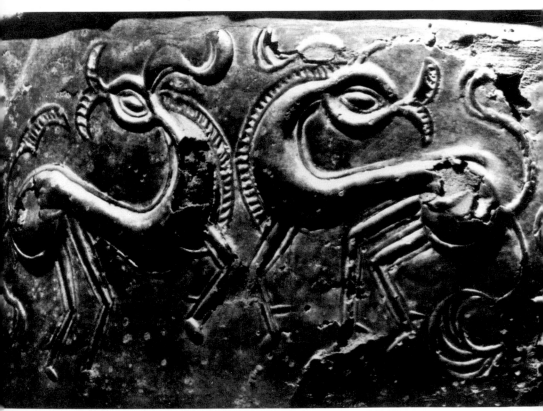

Prosaic but frequently attractive are the handles for the tankards from which chiefs quaffed their beer. The finest complete drinking vessel is the Trawsfynydd, Gwynedd, tankard. Made of wooden staves on a turned wooden base, its gently curved profile is plated with bronze. Underneath, a double circle of wavy bronze wire has been hammered into the wood to surround the central bronze roundel. The main decoration, however, is the handle, of graceful openwork, with *triskele* scrolls and a running scroll on the grip. Other surviving tankards are less pleasing, but the handles that have survived without their tankards are often very satisfactory art.

From around the time of the Roman conquest are richly enamelled harness and chariot-fittings. These begin well before the time of Claudius, and lynch-pins, bits and terrets (rein-rings for chariots and perhaps carts) were in production in the first century BC, as has been shown by the moulds and other metalworkers' debris from the pit at Gussage All Saints, Dorset, where three different 'styles' of art were apparently in use simultaneously.

122 3

124 Enamelled bronze 'horse brooch', 9.5 cm (3½ in) wide, from the Polden Hills, Somerset, hoard. The overall pattern of scroll design is the forerunner of the pelta-and-scroll design on the Oldcroft pin (Ill. 138)

124 The terret series includes examples with three lips or lobes projecting from the ring. Others had enamelled knobs, while yet others had expanded, enamelled crescentic plates. Alongside these were produced 'horse brooches' for harness. Outstanding examples of both products come from the Polden Hills (Somerset) hoard, deposited around the mid-first century AD. Some lipped terrets bear engraved designs infilled with dots. A harness brooch from the hoard has a symmetrical tripartite design which could be interpreted as a face or as two confronted hippocamps (sea-horses). The 'heads' of these creatures are forerunners of the bird-heads frequent in later Celtic art. Actual long-beaked bird-heads appear on another horse brooch from the same hoard.

125–6 Perhaps the finest of these enamelled horse-trappings is one from Santon (or Santon Downham), Norfolk, another hoard of Romano-British date, which is deceptively simple. Apparently symmetrical, it has sufficient subtle variation of pattern to soften the design and elevate it into the work of an artist.

Red was the most favoured colour for Iron Age enamelling, but green, blue and yellow were also used. The distribution of pieces might suggest that enamelling was particularly popular among the Iceni, or at least in East Anglia.

122

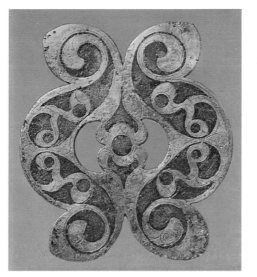
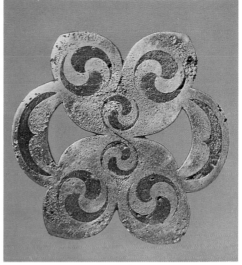

125–6 Enamelled horse-trappings 8 cm (3 in) high from a hoard found in a cauldron at Santon, Norfolk, mid-first century A D. Linked s-curves and commas anticipate the 'dodo head' motif of later Romano-British and Dark Age art (see Ill. 154)

The dotted infilling found at Polden Hills is encountered on a number of other pieces, such as a scabbard plate from Isleham, Cambridge, found in 1979.

THE ART OF CELTIC COINS IN BRITAIN

Coinage was adopted in Britain following continental models. The earliest issues were remote copies of Greek originals, but contact with Rome led to the imitation of Roman types and styles in the period between Caesar and Claudius, especially in south-east Britain. Although they copied classical types, the Celts used coins to express themselves in their traditional ways.

Celtic coinage in Britain began with a series of gold pieces, derived ultimately from the staters of Philip of Macedon in the fourth century B C, but which underwent many stages of transformation on the continent before they reached British soil in the late second century. Their obverses show the head of Apollo, his facial features overwhelmed by his hair, their reverses display a chariot reduced to a single horse, a token warrior and a wheel, or, even later, just a horse. 127 Some have argued that the earliest of the imported coins arrived as payment to British chiefs for support against Caesar; that now seems

unlikely, as some at least reached Britain by the early first century BC, if not before, but what is certain is that they were concentrated in the south-east, and gave rise to British versions.

As with all Celtic art, it is difficult to interpret the symbolism behind the images on Celtic British coins. The earliest native issues are uninscribed and their designs are highly abstract: oddly enough, they display a distinctive art which does not reflect contemporary work in other media. Basketry patterns, comma scrolls and the like are absent, and the faces, where discernible, show no obviously Celtic character-istics. Consider for instance the 'triple-tailed horse' coins that gave rise to the main coinages of the Dobunni of the Cotswolds. The wheel beneath the horse is the last remnant of the chariot – or is it? Since wheels were important symbols for the Celts, and votive wheels have been found as temple offerings where it has been suggested they were symbols of the sun, should this symbol be regarded now as a sun-motif, its original function quite forgotten? Behind the horse's high, arched back and flying tail is a symbol which might represent a charioteer; eye-shaped, it might equally well represent an eye or a Celtic shield.

In the later first century BC and early first century AD the coinage of south-east England was dominated by dynastic issues closely modelled on Roman prototypes. At first sight these are Roman coins, with familiar subject matter such as portrait busts, winged horses, figures of Victory, griffins, horsemen and the like. The conventional descriptions in numismatic literature describe the figures in classical terms: 'Jupiter Ammon', 'Hercules', 'Pegasus', and so on; but it is extremely unlikely that any British Celt would have heard of Jupiter Ammon, a local cult in Egypt, or would wish to represent him on their coins. This is quite simply the horned god (known often enough from later Romano-Celtic art), who, because of the classical style of the rendering has been equated with the only counterpart in classical mythology. Even the head of 'Hercules' wearing a distinctive 'lion scalp' headdress who figures on the coins of Epaticcus, a chief of the Atrebates, may not be what he seems. Careful scrutiny suggests that the ears of the lion are the wrong shape, and it has an odd bobble on the back. Is it in fact a personage wearing a bear's skin, and who thus belongs to some totally indigenous tradition?

There are two good reasons for believing these apparently classical types have Celtic meanings. First, the coins do not seem to have circulated widely outside their own territory, which they would have done had they been intended for trade with the Romans who would

127

128

124

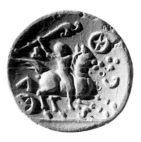

127–9 (left) Coin issued in Britain copying Gallo–Belgic originals: the chariot of the Philip of Macedon prototype has degenerated into a wheel below the triple-tailed horse. (centre) A silver unit of Epaticcus, *c*. AD 25–35: on the obverse a classically-inspired bust of Hercules. (right) A mounted horseman brandishes a Celtic carnyx or war trumpet (see Ill. 77), on the reverse of a gold coin of Tasciovanus, struck at the end of the first century BC or early first century AD

have understood the designs. Secondly, the subject matter on some of the 'Romanizing' coins includes representations never encountered in classical art, such as an aproned druid holding a severed head.

The most varied series of these Romanizing coins were those struck in bronze by Tasciovanus of the Catuvellauni, and his son, Cunobelin. 129

CELTIC RESPONSE TO ROME

After the Claudian invasion in AD 43 the patronage for artists changed. Although in the areas outside Roman rule the tribal warriors still required objects of adornment and prestige to attest their power, within the Romanized part of the province patronage was more concerned with financing the production of objects that were as classical as possible, and Celtic ornament largely became employed in the decoration of trinkets for a less socially elevated market. Celtic art did not die out in Britain with the arrival of the Romans – it was so persistent that it is difficult to be certain whether enamelled terrets and other items of horsegear were produced before or after the conquest, particularly in Iceni territory where resistance to Rome was strong.

It is informative to begin by reviewing the areas outside Roman control, where traditional patronage continued. These comprised Brigantia (essentially the north of England), Wales and the Caledo- 90 nian lands north of the Forth-Clyde line.

A tribal group which held out against Rome until the 70s AD was the Brigantes, centred on Yorkshire. A series of related schools of metalworking flourished through the first and into the second century AD, influencing taste in the more Romanized areas.

The achievement of Brigantian artists is perhaps best demonstrated by the Stanwick (Yorkshire) hoard. Found sometime before 1845 near an Iron Age fortification, the hoard comprises over a hundred items, many of them chariot and horse trappings such as lipped terrets, lynch-pins and bridle bits. The whole assemblage was probably produced around the middle of the first century AD. It has been suggested that most of the items were made at a time when contact with the Romans in the south had been established, but their artistic influence had not been felt.

The most notable of the Stanwick items are harness mounts with pelta patterns and confronted trumpet patterns, and particularly impressive are a sheet bronze mount with lugubrious horse head and another with a hirsute humanoid face.

Also present in the Stanwick hoard are strips of die-stamped metal. Die-stamping was a technique developed in south-east England, and particularly popular motifs were rosettes derived from Roman art. Die-stamped rosettes appear on a variety of other items elsewhere, mostly on what is known as 'casket ornament' mounts, probably intended for affixing to wooden boxes, though such die-stamped metalwork also appears on scabbards, for example on one from Putney.

1,130

130 Sheet-bronze mounts 7.5 cm (3 in) high from a large hoard of horse trappings found at Melsonby near Stanwick, Yorkshire. They are the work of smiths of the Brigantes tribe, which successfully held out against Roman power some thirty years after the invasion AD 43. The hoard was probably deposited between AD 47 and 73. Reversible faces make up the main design

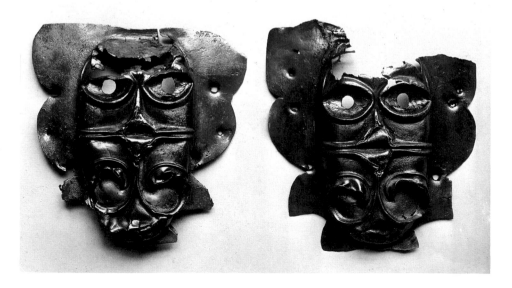

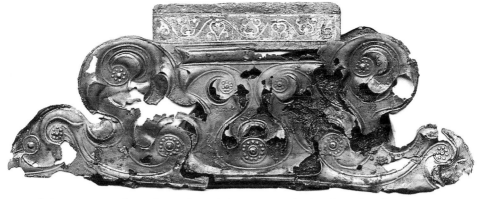

131 Gilt-bronze mount from Elmswell, Yorkshire, 24 cm (9½ in) wide, with red and green enamelled ivy-leaf scroll at top, 'Celtic' lyre-scrolls with berried rosettes below

A more sophisticated version of die-stamped ornament appears on the mount from Elmswell, north Yorkshire, with a band of Roman-style enamelled ivy-leaf scroll (probably modelled on Roman samian pottery) and an elegant low-relief lyre-scroll with berried rosettes. Its date is probably in the later first century A D. 131

In north Britain, similar horse gear of the first century A D has been found in a hoard at Middlebie, Dumfries. Richly decorated with enamel, the Middlebie pieces are further evidence for a flourishing tradition of ornamental metalworking among the enemies of Rome on the periphery of the zone of conquest. The Stichill collar from Roxburgh is another example of a product in a late native style. It has a 'swash-N' with central trumpet, a device developed by Celtic artists to fill un-Celtic rectangular spaces of the kind devised by Romans. The Stichill collar is fastened with a removable pin, and also bears a running scroll pattern in precise but shallow relief, not unlike the technique employed on a tin-plated bronze plaque from Moel Hiraddug, Clwyd, which uses the technique to display a broken-backed *triskele*. 133

The Caledonian smiths had much in common with their Brigantian cousins, but they were less refined in the application of their art. Apart from a series of massive and unlovely terrets, which they may have continued to make down to the fourth century, the Caledonians specialized in massive armlets and bracelets.

The armlets are clumsy affairs, perhaps insignia. They have elongated confronted trumpet pattern designs, in high relief, with round terminals sometimes inlaid with geometric enamels that hint at Roman influence.

Within the frontiers of Roman Britannia, which by the 80s AD had been extended into southern Scotland, Celtic art managed to keep its hold in the decoration of minor items. A bronze plaque from Dowgate Hill, London, displays a version of casket ornament. It links with disc brooches with *triskeles* of confronted trumpets, sometimes with lateral scrolls, of which the best example comes from the Roman town of Silchester, in Hampshire. These *triskele* brooches have a long life – they were current in the second century AD and still seem to have been produced in the fourth. Rather shorter lived were native styles of Roman safety-pin brooch.

134 A silver-gilt brooch from Carmarthen has been dated to the period AD 25–50 (but this has been questioned by some, who have seen it as late as the second century AD). Its symmetrical high-relief modelling includes trumpet patterns and raised bosses.

Two other brooches with Celtic ornament have been dated to the first century but are more probably also from the second. The first, a gilt-bronze example from the native hillfort at Tr'er Ceiri in Gwynedd, has on its bow a stylized human face with eyes formed of berried rosettes. It is related to a much more sumptuous brooch from

135 Aesica (Greatchesters) on Hadrian's Wall, also gilt bronze. Both are 'fantail' brooches. The Aesica brooch has a pair of sea-horses or dolphins with curved snouts and a pattern of confronted trumpets, and shows a connection with the *triskele* brooches.

The late first and second centuries AD also saw the production in Roman Britain of openwork bronzes with confronted trumpet

132 Pair of harness-mounts, 6.4 cm (2½ in) wide, found at the Roman fort of South Shields, Tyne and Wear. *Trompetenmuster* (or trumpet pattern) ornaments were widely used throughout the Roman Empire, but here the motif is rendered as a Celtic broken-backed *triskele*

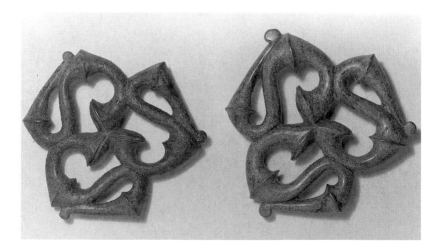

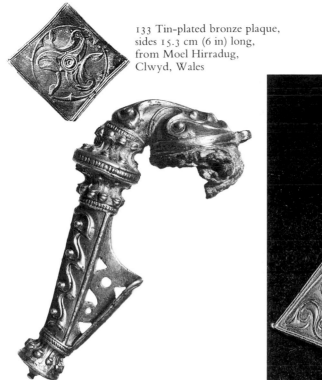

133 Tin-plated bronze plaque, sides 15.3 cm (6 in) long, from Moel Hirradug, Clwyd, Wales

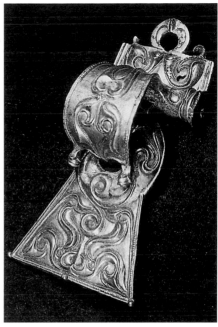

134–5 Two Romano-British brooches that still use Celtic ornament to fine effect: (left) silver-gilt trumpet-brooch 6.2 cm (2½ in) long from Carmarthen, south Wales, with openwork design on the catch plate that recalls the Santon horse-trapping (Ills. 125–6); (right) the 'Aesica' brooch, 10.3 cm (4 in) long, from Greatchesters on Hadrian's Wall, Northumberland, with lateral trumpets and a loop on the head that together suggest a face if the footplate is worn uppermost

patterns. The style is Celtic, but they were produced not only in Britain (a mould for one was found in South Shields) but in Switzerland (where a certain Gemellianus signed his work), and turn up all over the Roman Empire, even in Syria on the Euphrates. They were the products of a Celtic style taken up by non-Celts, and adopted as part of the Roman ornamental repertoire. Some may have survived into the third century and played their part in the resurgence of Celtic art in later Roman Britain. Among the finest are harness-mounts from South Shields, Tyne and Wear, with a *triskele* of confronted trumpets ending in swollen, folded-back tails. 132

A series of enamelled objects show how various motifs were taken up by the Celts from the Roman repertoire. They include some enamelled *paterae* or saucepans, the handle for one of which was found in the Thames. The late Sir Thomas Kendrick showed how its peltas, trumpets and voids could be simply re-arranged to make the kind of design favoured by the makers of hanging bowls in the sixth century. Another example, from Bradley Hill, Somerset, has ornament on the bowl itself, and from its context, shows that bowls of this type were still in use in the fourth century. In Gloucester a workshop perhaps making bowls with enamel set in geometric cells (a forerunner of other Dark Age designs) was operating in the fifth century.

Peltas, scrolls and trumpets appear on a variety of small bronzes, mostly brooches, but also on some curious bronze model stools, made as offerings for shrines.

Interlace, which appears along with peltas and running scrolls in Romano-British mosaics, also sometimes appears on metalwork, for example on a penannular brooch from the Roman fort at Newstead, Roxburgh, or on a beaten bronze bowl from Irchester, Northamptonshire, the latter of the fourth century.

One striking example of Celtic sculpture comes from Corstopitum 136 (Corbridge, Northumberland). It is a head, 18 cm (7 in) high, probably dating from the third century A D. On first impression this awesome effigy would appear very simple in conception, but the more one looks at it, the more complex it is. There is considerable tension between the realism of the depiction of the details of the chin, the cut of the beard, stylized yet somehow snipped in a finicky manner, the deep lines from nostril to jaw, around the cheeks, or the lines over the forehead and the bridge of the nose, and the treatment of the eyes – feline, lentoid, and like nothing we have ever seen in life. Here is a god (possibly, though this cannot be certain, the northern British god Maponus), complete with an offering dish on his head. We need only imagine him in a dimly-lit context, the eyes artfully catching the light, and he makes his statement with total clarity.

To compare with this is a little (12.5 cm/5 in high) bronze head 137 from Silkstead, Hampshire, fashioned in Roman style: hairstyle, nose, mouth, chin and brows are all realistically depicted. It would be an unremarkable piece were it not for the treatment of the eyes: here the Celtic lentoid eyes have the lashes treated stylistically, and huge pupils focus attention. Rather than sensing that we are confronted with the image of a deity, we are led to consider the spiritual aspect of a real girl. This is not unusual in other types of art, of which Roman and

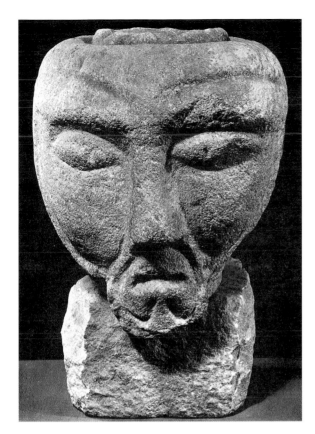

136 (left) An awesome stone head from Corbridge, Northumberland, probably third century AD. It represents a Celtic god, sometimes taken to be Maponus

137 (above) Hollow-cast bronze girl's head with pebble-inlaid eyes, from Silkstead, near Compton, Hampshire, probably second century AD

Egyptian are good examples, where an emphasis on eyes is intended to emphasize the soul.

THE BEGINNINGS OF DARK AGE ART

Roman influence on Celtic art had more than a contemporaneous effect, for in fourth-century Roman Britain the roots of Dark Age Celtic art must be sought. In particular, the fourth-century work-shops in Britain produced material which had an uninterrupted development that spanned the last decades of Roman rule without any visible evidence of the political upheavals.

The designs were simple, and clearly related to the kind of pattern found in earlier centuries in Britannia, as well as elsewhere in the Roman Empire. They appear in particular on a series of pins and brooches, and on a few small mounts for caskets and bowls.

131

The pins are 'proto-hand pins' and hand-pins. These are so named on account of their resemblance to a clenched hand, with three, later five, projecting fingers. They developed in the Roman period in north Britain out of earlier types of projecting ring-headed pin. By the late third century or early fourth the enamelled silver hand-pin had evolved, with simple ornament of a pelta flanked by a pair of scrolls. Such a design appears on a pin from a coin hoard deposited when already old in the mid-fourth century at Oldcroft, Gloucestershire.

138

The brooches are the kind known as penannulars: constructed with a pin which swivels round a hoop with a break to enable the pin to be inserted in the cloth. Penannulars start in pre-Roman Britain, and various types were current in the first and second centuries. By the fourth century they were 'zoomorphic', in so far as the terminals bore a faint resemblance to a backward-turned animal head, and it was this type of brooch that survived into the Dark Ages, to be developed in a variety of ways.

151

Some uncertainty surrounds the centres of production of ornamental metalwork in the fifth century – certainly north Britain was one area in which decorative pieces were produced, and it seems probable that the Bristol Channel region was another. Abundant metalwork from Lydney, Gloucestershire, implies that artists were flourishing there in the later fourth century, and there is evidence for a continuing tradition of decorative metalworking from Gloucester. Several penannular brooches of the fourth to fifth centuries have been found in the West Country and South Wales.

From this area of south-west Britain, and probably also from north Britain, pins, brooches and other minor works of art reached Ireland. It is possible that some arrived in the last years of the fourth century, introduced by Irish who had taken part with the Picts and others in raids on Britannia. These 'souvenirs' soon inspired local products. Put in less dramatic terms, economic contacts were being re-established between Ireland and Britain, and manifested in greater wealth being generated on both sides of the Irish Sea.

One of the earliest centres for metalworking so far recognized in Ireland was at the fort of Clogher, Co. Tyrone (where Romano-British bracelets of a type found at Lydney may be a clue to the origins

138 Silver pin found at Oldcroft, Gloucestershire, with more than three thousand Roman coins deposited in the mid-fourth century AD. Probably old when buried, it offers a parentage and starting date for the whole series of 'Dark Age' hand-pins

of the smiths). At Clogher, penannular brooches were being produced by the sixth century, by which time distinctively Irish forms of penannular were in vogue across the country and were occasionally taken over to Britain.

Our appreciation of the development of Celtic art in Britain in the fifth century is confused by the settlement of the Anglo-Saxons, although it is now clear that the Anglo-Saxon settlement was not on the large scale once envisaged. The population of fifth-century England was almost certainly mainly British (Celtic), although in many areas people rapidly adopted an Anglo-Saxon way of life. The Anglo-Saxon advance was also a gradual process, and many areas received no Anglo-Saxon settlement until the sixth century or even later. Accordingly, it is not surprising that Roman-British traditions in metalworking (and also of course in other materials which were less durable) survived during the fifth century to have an impact on the incomers. There are features of Anglo-Saxon metalwork that show a debt to Roman Britain; there are also strong indicators that native traditions of 'Celtic' metalworking survived, to be used by Saxon and Briton alike.

The continued use of penannular brooches is one clue to surviving traditions in England, although most of the brooches from Anglo-Saxon graves were re-used Roman ones. More significant are the hanging bowls, most of which have come to light in Anglo-Saxon graves.

More than ninety hanging bowls or mounts from the bowls have survived. In general, the bowls are small (averaging 15–30 cm/6 12 in across), with three, sometimes four, escutcheons with hooks to take suspension chains. On the base there are usually one or two decorative roundels attached inside or outside the bowl. 139–42

The earliest hanging bowls are Romano-British. These have plain or sometimes bird-shaped escutcheons. Trellis patterns, flowers, and peltas (which were widely employed in Romano-British decorative art) adorn another series of hanging bowls. Some, such as that from Eastry, Kent, had pelta-shaped escutcheons. The earliest were decorated, but similar undecorated types continued to be produced in the seventh and eighth centuries, as is shown by the mould for one from Craig Phadrig near Inverness.

Other 'Romanizing' bowls have enamelled decoration and the use of *millefiori*. This type of decorative glasswork involved fusing narrow rods together, drawing them out and then slicing them. The thin patterned slices thus produced were then set in (usually red)

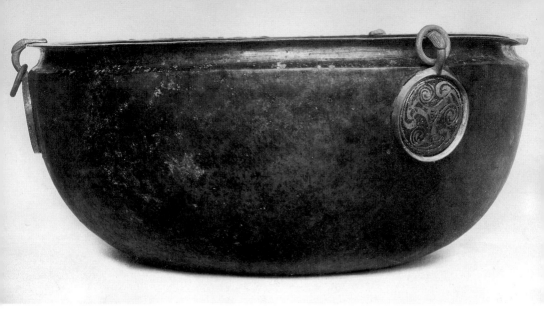

139 Bronze hanging bowl from Winchester, with enamelled *triskeles* on the escutcheons, fifth or sixth century AD

140 Appliqués decorating a bronze hanging bowl from Lullingstone, Kent, including a 'double-headed axe', bird, fish and deer

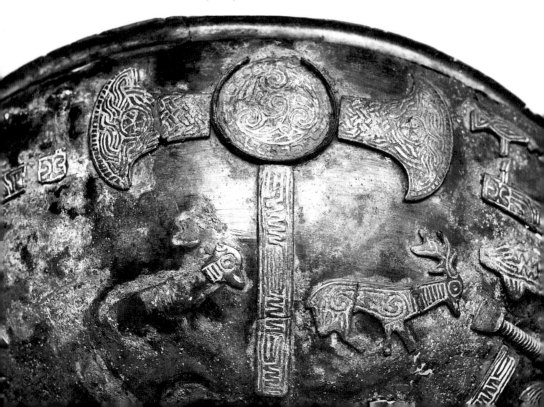

141–2 Two enamelled bronze mounts for a hanging bowl, from an Anglo-Saxon burial at Middleton Moor, Derbyshire, sixth or seventh century AD

enamel. Floral and chequer patterns predominate. Millefiori was also used in Roman Britain to decorate disc brooches. There is no evidence that the pagan Anglo-Saxons were familiar with it, though the technique (possibly re-introduced from Ireland) was later employed in the Saxon monasteries of Monkwearmouth and Jarrow.

A third series of bowls are decorated with escutcheons with enamelled designs based on a spiral motif popular in the seventh century (known as the 'Durrow spiral' for its use in the Book of Durrow). These bowls usually favour a *triskele* with confronted trumpets, and the pattern, with very little variation, appears on several bowls and in the eighth century on a lead die from Birsay in Orkney. They were made in the sixth and possibly in the seventh century.

The hanging bowls represent the last true flourish of Celtic metalwork in England, though the Celtic style of ornament was to continue to influence manuscripts and sculpture. From now on the main arena was Ireland.

In Ireland, after the auspicious beginnings suggested by the Bann scabbards, few objects are known to us for the early centuries AD. To the first century perhaps can be assigned the series of bone slips from later occupation at the neolithic site of Lough Crew, Co. Meath. Executed with compasses, they may be the Irish equivalents of Roman votive plaques. The style of the ornament, characterized by broken-backed curves, 'yin-yangs', pelta and quatrefoil flower-patterns, relates them to some of the work produced in southern Scotland, and to a hoard of bronzes of similar date from Somerset, Co. Galway.

141
146

143

Slightly later, perhaps, is a series of bronze decorated discs of unknown function with high-relief modelling incorporating snail-shell spirals. Known as Monasterevin discs after a classic example from Monasterevin, Co. Kildare, they are distantly related in style to some work found in Caledonia, and are further evidence for the artistic links in the early centuries AD between Scotland and Ireland. Very similar to the Monasterevin discs is a silver plate with high-relief modelling from a Pictish treasure hoard from Norries Law, Fife. The hoard was probably buried in the fifth century, but the plaque was obviously ancient when interred, perhaps of the second century. A Caledonian war trumpet or carnyx from Deskford, Banff, is in the same tradition, with high-relief work and slender trumpet patterns. Fashioned in the shape of a boar's head, when found it had a wooden tongue or clapper, and was brandished as a standard in Caledonian battles. Similar war trumpets appear on Celtic coins.

Fine-line trumpets are also found on two curious objects from Ireland, known as the Petrie crown (after its collector, Sir George Petrie) and the Cork horns. These have crested birds' heads forming the ends of spirals, a device also found in Caledonia and in later Dark Age art.

Apart from links with Scotland, Irish metalwork displays some evidence of contacts with Roman Britain. The designs on some horse bits assigned to the early centuries AD echo those on Romano-British brooches, and a few objects such as the disc associated with a bit from Killevan, Co. Monaghan, show strong affinities to objects found fairly widely in the Roman world.

It is possible to trace the development of Irish art into the first and second centuries AD, but thereafter continuity is lost. One or two items may bridge the third and fourth centuries, such as a tanged stud from Freestone Hill, Co. Kilkenny, and an openwork mount from Feltrim Hill, Co. Dublin, which come from sites with fourth-century Roman coins.

These Irish pieces can be seen as a last flourish of La Tène art in Europe, or the first works of the Dark Age Celtic Renaissance.

143 (top left) Bone slips from more than four thousand found at the site of a neolithic chambered tomb at Lough Crew, Co. Meath. They have been interpreted as 'trial pieces' for metalworkers' designs, but are more probably votive offerings

144 (top right) Bronze disc 30.5 cm (12 in) diameter from Monasterevin, Co. Kildare, Ireland, second century AD

145 (below) The bronze 'Petrie crown' (diameter of discs 6 cm, 2½ in), ornamented with slender trumpet patterns and elegant crested bird heads

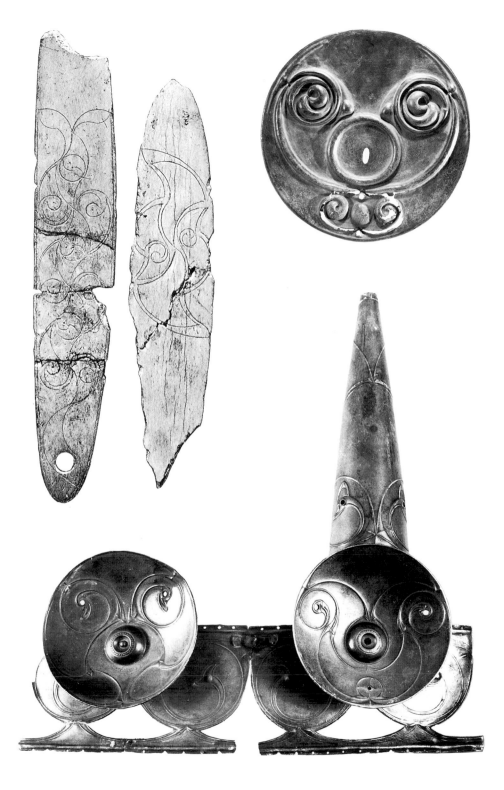

The renaissance of Celtic art, *c.* 400–1200

Conventionally, the conversion of the Celts to Christianity marks the beginning of a new phase of Celtic art, and it is true that from this period onwards, many of the masterpieces which have come down to us were of Christian function or meaning. However, the period also roughly coincides with cessation of Roman power in Britannia, and the inevitably slow economic recovery that followed. The influence of Germanic culture in what later became England had probably already begun before the Romans withdrew, and contributed towards a new barbarian art. The relationship between Anglo-Saxon and Celtic art as the two cultures interrelated during the fifth to eighth centuries is highly complex, and is inextricably bound up with the spread of Christianity to both peoples.

Outside the area of Anglo-Saxon settlement, kingdoms emerged in the fifth century which owed their origins to new tribal groupings and changes in farming that had begun as early as the second century AD. In Britain during the fifth and sixth centuries AD, hillforts were occupied or re-occupied as the strongholds of local rulers, though a diversity of other sites were also inhabited. Irish raids from the fourth century AD onwards were followed by Irish settlement in Britain, particularly in north-west Scotland, where the kingdom of the Scots, 147 Dalriada, centred on Argyll, maintained close links with the homeland of the immigrants in Ulster. Dalriada was in constant conflict with its powerful eastern neighbour, Pictland, whose territory extended from the Firth of Forth to the Northern Isles. Only with the conquest of the Picts by the Scots in the ninth century did continual feuding end. Despite the conflicts, Picts and Scots shared many cultural traits, and both received influence from Anglo-Saxon Northumbria, which at its greatest extent reached northwards to the Firth of Forth. In Ireland a plurality of kings and over-kings ruled over a predominantly agricultural society. Hillforts are rare, and the dominant settlement types are *raths* (earthen ringforts), *crannógs* (lake dwellings) and the occasional *souterrain* ('earth-houses').

138

146 Carpet page from the Book of Durrow (see p. 155)

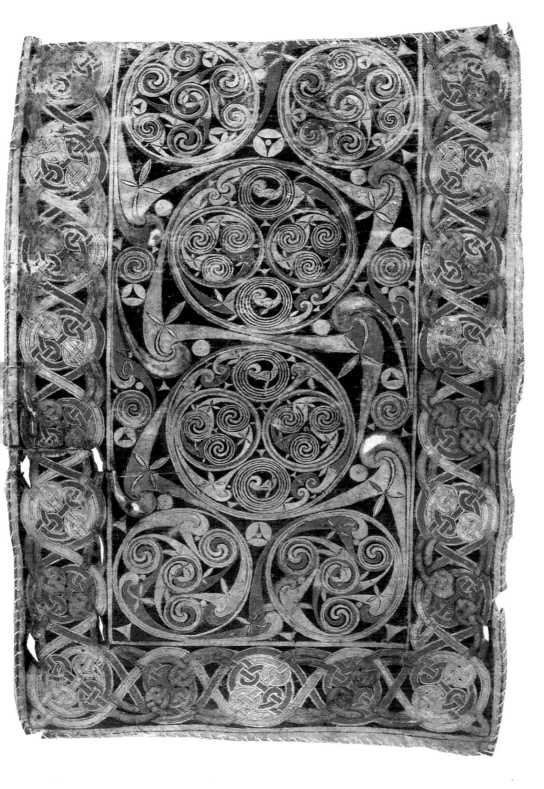

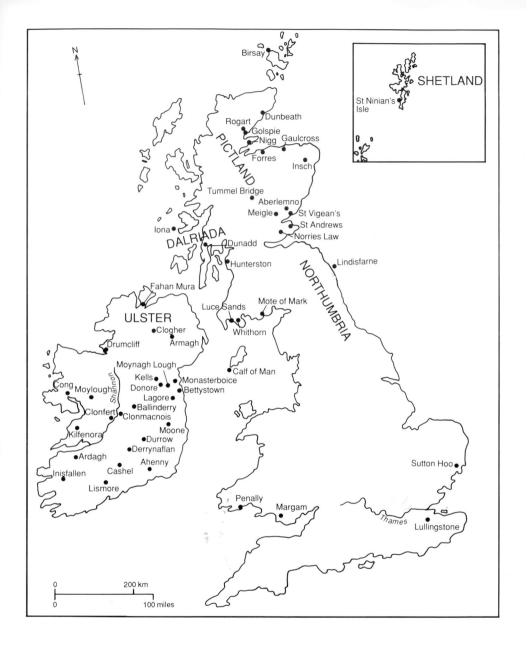

147 Location of 'Dark Age' Celtic art

Christianity was established in Roman Britain and probably spread to parts of north and south Wales and southern Scotland by the fourth century. Some Christians were already probably established in Ireland by the same period. By 431 Christianity was well enough established in Ireland for Pope Celestine to send Palladius to act as bishop; little is known of this mission, or of the early fifth-century activities of St Patrick, who apparently was of northern British Roman stock, and had first been taken to Ireland as a slave. Christianity in Wales and southern Scotland during the fifth and earlier sixth centuries was reinforced by contact with the continent, most notably Gaul. In the second half of the sixth century, monasticism, which had originated in the Mediterranean, spread through the Celtic areas, and many important monasteries such as Clonmacnois and Durrow were founded. In 563 St Columba crossed to Iona, an island off the coast of Argyll, and founded an important monastery there. By the seventh to eighth century many monasteries were rich and powerful, and were large communities with lay dependants. These monasteries existed alongside episcopal dioceses.

147

Traditionally, historians have seen Ireland as the nursery for the 'Celtic Renaissance', but as has been demonstrated in the previous chapter, Celtic art was never completely wiped out during the Roman period, either in Britannia or beyond her frontiers. It is probably more prudent to view the upsurge in Celtic works of art as the outcome of increasing Irish prosperity and influence, which was concomitant with the opening up of Christian links with the continent. New trade routes brought not only the Gospel, but new patronage, ideas, objects and income.

Both economic recovery and Christianity were factors which led to an enormous increase in outlets for the artist. Metalwork became awe-inspiringly intricate, both in terms of its technological execution and its artistic conception. Manuscript illumination offered new opportunities for reinterpreting classical or Christian art. Partly because of the greater proximity of the period to our own time, but also because of the increased production, a wealth of art has survived from the period.

149

148

Once the Anglo-Saxon settlements and the Celtic kingdoms of Wales, Scotland and Ireland were well established by the eighth century, Celtic prosperity was both challenged and stimulated by the arrival of the Vikings who came first as raiders, then as settlers, and made their own contribution to the artistic repertoire and style.

162

141

148–9 FOLLOWING PAGES:
(left) Lion symbol from the Book of Durrow (p. 153)
(right) Detail of the Cross of Cong (p. 190)

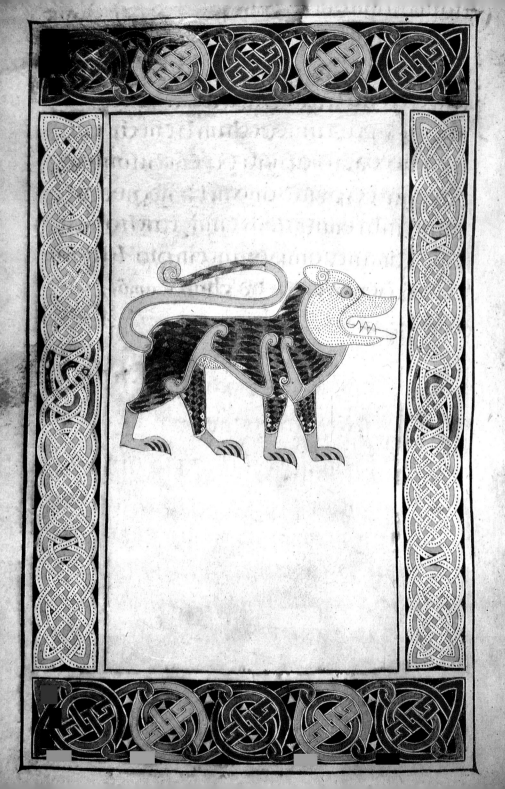

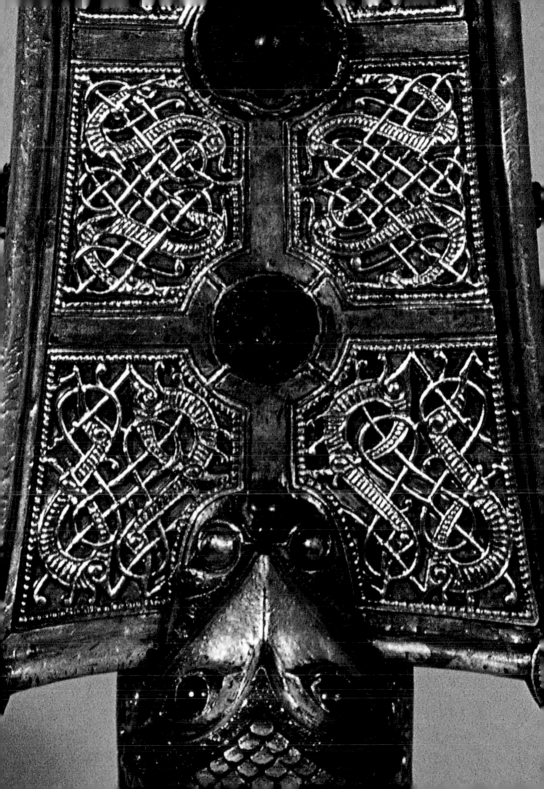

The artists who produced the masterpieces of Celtic Christian art were not regarded as lowly artisans. A Life of St Columba reported that 'it was a practice [with the saint] to make crosses, and book satchels, and ecclesiastical implements'. This was not necessarily the literal truth, but shows the status accorded to the artist, and indeed in later times the Book of Durrow was believed to be the work of Columba himself.

It is clear that the scribes who produced richly decorated manuscripts were held in high regard for their skill. The *Annals of the Four Masters* carries an entry for AD 844 noting that 'Ferdomnagh, a sage and choice scribe of the Church of Armagh, died'. We are fortunate in having an extant work from his hand – the Book of

196 Armagh. So famous was a scribe called Ultán in the early ninth century that his bones were in demand as relics. The Saxon Ethelwulf (*c*. 802–91) wrote: 'Fame proclaims that many live a perfect life, of which number is he who is called by the renowned name of Ultán. This man was a blessed priest of the Scottic nation, who could adorn little books with such elegant designs and so rendered life a pleasant kind of the highest ornaments.'

Gerald of Wales wrote in the twelfth century about a manuscript that he saw at Kildare, that it had 'intricacies, so delicate and subtle, so exact and compact, so full of knots and links, with colours so fresh and vivid', that it seemed to him 'the work, not of men but of angels'. He recounts the story of an angel appearing to the scribe in dreams and showing him the design of the pages, which he was able to memorize and copy.

Such comments, of course, refer to works produced for the glory of God, but there is no reason to suppose that those who worked for secular patrons were not also regarded as inspired artists, as other Irish sources suggest.

We are fortunate in having a substantial body of evidence for the study of the techniques of Dark Age Celtic artists. Very many of the major excavated sites have produced some evidence of ornamental metalworking, and large numbers of clay moulds have been recovered from such sites as Mote of Mark in Kirkcudbright, Dunadd in Argyll, Birsay in Orkney and Moynagh Lough in Co. Meath. Models in lead and other materials which were used to make the moulds have also occasionally been found. The moulds themselves were two-piece. As mentioned earlier, they seem to have been used only once: each object thus being a unique work.

Designs for metalwork, manuscript illumination and other media were often worked out on slips of bone or thin pieces of stone. Such 'motif pieces' are common in Ireland, though rarer in Britain.

The manuscript illuminator used quill pens and, presumably, brushes. Pigments came from a variety of sources – lead gave white or red; orpiment, yellow; verdigris, green; lapis lazuli, blue; folium, blue and pink to purple; woad, blue, and kerme, red. Some of the pigments were very costly, and had to be imported from far afield – although we do not know where the monks obtained the lapis lazuli in the Dark Ages, later it came from Afghanistan and the Arab world.

Manuscripts were executed on vellum – calf skin – which had a smooth and a 'hair' side and which thus in some measure dictated the quality of the work. The vellum was precious, and there is evidence, for example in the Book of Durrow, of imperfect sheets sometimes being used. The artist who decorated the pages was frequently the scribe, but in some cases artist and scribe may have been different people.

Manuscript designs were laid out with compasses (as frequently were metalwork designs and presumably also sculpture), rulers and templates. The perforations from the compass points can be seen on the pages of manuscripts. Designs were built up, as in the Iron Age, with intersecting arcs or circles.

SYMBOLISM AND CELTIC CHRISTIAN ART

It might be thought that for Christian Celtic art the symbolism would be readily understandable through an appreciation of the biblical sources: but although Christian texts help, they do not always provide explanations. In Celtic Christian art there is much that is enigmatic – certain episodes and symbols do not relate to any traceable tradition.

What, for example, are we to make of the two bird-headed men with a human head between their beaks that appears on a Pictish slab from Papil in Shetland? The same motif of human head between animals' jaws is shown in a variant form on a Welsh stone in St David's Cathedral, Pembroke, though here the confronted bird heads form the ends of interlace. The tiny severed heads on these Christian stones hark back to the pre-Christian past – they are almost identical to the 'severed' heads that are part of the iconography of the earliest Celtic art in prehistoric Europe.

Before rejecting ideas of pagan significance, it is worth looking at a Pictish stone from Meigle, Perthshire, which seems to depict the

horned god Cernunos, and another from St Vigean's, Angus, that has a scene of a man being sacrificed in a cauldron. Both the horned god and a cauldron scene appear on the Iron Age cauldron from Gundestrup, made some nine centuries before. As late as the twelfth century AD a cross from Kilfenora, Co. Clare, has a strange scene which defies Christian interpretation, in which clerics attack a bird which is devouring a man.

The unusual naturalism of these episodes makes their subject matter fairly clear, even though their symbolism remains obscure. When, as with Pictish sculpture, we move from representation to abstract symbolism, the problem of interpretation becomes doubly acute.

The complexity of Celtic symbolism is apparent in the cases where it has proved possible to detect the Christian theological symbolism behind the arrangement of ornamental elements. Nowhere is this more evident than in the Book of Kells, a manuscript created in the late eighth or early ninth century, now regarded as one of the finest achievements of Celtic art. For a long time the ornament in this manuscript was regarded as purely decorative, but detailed study by Françoise Henry and more recently George and Isabel Henderson has shown that the symbolism is extremely complex and subtle. Henry was convinced that Kells incorporated a 'wealth of now lost meanings', which are all the more complex to unravel because one symbol can serve to convey a variety of meanings. The apparently ornamental details of the *Christi Autem* page (folio 43), for example, have been noted by George Henderson to incorporate symbols of air (angels and a pair of butterflies), earth (two cats watching two mice or rats gnawing a church wafer) and water (an otter catching fish). The whole composition of the first great initial can be interpreted in the light of a text from Alcuin, which alludes to 'the four rivers of the virtues flowing out of one bright and health-giving paradise, irrigating the whole breadth of the Christian Church'. For Henderson, the form of the initial represents four curves flowing out into estuaries of swirling energy, emanating from Christ.

Symbolism is not confined to manuscript art. The ornament of the Hunterston brooch, made at the end of the seventh century, probably in the kingdom of Dalriada in western Scotland, is at first sight totally abstract, but close observation reveals two pairs of confronted bird-heads each reduced to a large eye and hooked beak. Between them these grip a rectangular panel which upon closer inspection reveals a cross, usually obscured by the pin.

150 The intricate *Christi Autem* page from the Book of Kells. Note the cats and mice (or rats) near the bottom left of the page, the angel with flying hair on the left near the top, and the otter catching fish in the centre bottom. Traditional peltas, trumpet patterns and 'Durrow' spirals are combined with interlace. Around AD 800

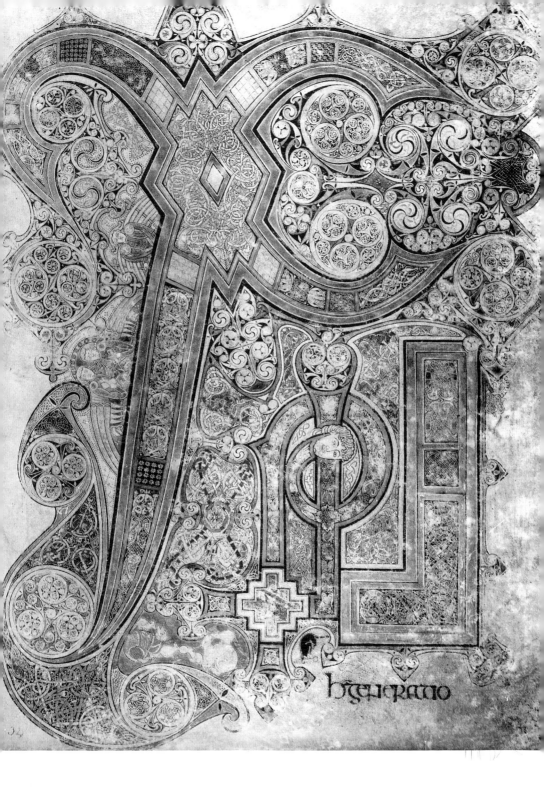

generatio

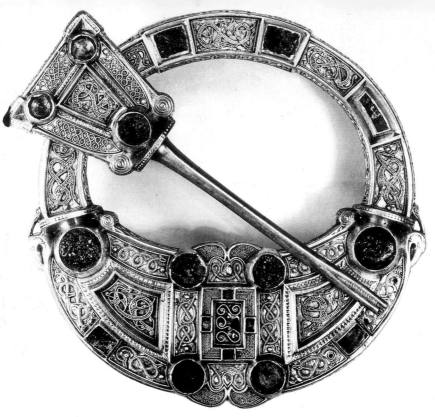

151 The Hunterston brooch, diameter 12.2 cm (4⅞ in), arguably the earliest of the ornate penannular brooches from Britain and Ireland, late seventh century AD. It is made of solid silver, ornamented with gold and silver filigree and amber studs. Note the cross and confronted bird-heads at the widest point of the hoop

One of the most ornate in the series of Celtic hanging bowls is that from Lullingstone, Kent, of the seventh century, which is decorated with a rich array of appliqués, among them a bird with a fish under its claws. This motif is found widely in Early Christian art as a symbol of resurrection; the fish is representative of the soul, and the bird of Christ. The appliqué stags which appear on the bowl are likely also to be symbolic. Stags are shown drinking from the Fountain of Life in a fifth-century mosaic in the Mausoleum of Galla Placidia in Ravenna, Italy, and the same animals are associated with the Fountain of Life in Carolingian manuscripts in ninth-century France, such as the Gospels of St Medard. However the symbols are also those of the pre-Christian Celts. Again, stag, fish and bird symbols are all found in Scotland carved in Pictish stones of the fifth to sixth centuries.

140

Of all Celtic symbols, those carved on stones by the Picts in northern Scotland during the fifth to the ninth centuries have attracted the most curiosity. There are two types of symbol. The first comprises (with two exceptions) creatures that were to be found in Pictland – boar, wolf, bull, goose, salmon, snake, eagle, stag and horse (the exceptions being 'mythical' creatures termed by archaeologists the 'swimming elephant' and the 's-dragon'). The second group comprises abstract designs, usually termed descriptively 'notched rectangle', 'Z-rod', 'triple disc', 'crescent and V-rod', and so on. Abstract and animal symbols appear in a variety of combinations, and numerous theories have been advanced about their date and meaning. Many, however, believe that they were in some way dynastic, and relate to marriage alliances, the animals serving as clan badges.

The Picardy stone, near Insch, Gordon, is typical. Made of hard whinstone with quartzite streaks, it stands probably in its original position, near the site of a burial discovered in the nineteenth century. On its rough face are incised a double disc and Z-rod, a serpent and Z-rod, and a mirror, the last suggesting a connection with the mirrors of the Roman world.

152

152 (below) Pictish symbols on the Picardy stone, Insch, Gordon, Scotland, perhaps sixth century AD

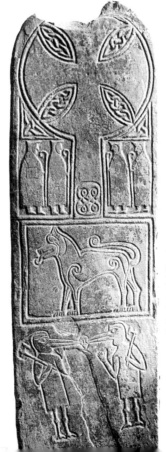

153 Cross-slab from Papil, Shetland, with (below) two birdmen with axes over their shoulders, pinning a human head between their beaks. Note the similarity of the dog-like lion and the lion Evangelist symbol of the Book of Durrow (Ill. 148)

The inspiration behind some of the motifs found in the new Celtic Christian sculpture may have arrived on very mundane trade objects. From the late fifth century onwards Celtic Britain imported a variety of pottery vessels of east Mediterranean origin that are invaluable for providing a dating scheme for Celtic sites. Most interesting from the art historical point of view are vessels with red, glossy surfaces imported from North Africa, often stamped with figures, double-outline crosses, *Chi-rhos*, animals, and some strange designs resembling examples from the Pictish range. Similar designs appear on early Irish slabs. While such imports may not have had a direct impact on Celtic art, they illustrate one avenue by which motifs could have been disseminated from the Mediterranean at this period.

There is very little evidence for a native tradition of ornamental metalworking in either Wales or south-west England after the fifth or sixth centuries. In southern Scotland, apart from a couple of pieces from Luce Sands, Wigtown, the only evidence for a tradition of metalworking comes from the sixth-century industrial site at Mote of Mark, Kirkcudbright, where a variety of penannular brooches, buckles and mounts were produced, some with interlaced ornament. After the early seventh century, metalworking died out here too, perhaps extinguished by the Anglian conquest from Bernicia.

In northern Scotland and in Ireland, metalworking flourished from the sixth century onwards. A variety of sixth-century zoomorphic penannular brooches have survived. These are mostly Irish, and display an increasing sophistication in the decoration of their terminals with red enamel and millefiori, materials also used to ornament hand-pins, latchets (an odd serpentiform type of Irish dress fastener) and a few other small items. In Pictland there are also to be found hand-pins, though the Irish types of penannular have no Pictish counterparts at this early period. Fifth-century Pictland, however, has left us a few hoards, notably that from Norries Law, Fife, with ornamental votive plaques, and from Gaulcross, Banff, with an ornate hand-pin, chain and spiral silver bracelet, all that remain of a much larger cache. These silver hoards, and a group of silver chains, some with Pictish symbols on their terminal rings, suggest that the Picts had acquired a taste for silverwork through possession of large quantities of silver looted from Roman Britain.

Artists in Ireland and Pictland drew upon a wide variety of sources of inspiration for their art. Apart from Roman Britain, the Anglo-Saxon world was the provider of new metalworking techniques, such

154

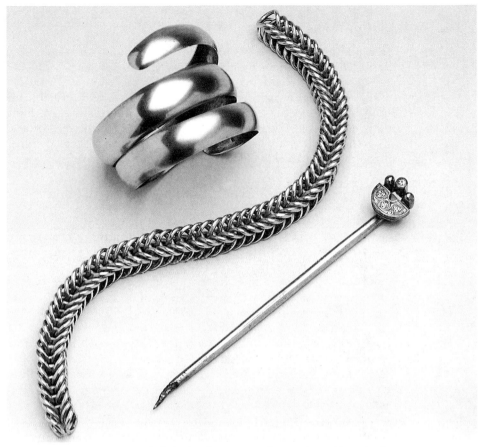

154 Pictish silver hand-pin with dodo-head ornament, chain and spiral bracelet from Gaulcross, Banff, Scotland, fifth century AD

as filigree and granular work in gold and cloisonné jewellery. These techniques, and the use of ribbon interlace (which might have come from the continent or Anglo-Saxon England) probably reached northern Scotland and Ireland in the last years of the sixth century and early years of the seventh. Although there are elements in the designs of metalwork that are peculiar to that medium, many of the ornamental devices can be matched in sculpture, and were to appear transposed in the new medium of manuscript illumination.

A few sculptures predate AD 700. The earliest inscribed stones of the early Christian period in Britain and Ireland have either ogham memorials (ogham was an Irish form of writing inspired probably

around the fourth century AD by the Roman alphabet), or their Latin equivalents in Britain, and virtually no ornament appears on them. A fifth-century stone from Whithorn, Galloway, has a cross of arcs with a tiny hook on one which turns it into a *Chi-rho*, almost identical to some found in North African pottery. Simple crosses or crosses in circles ornament a few other stones of the sixth century, but more ambitious designs do not make an appearance until the seventh century, except possibly in Pictland, where the flourishing tradition of sculpture referred to above may have begun in the fourth or fifth century.

The earliest of the manuscripts cannot much pre-date 600, if indeed it is so early. It is the fragmentary psalter known as the Cathach of St Columba, of which fifty-eight pages survive, with sixty-four decorative initials executed in red and brown ink. Traditionally it is by St Columba's own hand, but most opinion favours a date for it in the early seventh century, later than the saint's death in 597. It is almost certainly Irish.

The idea of decorative initials originated in the Mediterranean, where it was employed in some late Antique books such as the *Vergilius Augusteus*, but in the Cathach the initials are incorporated in a way which was novel, with the letters following the first initial starting large and quickly reducing to the general text size – a style of opening known as *diminuendo* or 'diminution'. The ornament of these letters is simple – peltas, spirals, scrolls, trumpet patterns and s-scrolls. Books in a similar style were produced in the early seventh century by Irish monks on the continent, most notably at the monastery of Bobbio in Italy which had been founded by St Columbanus in 614.

155 Initial letters of the Cathach (or 'Battler') of St Columba, the oldest surviving Irish manuscript. The psalter was carried in its *cumdach* (shrine) with the O'Donnell army in the fifteenth century

Art historians tend to term all the manuscripts with 'Celtic' ornament 'insular', and in doing so recognize that the tradition which they represent was to be found both in Ireland and Anglo-Saxon Northumbria, as well as in Irish monasteries on the continent. Some of the manuscripts, such as the Gospel Book Durham Cathedral A II 10 or the Lindisfarne Gospels, were evidently produced in Northumbria; others, such as the Book of Dimma, were clearly produced in Ireland. Debates over the provenance of individual manuscripts should not obscure the fact that all the books drew upon a common repertoire of ornament that originated in later Roman Britain, on to which has been grafted, in varying amounts, elements from Anglo-Saxon, Antique and Eastern Mediterranean art. 158

The complexity of the sources of insular art is perhaps most clearly demonstrated by an analysis of the elements discernible in the Gospel Book known as the Book of Durrow. Although arguments have been advanced for a Northumbrian provenance for the Book of Durrow, there is an even stronger case for it having been made at St Columba's foundation on the island of Iona, soon after the middle of the seventh century. Dalriada (embracing Iona) was the recipient of influences from Ireland, Northumbria and Pictland at that time, as can be shown by other evidence.

Durrow is a compendium of European ornamental art. Both the text and the form of the book (a bound codex) are derived from the classical Mediterranean. The animal ornament on the other hand has a mixed north European ancestry. The Evangelist symbols, man, calf, and lion, show features in common with the art of the Pictish symbols, and there have been protracted 'chicken-and-egg' discussions about which came first. In probability both are derivative of a much more ancient tradition of animal ornament which is ultimately descended from the art of the steppe nomads at the time of the Scythians and Cimmerians. Characteristic of this style is the use of shoulder and hip spirals, which can be seen in Pictish sculpture and in particular in the Durrow calf and lion. Such spirals were employed on the creature of the Basse-Yutz flagon handle, which also has a head not unlike the Durrow calf. The Durrow eagle, on the other hand, has closest affinities to continental metalwork, most notably Visigothic eagle brooches. 156 148 153 51

The ornamental frieze-animals in the Book of Durrow are more obviously Anglo-Saxon, though again a Eurasiatic ancestry for these, albeit remote, cannot be totally ruled out. Here the procession of long-snouted animals that make up the borders on some carpet pages

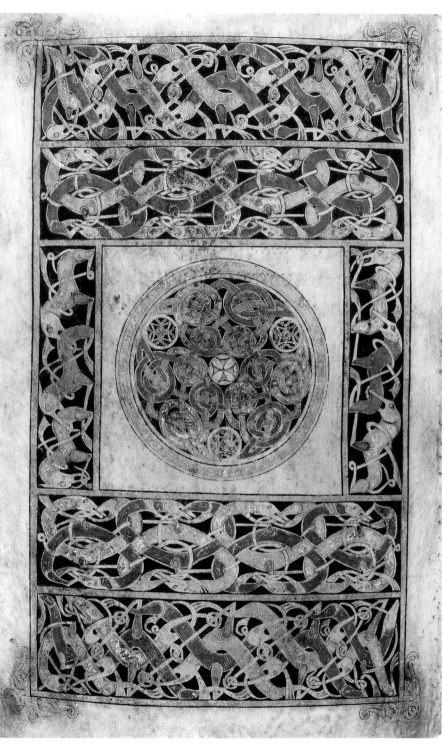

are most closely matched in the treasures from the Anglo-Saxon royal burial at Sutton Hoo, Suffolk, which it has been argued on stylistic grounds are only slightly earlier. An even closer parallel for some of the creatures can be found on a sword pommel from Crundale Down, Sussex. A complex step-pattern in a roundel in Durrow can be compared with the designs for bosses in Irish metalwork, but equally with the arrangement of Anglo-Saxon disc brooches of the late sixth and early seventh century.

Nowhere in Durrow can the mastery of the artist be better seen than in folio 3v. The rich patterns stand out against a dark background. The composition is balanced and apparently symmetrical, yet on closer inspection exhibits a host of subtle variations which elevate the conception from the mathematical patterns on which it is ultimately based and into art. The colours, while undoubtedly dependent on the limitations of what was available, are used with subtle effects to create a glowing vibrancy. Certain corner elements in the stems are more heavily coloured in dark red, giving a depth to the whole and making the lighter parts of the stems appear almost golden. 146

The similarity of the Gospel Books produced in the British Isles and on the continent – their 'cosmopolitan' character – is best accounted

156 (left) Interlace made up of forty-two animals on a carpet page (folio 129v) of the Book of Durrow, 24.5 × 14.5 cm ($9\frac{5}{8}$ × $5\frac{3}{4}$ in), seventh century AD

157–8 (below left) Calf symbol (folio 115v) from the Echternach Gospels. (below right) Detail of animal ornament and script from the Anglo-Saxon Lindisfarne Gospels, AD 698

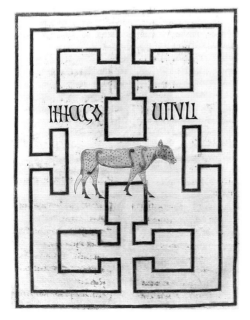

for by the travels of both monks and manuscripts between monasteries and countries. Both the Irish and Anglo-Saxon monks were peripatetic. For example, Willibrord, a Saxon, went from Ripon to Ireland when he was twenty and stayed to study for twelve years before departing with eleven companions (mostly Saxons) on a mission to Frisia, where in 698 he founded a monastery at Echternach (now in Luxembourg). Here a series of Hiberno-Saxon manuscripts were produced, the most famous of which is the Echternach Gospels, now in the Bibliothèque Nationale in Paris. Apart from Evangelist symbols, animal ornament is absent from this book, but instead fine interlace and trumpet-spirals is executed with academic precision. It dates from the end of the seventh century, and is the forerunner of a series of Echternach manuscripts in which animal heads and the occasional bird enliven the geometry of the main schemes.

THE 'GOLDEN AGE' OF CELTIC CHRISTIAN ART

The eighth century traditionally represents the Golden Age of Celtic Christian art. This very fact, however, has resulted in much uncertainly dated Celtic art of merit (and quite a lot without it) being labelled eighth century. The chronology of the period is far from certain, and dating to a large extent depends on internal evidence, which is confused by the very long currency of motifs and styles.

Celtic metalwork of the eighth century flows from traditions of the seventh, during which a type of penannular brooch had evolved with wide, flaring terminals. At first plain or minimally decorated, as for example the silver brooches from the Tummel Bridge (Perthshire) hoard, these brooches became increasingly elaborate. In Scotland they remained true penannulars, but in Ireland their heavy terminals seem to have weakened the junction with the narrow hoop, and the 'pseudo-penannulars' without an opening in the hoop may have been developed to combat this problem. The early stages in their evolution can be traced in Scotland, where the terminal of a silver brooch from Dunbeath, Caithness, is decorated with fine filigree and granular work, including gaping-jawed animals. The junction of hoop and terminal also has a projecting bird head, similar to those on the later 'Tara' brooch.

It seems quite likely that the highly developed penannular brooches were not produced over a long period of evolution, but were the conception of an artist or group of artists devising the entire design 'on paper'. The type of filigree and granular work encountered on what is

probably the earliest of the elaborate penannulars, that from
Hunterston, Ayrshire, is clearly derived from the similar work
produced in south-east England in the first half of the seventh century.
R.B.K. Stevenson has suggested that the Hunterston brooch was
produced by an Anglo-Saxon artist for a Celtic patron. Certainly the
jeweller who fashioned the Hunterston brooch had been well trained
in Germanic metalworking techniques of the seventh century.

The Hunterston brooch has features, such as the pseudo-penannu-
lar form, that lead some scholars to believe it to be the earliest of the
Irish brooches, taken to southern Scotland by Norse raiders (it has a
Norse runic inscription on the back). Features of its ornamental
animals and its use of amber might point however to manufacture in
northern Scotland, perhaps in Dalriada, where amber was popular, to
account for the fusion of Irish, Pictish and Anglo-Saxon elements. Its
date probably lies in the last years of the seventh century, since its
ornament recalls that of the Lindisfarne Gospels, but it could be as
early as 675.

The Hunterston brooch is also remarkable for the precision of the
design, presumably in strict conformity with an original mathemati-
cal drawing made by its designer. It has none of the characteristic
exhuberance and dynamism of Celtic art. There is a stillness about the
object to be found in other contexts, especially the religious.

The finest of the Irish brooches is that known as the 'Tara' brooch, 159–61
found at Bettystown, Co. Meath, in the nineteenth century. Enlarged

159 Detail of the front of the 'Tara' brooch: gilt bronze with gold filigree, set with
amber and glass mounts

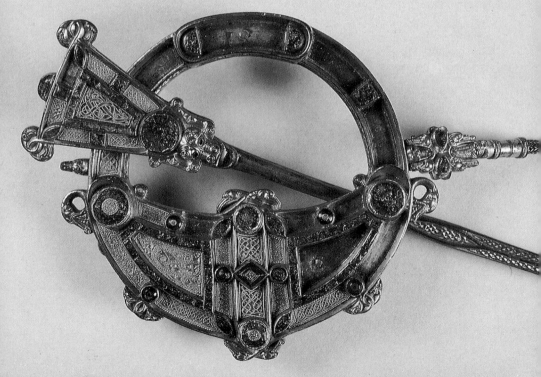

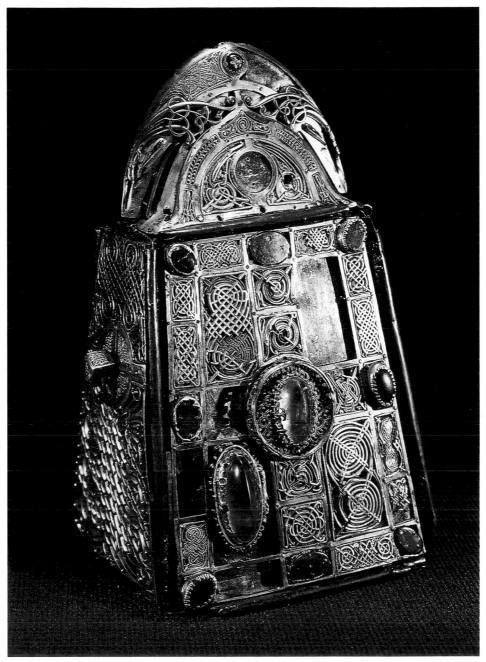

160–1 Front and back of the 'Tara' brooch, early eighth century. The design includes animal ornament reminiscent of the Lindisfarne Gospels (Ill. 158)

162 Viking-derived ornament has been added to the earlier repertoire on the Shrine of St Patrick's Bell, c. 1100 (see p. 190)

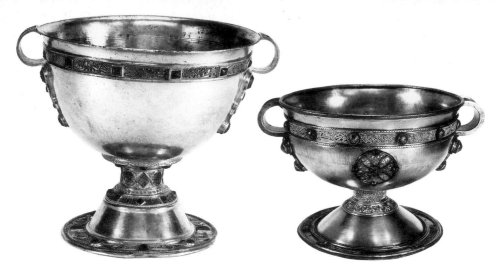

163, 165 (above left) The Derrynaflan chalice, 19.2 cm (7½ in) high, from Co. Tipperary. Of beaten silver, it has sixty-nine decorative panels, forty-nine of them filigree. With it was found a silver paten (detail top, facing)

photographs tend to obscure the fact that the 'Tara' brooch is not big (the hoop is 8.7 cm/3½ in across), and its brilliance arises from the precision of its detail. Made of gilt bronze, it has cast 'chip carved' ornament, glass studs with metal grilles, filigree and granular work and enamelled silver plates. Apart from its obvious similarity to the Hunterston brooch, the animal ornament is more obviously related to the Lindisfarne tradition (for instance the long-beaked, long-legged birds), and its date lies somewhere in the early eighth century.

The 'Tara' brooch has attracted considerable attention for its skilled workmanship. Where Hunterston conveys an almost spiritual atmosphere, 'Tara' is a regal object. It is almost totally covered in intricate detail: the only plain areas being the narrow frames. Within each section an abundance of varying interlaces are found, fitting their spaces comfortably, neither squashed nor skimped. It is a very 161 complete object. To modern eyes, the fact that the back is as decorated as the front is the most extravagant feature.

164 Very closely related is the Ardagh chalice, from Ardagh, Co. Limerick, the supreme masterpiece of Celtic Christian art, and arguably the finest piece of ornamental metalwork to survive from early medieval Europe. This liturgical vessel was found (as was the 'Tara' brooch) in a hoard deposited at the time of the Viking raids.

164, 166-7 (above right) The Ardagh chalice, 17.8 cm (7 in) high, dug up in a ringfort at Ardagh, Co. Limerick, in 1868. It dates from c. 700, more or less contemporary with the 'Tara' brooch. Fine filigree ornaments the band, chip-casting the collar (details, facing)

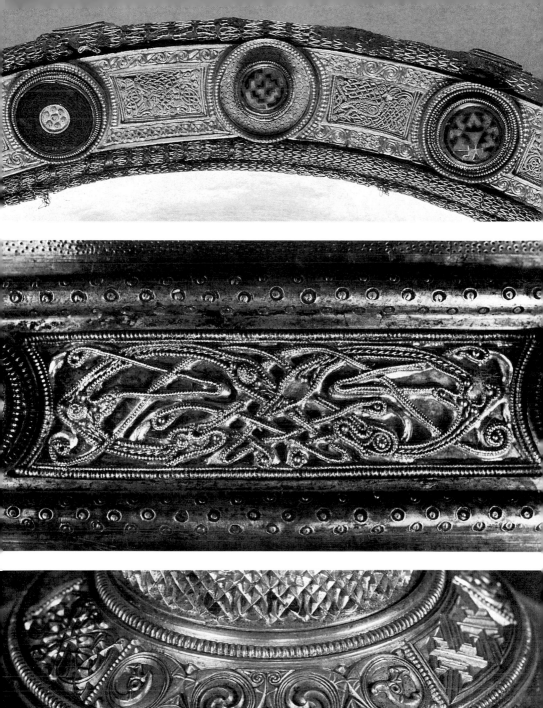

The Ardagh chalice is composed of two beaten silver bowls, one inverted against the other, with the junction obscured by a cast gilt-bronze collar. Two loop handles are fastened to the bowl with plaques, and these along with the medallions front and back are decorated with filigree and red and blue glass. A gilt-bronze decorative band runs just below the rim, and another round the foot. Underneath is a central stud of rock crystal, within a chip-carved roundel with studs.

167

166

Until the discovery of the Derrynaflan hoard in 1980, the Ardagh chalice was virtually the only richly decorated early medieval chalice in Europe. With it was found a plain bronze chalice, and there are plain silver and bronze chalices from Trewhiddle, Cornwall, and Hexham, Northumberland, in Anglo-Saxon England. The only decorated counterpart for it is the Frankish example from Gourdon, which is in quite a different style, or the Tassilo chalice from Kremsmünster. Byzantine prototypes for it may be inferred, but cannot be proved. The Lindisfarne animals are absent, but the Anglo-Saxon connection is perhaps indicated by the rock crystal stud and by the light engraving which names the apostles on the side of the bowl. This inscription uses the same kind of angular letters found in the Lindisfarne Gospels and apparently current in Northumbria in the early eighth century.

163

Magnificent Dark Age metalwork though it is, the Derrynaflan chalice is relatively a poor piece, with crude ornament by an inexpert hand. It was found in a hoard in Co. Tipperary, the objects contained in the cache being of different dates and buried together in the Viking period. The hoard comprises the silver chalice, a silver paten and stand, a gilt bronze strainer and large bronze basin. Although similar in design to the Ardagh chalice, the Derrynaflan chalice is probably somewhat later. The paten, stand and bowl are however in a similar tradition to the Ardagh chalice and 'Tara' brooch, and of early eighth-century date.

165

Outstanding for the intricacy and delicacy of its highly complex ornament is the gold, silver and enamel Derrynaflan paten and stand, used for holding the Host in Mass. Here is the Dark Age artist at his finest. From a distance the object is restrained, civilized, elegant; the composition is orderly, with large panels of metalwork relieved by studs of regular, geometrically-shaped enamelling. On detail, the artist has been more characteristically exuberant, though the zoomorphic interlace is still orderly; but so packed in is the detail on some panels of the rim that it gives the impression of being on the point of

bursting out of its confines. This effect is partly created by the lack of precision in the individual strands, which have probably been drawn 'freehand' rather than calculated with instruments. The paten displays the only instance of human ornament in Celtic filigree work. With large heads, the figures are not unlike some on the Irish High Crosses (described below). The paten and stand have gilded interlace patterns of a type first seen at Sutton Hoo, as well as running scrolls, 'yin-yangs', and knitted wire work (trichinopoly) which was also used to produce a chain attached to the 'Tara' brooch.

Of disputed date is the Moylough belt shrine, found in a peat bog in 168 1942 at Tubbercurry, Co. Sligo. Made of four sections hinged together, it contains the fragments of a leather belt. It has an imitation buckle (it is opened by removing the pin of the back hinge), and is decorated with a variety of elements, including silver *pressblech* (die-stamped) sheets with a design like those on hanging bowls and a series of interlocked Durrow spirals. There is also enamelwork with T- and L-shaped *cloisons*, millefiori, coloured glass studs with metal grilles, and openwork. Bird heads confront one another on the buckle loop, and there are also animal heads with rounded snouts in the 'Tara' brooch style. The millefiori might suggest an earlier date, but there are a number of features which seem very late and which compare with continental work of the late eighth or ninth century, such as the Adelhausen portable altar from Germany.

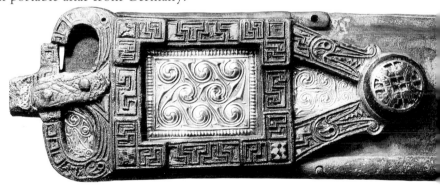

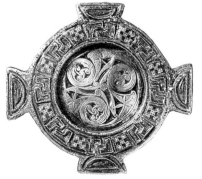

168 Ornament of the Moylough belt shrine from Tubbercurry, Co. Sligo, average width 5.2 cm (2 in). Note the pair of long-beaked 'Lindisfarne' birds forming the buckle hoop, and the long-snouted animals, of the kind found on the 'Tara' brooch, at the end of the buckle plate. Left, a 'Durrow spiral' mount on the belt

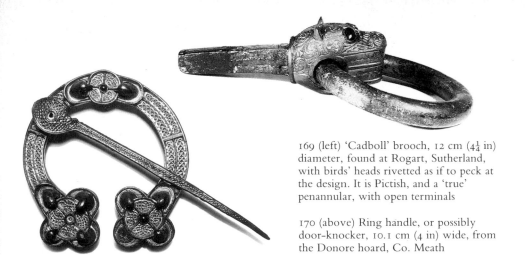

169 (left) 'Cadboll' brooch, 12 cm (4¼ in) diameter, found at Rogart, Sutherland, with birds' heads rivetted as if to peck at the design. It is Pictish, and a 'true' penannular, with open terminals

170 (above) Ring handle, or possibly door-knocker, 10.1 cm (4 in) wide, from the Donore hoard, Co. Meath

170 A rich hoard of ornamental metalwork came to light in 1985 at Donore, Moynalty, Co. Meath, not far from Kells. The hoard comprised nine objects, including a tinned bronze disc and a plaque of similar material, and the parts of an assembly for a ring handle of a door. All seem to have been the work of the same hand, and to comprise the furniture for a substantial and richly-ornamented door or pair of doors. The ornament is closely comparable to that in the Lindisfarne Gospels or on the 'Tara' brooch, and points to a thriving tradition of metalwork in the neighbourhood of Kells in the early eighth century, which perhaps maintained contacts with Northumbria. The most impressive piece is the assembly for the ring handle, the heavy bronze ring being gripped between the snarling teeth of a ferocious beast that springs from the centre of the plate. Its eyes are set with amber studs, and it presumably represents a lion. Its forehead and the disc are decorated with designs that are closely comparable to carpet pages (pages of all-over ornament) in illuminated manuscripts, and the find serves to remind us that wooden churches may well have been richly ornamented in a variety of ways.

In Pictland during the eighth century the finest achievements of ornamental metalwork are in silver, and are represented by a series of true penannular brooches with a distinctive type of panel on the hoop, distinctive pins and lobed terminals. Although this type of brooch probably goes back to the earlier eighth or even seventh century, the majority of the ornate examples were made around the end of the eighth century, and are best illustrated by examples from two hoards.

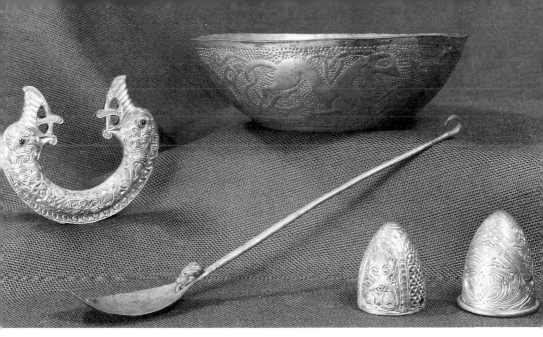

171 Pictish silver objects from the St Ninian's Isle hoard, Shetland, deposited around AD 800. The bowl, diameter 14.4 cm (5½ in), has a punched dot background; a sword chape (left) is decorated with dragon heads. On the stem of a spoon (centre) a dog's head licks from the bowl. The 'pepperpots' at bottom right are probably part of a sword harness

172 The Monymusk reliquary, a wooden, house-shaped shrine 9 cm (3½ in) high, embellished with silver, gilt, bronze and enamel. It once contained a relic of St Columba, and it was carried as a battle standard by the Scots at Bannockburn in 1314. The engraved decoration on the plates indicates a Pictish origin

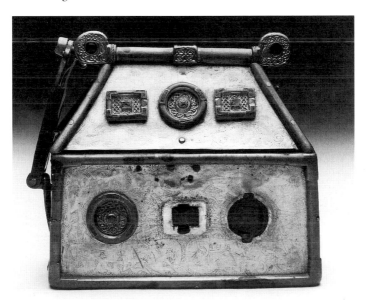

The first is the Rogart hoard from Sutherland, found in the late nineteenth century and dispersed. Of the surviving brooches, the two finest are known as the Cadboll brooches. The larger example has the Pictish feature of separately cast bird-heads rivetted to the terminals, apparently to peck at the design. In stylized form they appear cast as one with the brooch in pieces from the St Ninian's Isle treasure.

169

171 Like the Rogart hoard, the St Ninian's Isle Treasure was buried around the beginning of the ninth century, probably in the face of Viking raids. It was found in a larchwood box under the chancel arch of a church on the tidal St Ninian's Isle off the coast of Shetland. All the objects in the hoard were of silver, and comprise a hanging bowl (which may be Northumbrian and earlier than the other items in the hoard), a pair of sword chapes (one inscribed), a sword pommel, a group of three 'pepperpots' (actually harness sliders for a sword belt), seven silver bowls, a spoon and a knife-shaped object, as well as twelve penannular brooches and a porpoise jawbone. The inscribed chape, which has dragon heads, is lettered in Irish characters, but includes the names 'Resad' and 'Spusscio' (Pictish personal names). One penannular brooch has terminals in the form of ferocious dragon heads. Bird and dragon heads appear on brooch-moulds from both Birsay in Orkney and Dunadd in Argyll. The ornament on the silver bowls of the hoard includes punched dot decoration and animals with looped hindquarters which have their counterparts in Pictish sculpture. One bowl has a base escutcheon with very degenerate pseudo-filigree work, a central red enamel setting to imitate garnet and miniature confronted human masks. The spoon, with a charming dog's head licking from the bowl, and the knife-like implement, possibly for eating shellfish, are most readily matched in the Roman world. The ornament on the objects in the hoard is extremely eclectic, with elements of the 'Tara' brooch style as well as Anglo-Saxon and purely Pictish features.

172 Also Pictish is the only British example of a house-shaped shrine, the Monymusk reliquary, which is hollowed from a wooden block and has a hinged lid covered with plates. On the front is engraved ornament in the style of some of the St Ninian's Isle bowls. There are mounts on the lid and front panel, and an enamelled hinge for the strap with a weak version of a hanging bowl *triskele*. The crest has hook-beaked bird-heads in the 'Tara' brooch style. The whole probably belongs to the latter half of the eighth century.

An important series of sculptures dates from the eighth century, both in Ireland and in Scotland. In general terms in both areas there

166

seems to have been a progression from incised stones to low relief slabs, to shaped cross-slabs. Obviously this is not a strictly chronological sequence, and there is much overlap.

Without inscriptions, the dating of early Irish sculptures is very difficult. There are a few incised slabs that might belong to the seventh century, but not certainly so. A good example can be seen at Reask, 173 Co. Kerry, where the 'marigold' design of the head is supported by incised peltas and running scrolls.

Some scholars have believed that a group of cross-slabs from Co. Donegal belong to the seventh century. These are in low relief, and bear multi-strand interlace and figural work. The most famous are those from Carndonagh and Fahan Mura. The latter has been dated 174 by an inscription supposedly derived from a Greek manuscript, but its value is doubtful. Associated with the Carndonagh cross-slab are two small pillars representing ecclesiastics and a slab bearing 'marigold' flabellum (a processional cross) which may owe its design to Merovingian Gaul. These stones may be earlier, but the Donegal sculptures in general need not pre-date the ninth century.

The first datable Irish sculpture is a pillar from Kilnasaggart, South Co. Armagh, which has an inscription and incised crosses. It names a certain Ternoc, identified (not necessarily correctly) with a personage from the *Irish Annals* who died in 714 or 716.

173–4 Pillar stone from Reask, Co. Kerry (left), typical of the earliest sculptures from Early Christian Ireland in having incised rather than relief decoration. Right: cross-slab from Fahan Mura, Co. Donegal, with fine interlace in a style difficult to date, but seen on a ninth-century crozier from Hoddom, Dumfries (British Museum)

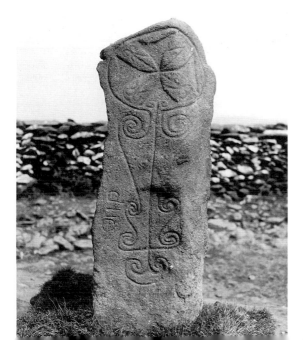
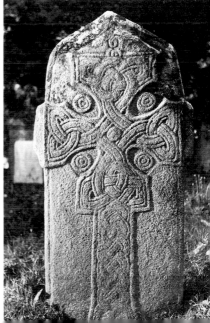

It is quite possible that free-standing crosses in stone were developed at the beginning of the eighth century. Fragments of one from Toureen Peakaun, Co. Tipperary, show that it had an incised cross on one face and lettering similar to that in the Lindisfarne Gospels and on the Ardagh chalice on the reverse. It appears to have been copied from a wooden prototype, suggesting that there was a tradition of timber crosses prior to the eighth century.

The lettering on the Toureen Peakaun Cross points to Northumbrian connections, and the immediate inspiration for Celtic stone crosses may have been the independent development of such crosses in Northumbria, notably the Ruthwell and Bewcastle Crosses, both produced around 700. Such crosses, whether of wood or stone, would have served a variety of purposes, notably as a focus for preaching and meditation.

Although the first stone crosses may have been erected in Ireland, it is in the Irish colony at Iona that the earliest surviving group of High Crosses is found. The Iona crosses are experimental, and use ornamental techniques derived from jewellery-making, in particular many small bosses of different sizes in imitation of granular work. On St John's Cross there are large bosses with dome-and-hollow centres, closely similar to a boss on the 'Tara' brooch. 'Bird nest' bosses on the Iona crosses may be inspired by examples with internal granulation that appear on both the 'Tara' brooch and Ardagh chalice.

Details of St Oran's and St John's Crosses at Iona recall features of the Book of Kells, while further connections with Pictland can be seen in their use of serpent-and-boss ornament which is found in Pictland on a cross-slab from Nigg.

175 St John's Cross on Iona, in the Western Isles of Scotland, eighth century. The cross has been restored, but the magnificence of the original conception can be seen from this view of the west face of the head. Devoid of figural ornament, this is probably the earliest of the Iona monuments. Note the prominent 'bird nest' bosses

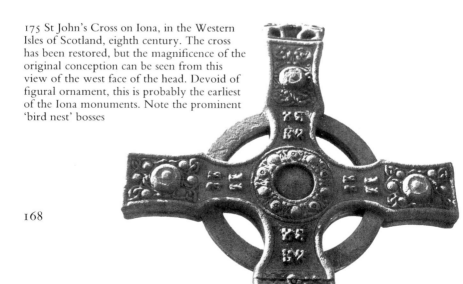

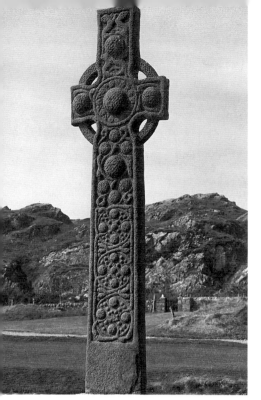 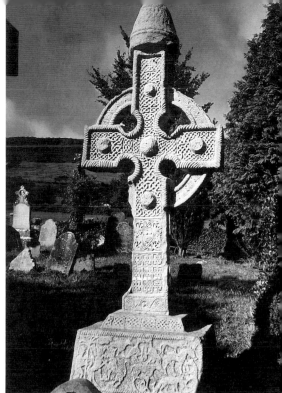

176–7 The granite Cross of St Martin on Iona (left), one of a small group of Iona monuments that have been seen as the forerunners of the Irish High Crosses. The North Cross, Ahenny, Co. Tipperary (right), is one of the early free-standing crosses in Ireland. Fine interlace and bosses recall Iona. The cable beading round the edge is inspired by metalwork (compare Ill. 172)

The Cross of St Martin on Iona may originally have had lateral arms slotted into the head with a kind of tenon appropriate to wood carving, though in the high winds of Iona the presumed wooden arms may have been fitted only on special occasions. Certainly there were free-standing crosses on Iona in the time of Adamnan, Columba's biographer, at the end of the seventh century, and king Oswald of Northumbria (who spent some time on the island) erected one before the battle of Heavenfield in 635.

In Ireland, a near-contemporary group of crosses (of the later eighth century) at Ahenny, Co. Tipperary, similarly show features more common on metalwork. They resemble metal crosses, and have hatched-edge mouldings reminiscent of filigree work (or more probably representing the corner-bindings found on reliquaries), and

176

177

bosses to represent rivets, or rather the glass studs covering them. The better of the Ahenny crosses is heavy and ungainly. The structure is strengthened by the addition of the ring which binds together the upper arms and shaft; it is notable for its use of five very heavy bosses and a strange 'up-turned barrel' cap. In contrast to these devices, the lower part of the cross is executed in much finer style: patterns typical of stone, metal and manuscript art infill segments and the base of the monument displays a number of figures, both animal and human.

The figural work on the Ahenny crosses is confined to the bases. The North Cross has a base decorated with a hunt scene which has much in common with similar scenes in Pictland, and is inspired, not by a manuscript, but by late Roman sculptures such as sarcophagi or ivories. Both these features are in contrast to the Iona crosses.

High Crosses with scriptural scenes on their shafts first appear in Ireland probably around 800. The earliest may have been the South Cross at Kells, which has disordered and also innovative scriptural scenes. The South Cross at Clonmacnois is very similar to those at Ahenny in resembling metal prototypes, and Clonmacnois was a centre for the production of pillars with hunting motifs. A good example in the same style also comes from Banagher, Co. Offaly. The Banagher slab, which has been dated to around 800 on various grounds, is stylistically extremely close to several cross-slabs in Pictland, discussed below.

An early ninth-century cross at Bealin, Co. Westmeath is the best of a group of crosses, including the North Shaft at Clonmacnois, that have low relief modelling and expansive backgrounds as well as complex animal interlace.

Perhaps slightly later, the cross from Moone, Co. Kildare, is tall and slender, with forceful carving in shallow relief. (It is carved from granite, not the easiest stone to work.) The figures on the Moone Cross have square bodies and staring, surprised faces. Detail is confined to a minimum, and the stylization is superb. The designs include a mixture of Old Testament and New Testament subjects – Daniel in the Lion's Den, the Children in the Fiery Furnace, the Flight into Egypt, Adam and Eve, the Sacrifice of Isaac, the Twelve Apostles and the Crucifixion. The Miracle of the Loaves and Fishes is symbolized by two confronted fish and five discs, flanked by two eels. The shaft displays animals in panels, not unlike some to be found in Mercia. Similarities between the Moone Cross and the Canterbury Codex Aureus (now in Stockholm) has led to the suggestion that it dates from the late eighth century, which would fit in with the fact

177

178

179–81

170

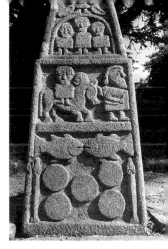

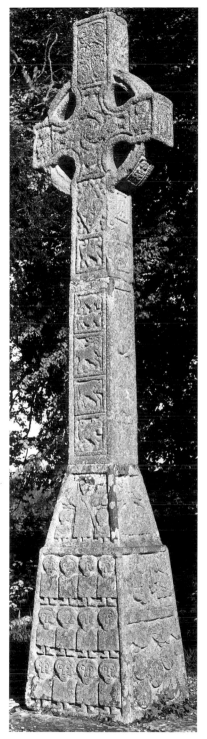

178 (below) Stone slab from Banagher, Co. Offaly, *c.* 800, showing a mounted cleric with a crozier over his shoulder, above, and a stag caught in a trap, below, both reminiscent of Pictish slabs

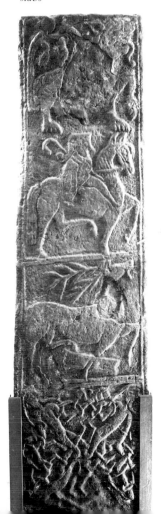

179–81 The Moone Cross, Co. Kildare (left), with dramatic, simplified low-relief ornament showing (top) the Children in the Fiery Furnace, the Flight into Egypt and the Miracle of the Loaves and Fishes; (above) the Twelve Apostles

that the subject matter (mainly concerned with deliverance and redemption) was popular with the Culdees (a monastic order) at this time. Not all however would agree with so early a date, and most would see the Moone Cross as a mid-ninth-century work.

In Scotland, apart from the Iona group the High Cross was not popular – the few examples include a late outlier at Dupplin, in Tayside, of the later ninth century, erected after Pictland had been absorbed by the Scots.

The Pictish sculptures are mostly of the eighth to ninth centuries. The typical monument is a cross-slab, decorated with a relief cross on one side and with a diversity of subsidiary designs, including Pictish symbols in relief, hunt scenes and figural subjects from both Christian and secular sources, as well as a variety of abstract and animal ornament.

The earliest of the slabs comprise a small group executed in very low relief, which seems in Pictland a natural development out of deep incision, as employed on some of the symbol stones. Of these mention may be made of the slab from Barflat, Rhynie, a similar stone from Golspie, Sutherland, and the slab from Birsay, Orkney, with its

182–3 Pictish cross slab in Aberlemno Churchyard, Angus, showing, left, the front with the cross, and right, the back with low-relief symbols – a notched rectangle and triple disc – and grim battle scene beneath

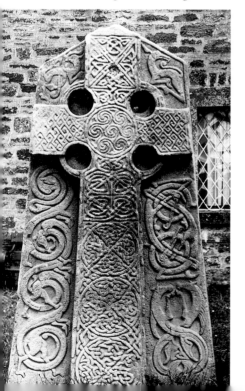
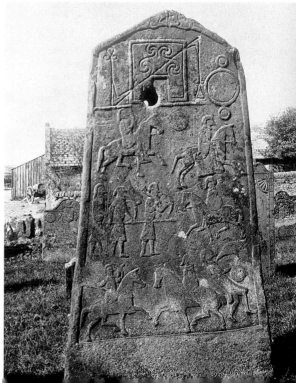

procession of three warriors with square shields. A slab from Papil, 153 West Burra, Shetland, bears a lion that is very similar to the Evangelist symbol in the Book of Durrow, as well as four clerics with croziers and book satchels and a scene in which bird-headed men support a human head between their beaks. The simple monolith has been hewn in a straightforward manner, and on its flat face the figures have been lightly incised with a minor amount of abstract pattern.

The meaning of the scene with the two beaked men is lost to us, nor do we know the function of the other figures. Strange details are incorporated, like the heavy 'knees' and claw-like feet of the 'birdmen', and the magnificent spiralling muscles of the lion with its docile expression. The imagery of the Papil stone is an enigma.

Still in fairly low relief is the Aberlemno Churchyard stone. The 182–3 reverse is occupied by relief symbols and a battle scene (a subject popular with the Picts), the front has a superb cross with flanking Lindisfarne-style birds and hippocamps, as well as other animals. The close connection with the Lindisfarne Gospel style and Northumbrian influence date the Aberlemno Churchyard stone, which should thus be assigned to the early years of the eighth century, along with a few others such as those from Eassie, Glamis and Rossie Priory.

The art of the Pictish sculptor was extremely eclectic, and detailed studies have been made of the diverse sources. What is very much apparent, however, is that regardless of the model, the interpretation is essentially Pictish, and the details are those of Pictish life, not based on some remote Anglo-Saxon or Mediterranean prototype. Even the shapes of the crosses tend to be distinctive, with a quadrilobate ring or double square hollow angles. The latter is derived from manuscript art, as it is a drawn design and figures in the Book of Durrow, the Lindisfarne Gospels and Lichfield Gospels.

An enormous diversity of ornament was used on the Pictish cross slabs, and it is possible to recognize regional variations. Northumbria, Mercia and Ireland are but three of the sources of motifs used by the Pictish sculptor. The finest works, as in Ireland, were produced in the ninth century, and they will be considered below.

Few manuscripts of the eighth century survive. Most characteristic of this period are the 'pocket gospels', which were small enough to be carried by travelling clerics. The Book of Dimma and the Book of 184 Mulling are the earliest, both of the late eighth century. The stylistic tradition continues with the luxury Gospel Book known as the Book of MacRegol in the ninth. The pocket gospels tend to be executed in a more rapid style than the sumptuous Gospel Books, but employ

bright colours and simple ornament, as well as stylized Evangelist portraits.

184 The Eagle symbol of St John the Evangelist appears in a subdued page in the Book of Dimma that uses browns, blacks, blues and pale gold to produce a mosaic-like picture. The drawing is careful but not symmetrical – even the colouring on the eagle is not the same each side. The bird is thrown into high profile by the totally void vellum within the complex frame which itself displays a variety of fret and interlace designs.

150,185 The culminating work of the art of the Golden Age is surely the Book of Kells. Now in Trinity College Dublin, like most manuscripts it has had a chequered history, and various dates and provenances have been suggested for it. A date around 800 seems likeliest.

 Previous studies had stressed its Irish origin, until Julian Brown, studying the text, came to the conclusion it was produced in Pictland at the end of the eighth century. There are certainly many Pictish features in the book, most notably in the figural work, but as Pictish influence was felt in Dalriada (as is shown by the hybrid Pictish-Irish metalworking style current at Dunadd), there is no reason to reject the idea that it was produced mostly on Iona, perhaps being finished in Ireland subsequently.

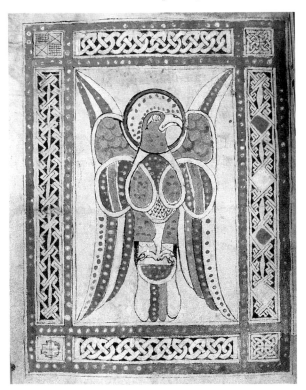

184 (left) Eagle symbol page, 17.5 × 14.2 cm ($6\frac{7}{8}$ × $5\frac{1}{2}$ in), from the Book of Dimma, late eighth century. The manuscript was probably written and illuminated at Roscrea, Co. Tipperary, and was the work of several hands

185 (right) Virgin and Child, folio 7v, the Book of Kells, 33 × 25 cm (13 × $9\frac{7}{8}$ in), around AD 800

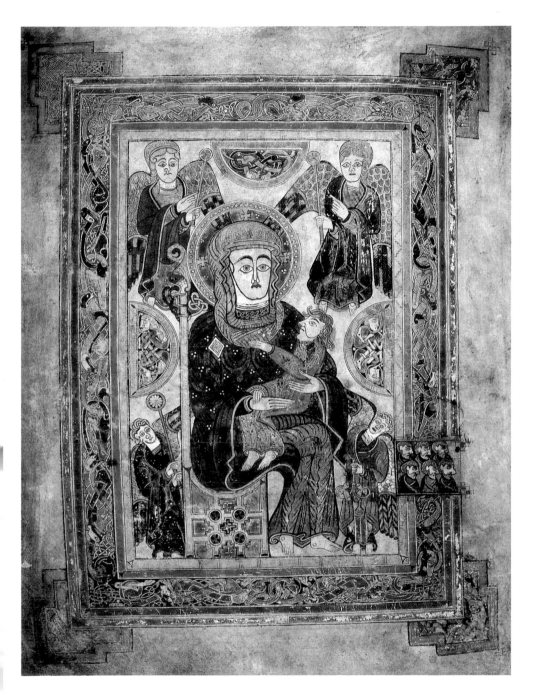

The Book of Kells progresses from Durrow in its use of full-page illustrations. In addition to the Evangelist symbol pages and a carpet page it contains the Temptation of Christ (the so-called Temple page), the Betrayal and the Virgin and Child, as well as portraits of Christ and the Evangelists. Particularly delightful is the wealth of amusing detail – amidst the ornament of the *Chi-rho* page are to be found two cats watching two mice. Elsewhere lions spring and bearded warriors with small, round Pictish-style shields advance.

185 The Virgin and Child (folio 7v) is clearly based on Eastern models: the treatment of the Virgin's face in particular with its unrealistic eyes and arched brows, as well as her nimbus and the general composition of the figures point to an east Mediterranean origin. The circles on her ankles suggest the image may be copied from a bronze plaque that was attached to some object such as a book cover or pax. The colours are vibrant and varied. A blue-green cools down the heavy warmth of the brown, red and golden hues, and the artist has allowed himself a limited amount of 'white space' around the figures, though the frame is totally infilled. The only devices used to fill in the space are three semi-circular motifs with strange animal and humanoid interlace that recall the mosaics in Byzantine church apses. The two left-hand-side corners are clearly copying gold filigree work. The Christ Child appears as a small man, not simply in the adult proportions of His body, which is common in early art, but in the facial features, which make Him appear if anything older than His Mother.

The Book of Kells represents virtually the last flowering of insular Celtic art before the impact of the Vikings.

THE VIKING AGE

The Viking raids began in the late eighth century. The earliest recorded attack is in the Anglo-Saxon Chronicle for 787; in 793 the monastery of Lindisfarne was sacked and the following year Jarrow was a target. The raids on Scotland probably began around the same time – the earliest Viking material in Scotland belongs to the period 790–810. By the early ninth century Iona was being raided.

Despite the Viking impact on Ireland, outside Dublin the archaeological evidence for Viking settlement is slender, being confined mainly to a few graves and hoards and a scatter of stray finds. The Viking impact on Irish art, however, was considerable, probably because of an affinity between the Scandinavian styles of animal ornament and Celtic. That the Vikings approved of Celtic art is

apparent from the fact that so much of what survives does so in graves in Scandinavia, which have been used to provide a 'latest date' for the treasures found in them. There is an illogical assumption that everything found in ninth-century graves in Scandinavia must be eighth century, since such objects must have been old (but not antique) when buried with the deceased. It has led to the abundance of objects assigned to the eighth century, and the relative dearth of those of the seventh or ninth.

The development of Celtic art from the beginning of the ninth to the twelfth century is influenced by a series of Scandinavian styles. From the point of view of Celtic art, the most important of the styles are the Jellinge, Ringerike and Urnes.

Jellinge style is named after the royal centre at Jellinge in Jutland. Its earliest appearance is in the late ninth century, and it remained current until around AD 1000. It is typified by animal ornament, the animals having sinuous double outlines, lip-lappets and pigtails. The Ringerike style developed on sculpture and metalwork in the early eleventh century, and is characterized by animals from which come tendrils of acanthus-leaf foliage. Around 1050 it gave way to the Urnes style, named after a decorated wooden church in Norway. Urnes ornament is typified by tendrils of which the foliage origin is less apparent, and 197
which have become even more elongated. In Ireland the style is found mostly in metalwork, but an outstanding example appears on a stone sarcophagus from Cashel, Co. Tipperary.

The various Viking styles can be seen in the finds from the 1970s in Dublin, where it is clear Scandinavian and Irish craftsmen worked side by side, pooling motifs and ideas when producing wood, metal and leather objects that were probably traded quite widely. The objects of wood include the boss of a High Cross, riding-crop handles, the pommel from a chair and a box lid. Apart from the objects themselves, the excavations at Dublin have produced a series of 'motif pieces', bones (usually ox long-bones or scapulae) on which various designs have been tested out. Similar motif pieces (sometimes of bone, sometimes of stone) have been found on a variety of other sites in Ireland and help to provide a 'pattern book' of early Irish art. Some of the best come from the royal *crannóg* or lake dwelling at Lagore, Co. Meath. By the twelfth century Viking animal art and Irish art were combined with elements from the widespread Romanesque tradition to produce a very distinctive style of medieval art.

From the ninth and tenth centuries relatively little Celtic art of note survives, apart from sculptures. Metalworking declined over the

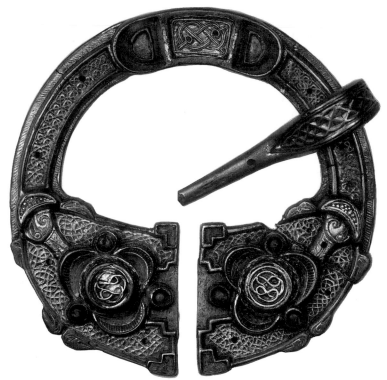

186 The Breadalbane brooch, diameter 9.8 cm ($3\frac{7}{8}$ in), an Irish 'pseudo-penannular' brooch converted for use in Pictland. The Picts, who favoured 'true' penannulars, i.e. circles with a break, divided the terminals and provided a replacement pin (now broken). Of solid silver, gilded on the front, it has gold filigree and green glass cabochon settings, and is one of a small group of very accomplished brooches of the eighth to ninth centuries

period – there is little surviving ornamental metalwork of note of the ninth century in Scotland, Wales or Cornwall – to revive again in the eleventh century. From Scotland there are a few items that have been found in Viking graves, but their place of manufacture is in doubt, and they could have been looted from Ireland.

In Ireland the 'Tara' type of penannular brooch continued in fashion down the Viking age. Of the native brooches the finest is that from Co. Cavan and that known as the Killamery brooch. The Co. Cavan brooch (also known as the Queen's Brooch, after Queen Victoria), has human heads as part of its design.

To this period, too, belong the elaborate pseudo-penannular brooches found with the Ardagh chalice, and the Londesborough

brooch. The Ardagh brooches are of silver, with stylized animals in gold and with amber, glass and enamel inlays.

The increased use of silver was the outcome of a new source of supply, coins from the Arab world reaching Europe with the Vikings. Ninth- and tenth-century metalwork in Ireland is in general terms fairly coarse. Enamelling fell out of popularity, filigree became crude, and new foliage patterns, based on the classical acanthus, made their appearance, as they were also doing in Anglo-Saxon England and Carolingian France.

The main series of objects surviving from the ninth and tenth centuries are croziers. The series begins with the Prosperous crozier, which dates from around 850 and has some enamelling. To the late ninth century can be ascribed the 'Kells' crozier (also known as the 187 British Museum crozier), and the croziers of St Dympna and St Mel. In their ornament these works show the influence of the Trewhiddle style of Anglo-Saxon England (named after the ninth-century Cornish hoard), and employ small, contorted, yapping animals in triangular or other awkward-shaped panels. The British Museum crozier was found behind a solicitor's cupboard in the nineteenth century in London, and bears an inscription 'Pray for Cuduilig and Maelfinnen'.

The cult of venerating relics seems to have spread to Britain and Ireland from the Mediterranean, and by the seventh century was well established there. The bones of saints were seen to give grace to the living, and to the dead interred near a reliquary. Both corporeal relics (bones or other parts of the body) and incorporeal relics (objects closely associated with the saints, such as a crozier, bell or even piece of cloth) were venerated and believed to have miraculous properties. Such relics were carried in processions, used to solemnize important occasions and in the making vows and curses, and carried as talismans in battle. The Monymusk reliquary is a good example: it served as a 172 military standard, and was taken into battle at Bannockburn in 1314. Shrines partook of the holiness of the relics they contained, and were re-embellished in successive periods, rather than remade.

Books, too, were venerated. A strange object known as the *soiscél* 188 *Molaise* was made around AD 1000 as a *cumdach* or book-shrine for the Gospel of St Molaise, using pieces of a house-shaped shrine of the early eighth century. The cover has four Evangelist symbols and inscriptions naming them, done in low relief in the compartments of a cross in a rectangular frame. On one of the sides is an Evangelist with small intertwining animals around.

179

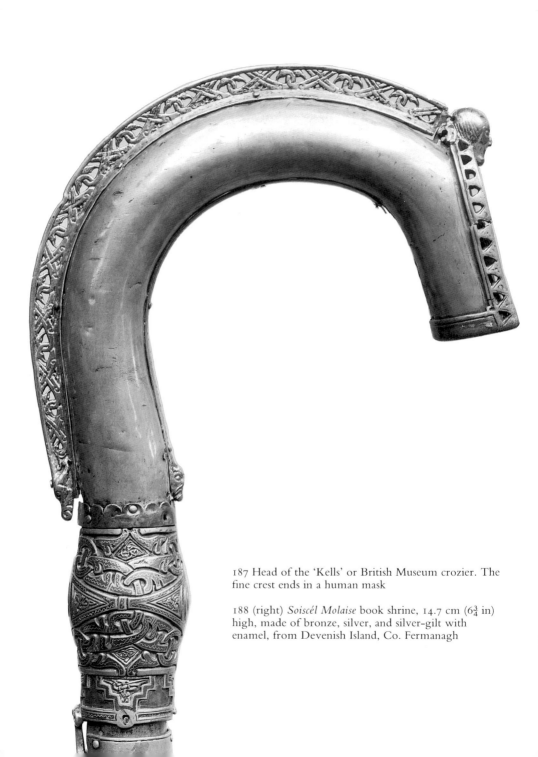

187 Head of the 'Kells' or British Museum crozier. The fine crest ends in a human mask

188 (right) *Soiscél Molaise* book shrine, 14.7 cm (6¾ in) high, made of bronze, silver, and silver-gilt with enamel, from Devenish Island, Co. Fermanagh

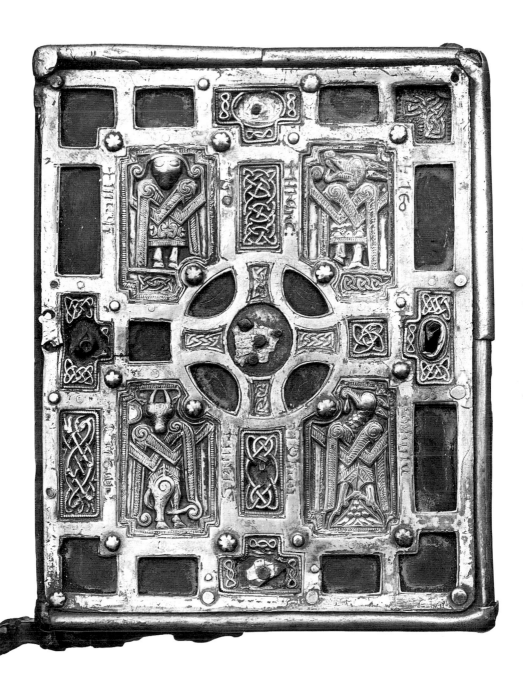

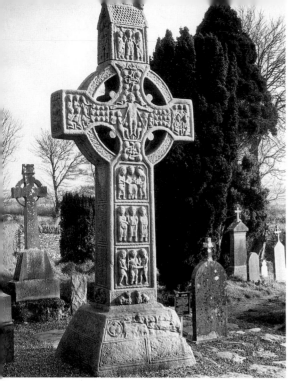

189–90 Muiredach's Cross at Monasterboice, Co. Louth, also known as the South Cross (left), showing the Last Judgment with St Michael weighing a soul (interrupted by a devil), the mass of the Saved, the Adoration of the Magi, and other scenes. At the foot of the shaft, two cats swallow birds and frogs. The Cross of Patrick and Columba, Kells (right), is one of a group of crosses decorated with scriptural scenes at this major monastic site. On the base can be seen a hunt

To the ninth and tenth centuries belong most of the Irish High Crosses. The raids on Iona by the Vikings led to many monks fleeing to Kells. Here, perhaps inspired by the Iona crosses, we see a vigorous tradition of sculpture in the ninth century. The Cross of Patrick and Columba, relatively short by later standards, stands on a truncated pyramid base decorated with a hunt scene after the manner of that at Ahenny. The ornament on the rest of the cross, which includes Christ with Evangelist symbols, David and the bear and David breaking the jaws of the lion, is done in a fairly free style, and the subject matter of deliverance predominates. This fine and innovative monument shows the influence of the Iona crosses in its spiral and vinescroll ornament. It is closely related to a small cross at Drumcliff, Co. Sligo, and a superb example from Durrow (also monasteries with Iona connections).

190

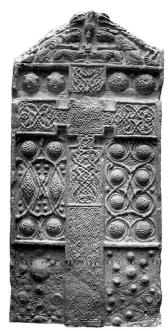

191 (above) Slab from Nigg, Ross, height 2.4
metres (7 ft 9 in), an outstanding example of the
'Boss style' of Pictish sculpture

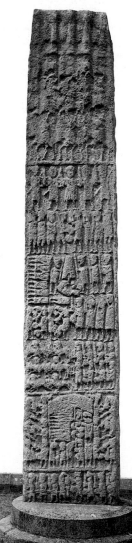

194 (above) One of the latest of the
Pictish stones: Sueno's stone, near
Forres, Moray, ninth or tenth century
AD

192–3 (left) Relief modelling of
the St Andrews shrine, stylistically
related to the Nigg slab

The other crosses at Kells are extremely eclectic in their ornament, displaying subject matter found separately in other parts of Ireland.

The Cross of the Scriptures at Clonmacnois is very similar to what is probably the finest High Cross in Ireland, the Cross of Muiredach at Monasterboice, Co. Louth. There is some uncertainty about the dating of both. Muiredach's Cross bears his name – but which of two abbots called Muiredach set it up? One died in 844 and the other in 921 or 922. For many years the tenth-century abbot was favoured, but recently Peter Harbison has suggested that features of both crosses indicate a ninth-century date as being more likely, though this has not been universally accepted.

The relief work on these crosses remains high despite a thousand years of exposure to Irish weather. Only the bases are seriously weathered. Each is capped with a stone version of a shrine, which in turn represents a church with hipped, tiled roof and ornate ridge-pole.

In Scotland there are several groups of sculptures of the Viking Age. Perhaps the finest are the Boss style monuments of the Picts – massive slabs with pronounced bosses and a wealth of detail. An early group can be identified that includes the Nigg Cross and the large stone St Andrews shrine, which may have been made for the relics of the saint when they were brought to Scotland in the second quarter of the ninth century. The St Andrews Shrine is shaped like a reliquary, with hipped roof (now missing) and with very high relief modelling.

In the north of Scotland, the late Boss style represents a last stand of Pictish independence before Picts and Scots were united by Kenneth mac Alpin, c. 847. Pictish symbols disappear totally from sculptures, and Irish influence increases (attested, for example, by the form of the Dupplin Cross). Of the latest sculptures, Sueno's Stone near Forres is a *tour-de-force*, supposedly set up to commemorate a victory over the Vikings. Standing over 6 m (20 ft) high, this monolithic pillar is covered with a wealth of weathered figural work, including rows of beheaded captives.

In Wales and the Isle of Man there was a flowering of sculptural art. In the Isle of Man it lasted but briefly, before being drowned by a vigorous Norse tradition, but to the pre-Norse period can be ascribed a fine crucifixion slab from the Calf of Man, and some interlace-decorated wheel-headed crosses. In Wales, although there are some sculptures in the north, the main workshops were centred on the monasteries of the south. The two finest works are the Margam Cross and the Carew Cross. Apart from at Margam, there are important collections at Llantwit Major and Merthyr Mawr. The crosses of

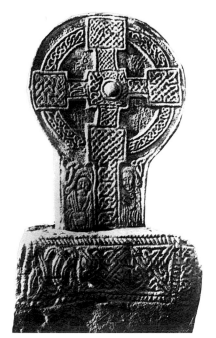

195–6 (left) Wheel-headed cross with interlace, 149 cm (58⅓ in) high, from Margam, Glamorgan, one of a group of later sculptures from south Wales, c. 900. (right) Evangelist symbols page from the Book of Armagh, 19.5 × 14.5 cm (7¾ × 5¾ in). It contains various texts relating to St Patrick, a Life of Martin of Tours and a New Testament

south Wales may well have been begun by sculptors forced out from other areas by Viking incursions. These south Welsh stones are notable for the intricacy of their all-over interlace. Because of the diverse origins of the sculptors, the styles are very eclectic, and thus we see Irish influence in one of the Margam stones of around 900, southern English influence in one from Penally, Pembroke, of around the same date, Northumbrian influence in one from Ramsey Island, Dyfed, probably of slightly earlier date, and Scottish or Manx influence in one from Caerleon churchyard, Gwent. Some, such as the north Welsh examples from Penmon, Anglesey and the Maen Achwyfan, Clwyd, show the adoption of Scandinavian elements.

The Book of Kells had no real successors. The few ninth-century manuscripts to have survived look poor and garish. The Book of Armagh, produced c. 807, is perhaps the best, illustrated in line with confident uncoloured drawings of Evangelist symbols. Such uncoloured drawings were a feature of smaller, less luxurious manuscripts, 196

illustrated often by the scribe rather than an artist–illuminator, from this period down to the twelfth century.

Although there are no psalters of the eighth or ninth centuries, there are some from tenth-century Ireland. The Cotton Psalter (also known as the British Library Cotton Vitellius F XI), was produced in the early tenth century. It was badly damaged in a fire in the eighteenth century that destroyed many manuscripts, but enough survives to show its vigorous colours and combination of realism and stylization. Two surviving pictures show David as Musician and David and Goliath.

THE ELEVENTH AND TWELFTH CENTURIES

Except in the West Highlands, there is little Celtic art in medieval Scotland after the Anglo-Norman penetration under David I (1124–53). In Wales, a few sculptures carry the story forward into the twelfth century, but there is no metalwork, and little manuscript art of note in a Celtic style apart from the eleventh-century Psalter of Rhigyfarch or Ricemarch.

In Ireland, however, there was a great resurgence of art in the eleventh and twelfth centuries, and we are fortunate in having a number of inscribed pieces to which dates can be assigned. The Irish monasteries were very richly endowed at this period, and seem to have had workshops attached to them in which sumptuous ornamental metalwork was produced. Nearly everything we have is ecclesiastical – there is a dearth of secular sites securely datable to this period, and very few examples of secular metalwork apart from the finds from the 1970s excavations in Dublin. When it is considered just how much metalwork has survived, despite, it must be assumed, looting by the Anglo-Normans and again in later times, notably at the Reformation, it suggests a vast output from monastic workshops.

Two new devices were developed in the eleventh century. The first consisted of borders with plaits of red copper and silver wire which were hammered into grooves and were then polished, producing a two-coloured rope-pattern. Developed in Gaul and Scandinavia, the device was already falling out of favour on the continent by the time it gained popularity in Ireland. The second device used silver ribbons inset into shallow grooves in the bronze ground, with black bands of niello on either side to produce a black-and-white effect. The bronze ground was probably gilded, and the whole result is very impressive, particularly on the shrine of St Lachtin's arm.

186

197–8 Shrine of St Lachtin's arm, Donaghmore, Co. Cork, 40 cm (15¾ in) high. Rich Scandinavian 'Urnes-style' ornament covers all but the finger-nails

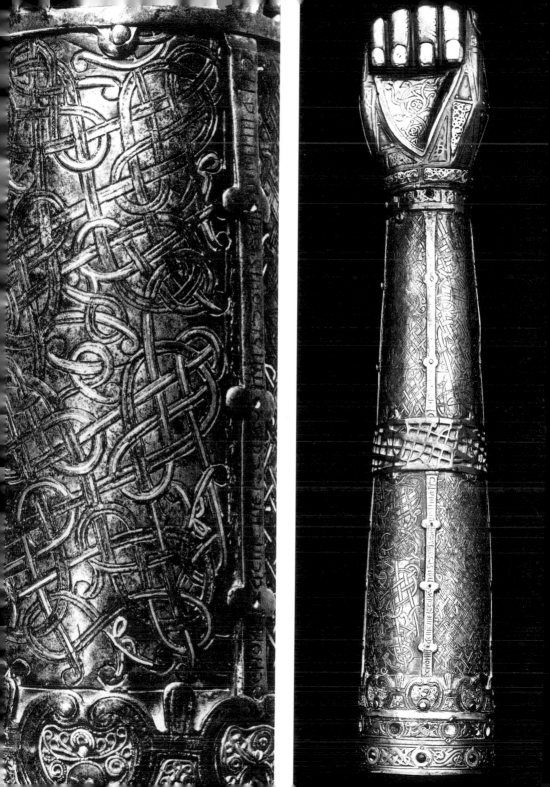

Alongside these new techniques, most of the old ornamental devices continued in use. Filigree (or rather pseudo–filigree, since it was part of the casting) tended to be fairly coarse; niello became quite widely used, and red enamelling on yellow (as opposed to yellow on red, which had been popular earlier) added colour to the compositions. Scandinavian artistic devices played an important part in the ornament, particularly the Urnes style, which was developed to a degree of excellence not seen in its parent Scandinavia.

It is possible to group the main works. Although there is some disagreement about the precise attribution of some pieces, broadly speaking there are five main regional traditions.

The first dates from the later eleventh century, and may have been centred on Kells, though there is no firm proof of this, since all the objects come from northern and eastern Ireland, with the exception of the Innisfallen crozier. The characteristics of the tradition include the use of panels or friezes of foliage or relief-cast zoomorphic ornament, though other features are zig-zag silver inlays with niello, foliage patterns and shell spirals. The key works are the Innisfallen crozier, the shrine for the 'Cathach', the Misach and a couple of bell shrines. One 187 of the knops on the 'Kells' crozier is also in this style. Peculiar to this group of objects, though also found in manuscript art, are lobed tendrils with a semi-circular notch where the tendril joins the stem. The Innisfallen crozier, which was found in the river Laune in Co. Kerry, is one of the earliest of the group. It is formed with silver plates round a wooden staff, and has four knops, the lowest joining with the ferrule. The middle knops are older in style, and closer to the ornament on the croziers of Dympna and Mel.

155 The manuscript known as the 'Cathach' (or 'Battler') of St Columba owes its name to the tradition that it was carried out before a battle during St Columba's lifetime. The shrine to contain it takes the form of a wooden box, the top of which was ornamented in the fourteenth century, but the rest of which was covered with silver-gilt plates in the eleventh, when Ringerike ornament was employed. The side panels have pairs of animals in figure-of-eight patterns, with bands of silver and niello.

The second group comprises mainly croziers and fragments of croziers. The classic example is the Clonmacnois crozier. Characteristic of the works in this group is the use of inlaid strips of silver with niello bands, the rest of the metal being left plain. The workshop that produced this was perhaps at Clonmacnois. These works all employ a special motif – a pair of opposed spirals, sometimes with a central lobe.

188

Foliage was not in favour with the craftsmen who produced these objects. The Clomancnois crozier has animals with Urnes style heads, very similar to those on the creatures that decorate the stave church at Urnes itself, but the animal bodies are more akin to Ringerike work.

A somewhat amorphous group of works include the Shrine of St Lachtin's Arm, which came from Donaghmore, Co. Cork. Although 197–8 only two such arm shrines have survived (the other for St Patrick's arm), they were probably not uncommon in the Early Christian period. This shrine is composed of a wooden cylinder covered with metal plates, terminating in a clenched fist. Every portion of the object except for the finger nails is covered in ornament, mostly of tightly-woven animals in Urnes style. The vertical strips carry a long inscription which refers to a king of southern Ireland who died in 1121, and another who ruled between 1118 and 1124, so the shrine must have been made between 1118 and 1121. The filigree work is poor, and gold foil (instead of gilding) is fastened on with stitching. The plant motifs are new, and may be borrowed from English or French Romanesque manuscripts.

The fourth group is typified by the Lismore crozier, and the objects 200 in it seem to have come from Munster. The Lismore crozier was found walled up in Lismore Castle. Characteristic of these pieces is low-relief cast panelling, bordered with silver and niello. The shaft of the crozier is made up of heavy plates, and decoration is confined to the head, knops and binding strips. The head carries a openwork crest. It is dated by an inscription which mentions a bishop of Lismore who died in 1113.

The Lismore crozier is perhaps the most outstanding piece of ornamental metalwork of the period, effectively combining Viking Urnes and Irish ornament. Looking strangely like a metal seahorse, it shows an elegant balance between decoration and voids. Large areas are left blank, with delicate outline patterns separating the segments. The only colour is introduced sparingly in the form of millefiori. Each roundel is different, each originally drawn mathematically but executed without rigour to create the softened effect so characteristic of the Celtic artist at his best. Small blocks infilled with interlace adorn the 'nose' of the crozier. The most outstanding feature, however, is the magnificent openwork crest with its zoomorphic ornament. Three beasts follow one another, almost disguised by the abstraction of their limbs and snouts which have been exaggerated and elongated into a simple interlace pattern. A fourth beast, represented only by its head, might have surveyed the congregation in processions – his snout

is an interlaced pattern, his neck openwork echoing the snouts of the other three beasts.

The crozier is a restrained, balanced work, suited to the solemn and dignified nature of its use. The snake-like animals owe a debt to the English version of Urnes; the knops carry figures including four interlocked humans, a figure in a kilt and a figure with a book satchel round his neck. The style of these is close to that on a cross from Cloyne that was clearly a product of the same workshop. A small human mask stares out from where head meets staff.

162 Sometimes grouped with the Lismore crozier is the Shrine of St Patrick's Bell, though a recent study by Ó Floinn has set it on its own. The plain iron bell still survives. The shrine to contain it was not fashioned until the late eleventh or early twelfth century, possibly at Armagh. The object is made of thick bronze plates, held together by rounded joint covers, and it has openwork in high relief. An inscription mentioning a king and a bishop dates it to the ten years centred on 1100. The gold filigree work is poor but intricate, and the interlaced animal ornament is somewhat monotonous, but the openwork is of high quality, and seems to borrow again from English Urnes.

149,199 The fifth and last main group is characterized by the Cross of Cong, and objects in the style are concentrated in the region of the middle Shannon. The monastery at Roscommon may have been its centre, for here literary sources say a portion of the True Cross was enshrined in 1123. Related in style is the largest of the medieval Irish reliquaries, the Shrine of St Manchan. The works in this group employ openwork metal plates of zoomorphic ornament, with a cross as a central motif.

The Cross of Cong is a quiet, dignified object probably created to house one of the most important relics of the Christian Church, a fragment of the True Cross, which is protected behind an inset of rock crystal where the shaft meets the transom. The entire surface of the cross was decorated, mostly with fine interlace, small and delicate enough not to be imposing in its own right and thus not to detract from the relic itself. This is art used to support the most holy of remains, not to compete or to be admired for its own sake. Nevertheless, the interlaced filigree Urnes style animals are as outstanding in their own way as the animal ornament in the Book of Kells. Along the edges of the shaft and transom are settings for red and yellow enamel. This type of cross was commonly used in twelfth-century Spain.

190

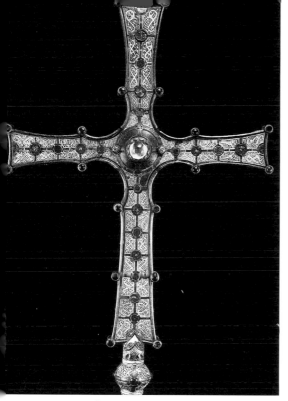

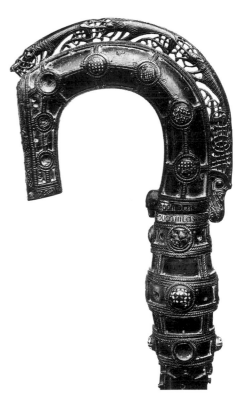

199–200 The Cross of Cong (left), a type of processional cross found in Spain but here distinctively Irish in form, with outstanding Urnes-style ornament (see Ill. 149). The Lismore crozier (right) is adorned with low-relief cast panelling with silver and niello, on head, knops and binding strips, and a splendid Urnes-style crest

The cross itself was not intended to be held by human hands: there is a definite point where the 'cross' part of the object ends and is gripped in the jaws of a stylized animal head. This is the 'handle' which enables the sacred object to be manoeuvred without being either partly concealed by the bearer's hands, or (just as likely a motive) desecrated by human touch.

Unique, each in their own ways, are the Stowe Missal shrine and the *Breac Maodhóg*. The Stowe Missal shrine is a bronze box, altered at many periods. The upper portion is medieval, which at first obscures the perception that the lower part dates from the eleventh century. The iconography has caused some debate, and includes panels with dumpy little figures recalling tenth-century sculpture. One shows two clerics, with a bell and a crozier, on either side of a harpist and

201

angel. Enamel, glass and chip carving are all employed, and the whole alternates between the stereotyped and the vigorous.

In contrast to the resurgence of metalworking, sculpture is little employed in the eleventh and twelfth centuries in Ireland, except in the decoration of Romanesque churches.

A few crosses serve as a bridge between the achievements of the ninth- and tenth-century sculptors and those of the Romanesque period. Of these, the cross at Drumcliff, Co. Sligo, perhaps can be singled out, with its fine-line interlacing and elegant profile. The figural work is coarser and more limited than on the earlier crosses. It includes Adam and Eve and a huge hump-backed animal. The later crosses of the Romanesque period are somewhat different in style, having very high relief.

203 Far superior to Drumcliff is the Dysert O'Dea Cross, which has a tapering profile with Christ, again in a long robe, occupying the head and a grim bishop with a curl-headed crozier (unlike the Irish type of the crozier shrines). The base has interlace which has been partly cut away to take an inscription chronicling the cross's varied history. It also has on its base Daniel in the Lion's Den, with bizarre lions with hindquarters that turn into tangled snakes.

A Kilfenora in Co. Clare there are two major crosses. The first introduces the medieval type of thin slab, in this case fashioned into a cross. It stands 4.5 m (15 ft) high, and has an awesome Christ in the centre of the head with simple key-and-fret patterns and interlace. Christ's arms are attenuated as though modelled in clay, and there is a creature with a head too big for its body above, biting its own tail.

202 An echo of earlier crosses is another from Kilfenora, with a mitred cleric with curling-topped crozier and two disproportionately large clerics beneath. Unlike the bishop above, each have Irish croziers – one has a straight drop, the other a Tau head. A huge beast does battle

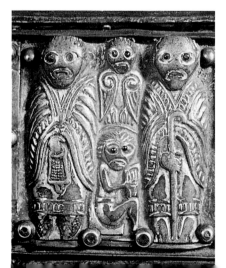

201 Panel of the Stowe Missal shrine, tenth or eleventh century

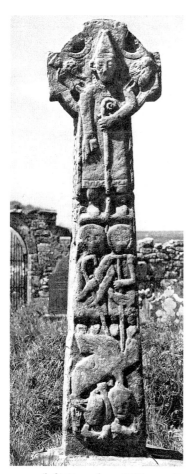
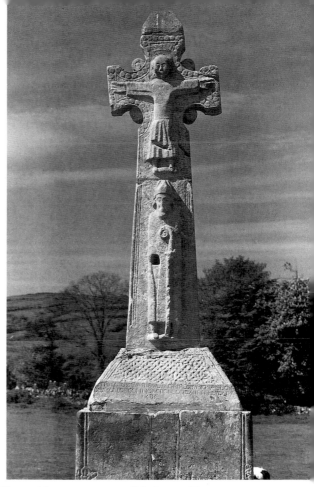

202–3 (left) Cross from Kilfenora, Co. Clare, with a strange scene of clerics attacking a bird. (right) Twelfth-century Cross from Dysert O'Dea, Co. Clare, with high relief and coarse modelling, a far cry from the sculpture of the ninth and tenth centuries

below; it appears to be a bird, into which the clerics are sticking their croziers. The bird, in turn, is attacking a human head beneath. What does it all mean? Perhaps some forgotten story of the triumph of good over evil. The bishop's mitre is distinctive, looking more like a dunce's cap, which has led to suggestions that it may be papal. Christ appears in the usual position on the other side.

Some churches in purely Romanesque style display elements which echo the Celtic past. Particularly noteworthy are the 'severed heads' that adorn some Romanesque doorways. One cannot look at

204 Tympanum of the Romanesque cathedral at Clonfert, Co. Galway, c. 1160

70 the tympanum at Clonfert, Co. Galway, without thinking of the skulls in their niches at Roquepertuse. Similarly, the animal gargoyles that appear on some churches (including again at Clonfert) have their counterparts in Celtic metalwork from the 'Tara' brooch onwards.

Manuscript art of this period has little to offer. A number of decorated initials are all that are to be found in the Drummond Missal, with a few bug-eyed animals lamenting the passing of art.

Vegetation, fleshy and ubiquitous, sprouts on subsequent manuscripts of the eleventh and twelfth centuries. It appears for the first time in a manuscript in the Palatine Collection in the Vatican. This work, the Palatine Ms 830, can be dated to the late eleventh century. Here we can see the notched foliage that was noted as a feature of the metalwork, and which was to be popular with manuscript illuminators subsequently.

Somewhat more accomplished is the Corpus Gospel Book, in Corpus Christi College, Cambridge, which is extremely well preserved and of finer execution, with notched foliage. The colours are more subtle, the design elegant. It dates from around 1140.

194

In Wales the Psalter of Rhigyfarch (Ricemarch or Ricemarcus), 205
now in Dublin, had been produced by a Welshman who had spent
some time in Ireland, and who decorated his book in the early
eleventh century.

One last manuscript must claim our attention. This is the
magnificent Cormac's Missal, now in the British Library. Although 206
we have Cormac's name, we know nothing about him save that he
was Irish and must have produced it in the second half of the twelfth
century. Although tiny (17.8 by 14 cm, 7 by 5.5 in), it is *multum in
parvo*, for from its pages glows forth a rich array of ornament in blue,
purple, green and yellow, against red grounds. These brilliant but
unlikely colours chime joyously without garishness. There is a
preponderance of plant-like tendrils which terminate abruptly rather
than in the mass of little spirals so common in earlier manuscripts, and
the ornament is very definitely subordinate to the regimented words.

205–6 (left) Page from the Psalter of Rhigyfarch or Ricemarch, with Urnes-derived
animals. (right) Cormac's Missal, a late, brilliant flourish of Celtic manuscript art
before its eclipse by the Anglo-Normans

207 West Highland sculpture: interlace and the scene of a hunt ornamenting the back of the Cross of Alexander MacMillan, Kilmory, Knapdale. It is a work of the Loch Sween school, one of a number carving crosses and slabs in the Scottish Highlands and islands in the fifteenth and sixteenth centuries

Celtic revivals

The twelfth century virtually marked the end of independent Celtic art. Manuscripts produced in the Celtic areas in the Middle Ages cannot be shown to owe anything to a Celtic past, and most of the sculpture belongs to the mainstream of medieval tradition, sharing more with English Gothic taste than the native past.

In the West Highlands of Scotland, however, there lingered a sculptural tradition that was at least distinctive, if not obviously 'Celtic'. Although the forms were in keeping with the rest of medieval Britain and Ireland, the vigour and ornamental detail suggest their Celtic inspiration.

More than six hundred examples of sculpture survive or have been recorded in the West Highlands, dating from the fourteenth to sixteenth centuries. A distinctive series of late monuments bear dates between 1489 and 1555 – the appearance of dates on the stones coincides with the introduction of Gothic 'black letter' inscriptions and the representations of swords of the type known as the claymore.

The West Highland sculptures are notable for interlaced all-over patterns, and among the rich repertoire of motifs are to be found a large number of animals. There are echoes of contributions from Pictish stones, Anglo-Saxon and Viking art, as well as from Romanesque and Gothic.

One of the largest and earliest groups is that designated the Iona school. Here can be seen from the first the plant-scroll which was the main decorative element of West Highland sculpture, sometimes with stems intertwined to produce interlace or linked to a pair of fantastic animals reminiscent, probably fortuitously, of the 'twin beasts' of Anglo-Saxon crosses. The Iona school produced both free-standing crosses and recumbent grave-slabs. The earliest work can be ascribed to the early fourteenth century, and by the late fourteenth century some of the finest products were being made.

A short-lived school in Kintyre seems unlikely to have begun production before about 1425, and had ceased operating by 1500, but favoured single-, double-, or triple-strand interlace patterns. Its focus

was probably Sadell Abbey. Interlace too was favoured by the Loch Awe school, which sometimes employed creatures reminiscent of those found on the Early Christian period cross at Keills in Knapdale.

Interlace still decorated West Highland stones in the sixteenth century. One from Oronsay Priory has interlace knotwork ending in a snub-snouted creature that is surely a remote descendant of those that decorated objects in the Pictish St Ninian's Isle treasure. A sixteenth-century tomb-chest from Craignish has both triple-strand interlace and a deer-hunt which look similarly Pictish.

Of exceptional interest are the whalebone ivory boxes from Scotland known as the Eglinton and Fife caskets. Their single-strand interlace patterns have been seen as 'Dark Age', and in the past the Eglinton casket has been canvassed as a tenth-century work. The shape and mountings of the casket, however, betray a later date, and current thinking would assign it to a Gaelic Revival of the sixteenth century, and to see them both as the products of a West Highland school.

Interlace adorned a variety of other objects in sixteenth and seventeenth century Scotland. The Queen Mary harp also bears foliage and animal carvings in a style close to that of the West Highlands. In the seventeenth and eighteenth century, silver or more frequently brass annular brooches, some as large as 20 cm (8 in) across, were produced in the Highlands where they were an important element in female attire. These had interlace and animal designs. The finest were made in the north-west.

Interlace forms an important element, too, in the decoration of the Highland dirk (a type of long dagger), which evolved in Scotland during the seventeenth century. The wooden handles began with simple ornamentation, but progressively they were carved with interlace. They remained popular until the 'Forty-Five' (the 1745 Jacobite Rebellion). Highland clansmen also favoured interlace for decorating their targes – small round shields about 50 cm (20 in) across (perhaps the descendants of the similar shields carried by Picts in Dark Age sculptures). These were made of wood covered with leather, which was then tooled with animals, plants and interlace, and studded.

In the same tradition of Gaelic Revival are the fine powder horns produced in the seventeenth and eighteenth centuries. These were made from boiled and flattened cow horn, which was then engraved. Some carry dates, and the finest, like the brooches, were made in the north-east.

In Scotland the 'Forty-Five' and its aftermath put an end to the Gaelic Revival, and it was not until the nineteenth century that Celtic art became popular again.

In Ireland in the later Middle Ages, reliquaries and objects of veneration of earlier date continued to be remodelled and added to, not always to their advantage. A notable exception in being improved is the Domhnach Airgid book shrine, dating in its final form to the fourteenth century when silver-gilt panels with fairly spirited figural subjects were added.

208 Harp of Brian Boru, one of the national emblems of Ireland, with interlace among the ornament. The harp is connected with the Viking-Age patriot only by name, and was made between the thirteenth and the sixteenth century

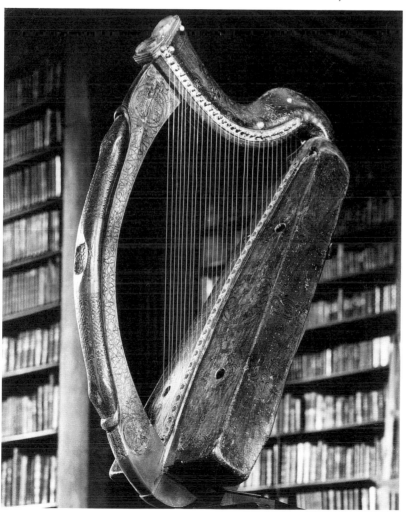

209 Fifteenth-century leather *budget* or book satchel for the ninth-century Book of Armagh (Ill. 196)

It was in woodwork and leatherwork that the Celtic love of interlace re-asserted itself in Ireland in the late fifteenth and sixteenth centuries. The 'Harp of Brian Boru' made between the thirteenth and sixteenth centuries displays a certain amount of interlaced ornament, and a similar liking for interlace, single-strand and symmetrical, distinguishes the leather *budget* or satchel for the Book of Armagh, made in the fifteenth century and employing *cuir bouilli* (a technique involving the moulding of wet leather) for its ornament. A *triskele* of backward-looking animals on one of the roundels is surely Celtic – there is nothing comparable in English leatherwork of the period – and one authority has suggested that there is Jellinge influence on the animals. This would place them (and the *budget*) in the eleventh or twelfth centuries rather than later, though in view of the debased Gothic lettering on the *budget* this seems unlikely, and it is best seen as one of a series of 'Gaelic Revival' works of the fifteenth to seventeenth centuries which looked back to pre–Norman models and favoured interlace patterns.

208

209

Almost nothing of the Celtic repertoire survived in later medieval Wales. Medieval Welsh sculpture, like Irish, for the most part follows the English pattern, and there are some notable grave-slabs. A few monuments of the eleventh to thirteenth centuries show an awkward transition. The shapes of the stones are medieval, but they carry inscriptions and decoration more in keeping with a Celtic past. They include pillar crosses, coped stones and fonts, some of which, such as one from Cerrig Ceinwen in Anglesey, display some late twelfth-century interlace.

CELTIC REVIVAL AND 'DRUIDOMANIA'

The Celts came to the fore in academic attention in the late seventeenth century through the work of Edward Lhuyd and other scholars. In the eighteenth century there was a wave of enthusiasm for things Celtic, and in particular for things druidic. Part of the background of this lay in 'soft primitivism' – the search for a society untainted by the evils that beset 'civilized' man. This trend culminated in the eighteenth century with Rousseau's 'noble savage', but the seeds had been sown with the discovery of the American Indians, who were considered by early antiquaries to provide an insight into the lives of their forebears. John Aubrey, the seventeenth-century antiquary who carried out pioneering studies of Stonehenge, considered the Ancient Britons were '2 or 3 degrees, I suppose, less savage than the Americans', and suggested, on analogy with America, that the linear earthworks of Wessex were tribal boundaries, and that the Ancient Britons had cleared Salisbury Plain for agriculture (in which latter deduction he was correct).

This new concern for ancient savagery was tied up, from the later seventeenth century onwards, with a concern for the 'Picturesque'. In a sense, Neoclassicism and Romanticism were related movements. For the Neoclassicists, if a landscape was to be *pittoresco* it had to contain some classical ruins. Although it is true there were some classical ruins still standing in eighteenth-century Britain – Arthur's Oven in Scotland and Roman gates in Lincoln and Chester, for example – they were hardly abundant, and the vestiges of other periods had to be substituted. Gothic abbeys and churches appealed to many tastes in this respect, as did castles, but others turned to more remote periods and gained inspiration from standing stones.

This is a far cry from Celts, it might be said, and a further one from Celtic art. But it is only divorced from the Celts as we think of them

today (and who knows in what light they may be viewed two centuries hence). For eighteenth-century antiquaries such as William Stukeley 'Ancient Britons' were all one happy race, who put up standing stones and went around robed as druids cutting mistletoe with golden sickles.

William Stukeley, who was born in 1687, began his first draft of a book on Stonehenge with the title of 'History and Temples of the Ancient Celts'. By 1733 he had replaced 'Celts' with 'Druids' and from this point on the shadowy priests became the leading figures in the procession of forebears of modern Britons.

It was but a short step from Stukeley's druidomania to a spate of related romantic literature, such as Gray's poem, 'The Druid', and by extension to the forged pseudo-Celtic poems of 'Ossian' perpetrated by Macpherson in 1760. Eighteenth-century romantic literature concerning Celts (and in particular, Druids) was considerable. Celts soon were hailed as a symbol of national spirit, holding out against Rome – Cowper's *Boadicea* appeared in 1782. But beyond prompting a certain amount of antiquarian interest in Celtic remains, it did not lead to a revival of Celtic art in the way that the discovery of Pompeii stimulated a revival of classical art.

Celtic art, nevertheless, did not go unnoticed. Grose and other topographical writers in the late eighteenth century chose to illustrate Pictish stones, and by the early nineteenth century in both Scotland and Wales Celtic sculptures were attracting a good deal of attention. Pre-Roman Celtic art, too, was beginning to be published and appreciated.

By the middle of the nineteenth century Iron Age Celtic art was being properly evaluated in a series of studies – Sir Wollaston Franks listed 'Late Celtic' antiquities in Kemble's *Horae Ferales*, which contained beautiful illustrations of, among other objects, the enamelled horse fittings from Polden Hills. By the end of the century Sir Arthur Evans, the discoverer of Minoan civilization, felt able to deliver a series of Rhind lectures on Celtic art in Edinburgh in 1895 (though they were never published).

124

CELTIC REVIVAL IN NINETEENTH-CENTURY IRELAND

Political factors were probably responsible for the nineteenth-century 'Celtic Revival'. It was mostly focused in Ireland, but due to Queen Victoria's enthusiasm for all things Scottish, it was not without its impact in Scotland either.

When it came, the Irish Revival was the Celtic counterpart of the Gothic Revival in England. It owed its origins to the Catholic Emancipation Act of 1829, and was a conscious attempt to demonstrate an Irish national identity swept away by years of English rule. The symbols of Ireland became the shamrock, the Harp of Brian Boru, the wolf hound and the round tower. None of these were diagnostically Celtic, and it may be said that the Irish Revival was a by-product of Irish nationalism.

Its foundations, however, were laid on a sound academic base. Sir George Petrie (1790–1886), himself no mean artist, spearheaded the serious study of Irish antiquities. Apart from his famous book on Irish round towers, Petrie was partly instrumental in the formation of the collection of the Royal Irish Academy, and in his time it acquired such notable masterpieces of Celtic art as the Petrie crown, the Ardagh 145,164 chalice (found 1868) and the 'Tara' brooch (found 1850). The 160–1 collection of the Royal Irish Academy had started with the Cross of Cong, which was purchased by James MacCullagh for the Academy 199 in 1839.

Petrie had his literary counterparts. A Gaelic Society had been founded in 1807, and Celtic scholars such as O'Donovan and O'Curry began the process of collecting and translating key Gaelic texts. The formation of the Ordnance Survey of Ireland similarly gave a boost to the study of Celtic antiquities, and we find Henry O'Neill drawing and publishing 'The Most Interesting High Crosses of Ireland' in 1857. His highly popular 'Fine Arts of Ancient Ireland' appeared in 1863.

Samuel Ferguson was a Belfast lawyer and antiquary whose first love was Irish music, but he wrote a poem, 'The Cromlech on Howth', published in 1861, that can be said to mark the beginning of the Celtic artistic revival in Ireland. Its cover was decorated with gold blocked interlace, and the poem itself was ornamented with decorative elements taken from the Book of Durrow and Book of Kells, coloured in red, green, yellow and purple. The decoration was the work of Margaret Stokes (1832–1900), who was perhaps the only 210 Celtic Revival artist of the time really to study and understand the designs she was using. She wrote a book on Celtic art, for long a standard reference, which was illustrated with her incomparable drawings. The *Cromlech on Howth* included chapters on 'The History of Irish Illumination in Europe' and 'On the Characteristics of Scotto-Celtic art', contributed by Petrie.

THE

CROMLECH

ON HOWTH

·S·Ferguson·

·mdccclxi·

211 'The Royal Tara Brooch', a nineteenth-century copy of the original made by its then-owners, the Dublin jewellers Waterhouse and Company

These publications, the Dublin Great Exhibition of 1853, and the proliferation in the 1850s and 1860s of copies of the 'Tara' and other 211 ornate penannular brooches, firmly established Celtic art in the minds of patriots as one of the finest achievements of Irish culture, and art led on to a fully-fledged Gaelic Revival. Lady Wilde saw that 'Irish art illustrates in a very remarkable manner those distinctive qualities of Irish nature, which we know from the legendary traditions have characterized our people from the earliest times. . . . All these reverential, artistic, fanciful and subtle evidences of the peculiar Celtic spirit find a full and significant expression in the wonderful splendours of early Irish art. . . .' (*Legends, Mystic Charms and Superstitions of Ireland*, 1888).

Much of the mid-nineteenth-century revival of Celtic art took the form of un-original copying from ancient works. One of the first to innovate, and to use Celtic motifs to produce new effects was a Scot, Charles Russell, who came to Ireland around 1872 and began promoting the revival of Celtic art. His designs were primarily to be found on pottery produced by Voudre in Dublin.

Most of the 'Celtic' art produced in Ireland in the later nineteenth century was uninspired. To look on the serried ranks of imitation High Crosses in Maynooth Cemetery in Co. Kildare is an artistically

210 Title page of the poem 'The Cromlech on Howth' by Samuel Ferguson, ornamented by Margaret Stokes, published 1861

depressing experience. Henry O'Neill's book on Irish crosses had been plundered for models, and a whole industry grew up manufacturing small High Crosses, not only for Ireland but for export to the graveyards of England, America and Canada.

Some of the copies of pseudo-penannular brooches were very competent, however. Leading the field was the Dublin firm of Waterhouse and Co., who were permitted to copy brooches in the Royal Irish Academy's collection, and who were producing, by 1853, a series of reasonable versions of the 'Tara' brooch, the Inisfallen brooch, the Ballyspellan brooch, and others.

Waterhouse acquired the 'Tara' brooch, so tradition has it, from a watchmaker in Drogheda who had bought it from a poor woman whose children had supposedly found it on the beach. As has already been noted, it was found at Bettystown, not Tara, but the name was changed to make it more romantic. Waterhouse was not persuaded to turn it over to the Royal Irish Academy until 1868 – Petrie had written in 1850: 'I cannot but feel assured that Mr Waterhouse, who has derived a great pecuniary benefit from our exertions to create an interest in such remains, will feel it is due to us in return to give a deaf ear to all temptations to seduce him to let this Brooch out of Ireland.' Waterhouse called it at first 'the Royal Tara Brooch', because Queen Victoria and Prince Albert, having been shown it at Windsor in 1850, bought two copies of it. Its popularity led to a matching Tara bracelet, and other firms followed his lead in making copies of brooches in Ireland and in Scotland, where the Hunterston brooch was also deemed a suitable subject for imitation.

Bog oak was another medium in which 'Celtic' trinkets were produced. Bog oak versions of the 'Tara' brooch sold surprisingly well. The quality of these bog oak souvenirs varied – the best were very good, the worst abysmal.

The Celtic Revival of the 1880s was mainly literary, associated with such figures as the playwright J.M. Synge and the poet and playwright W.B. Yeats. The late nineteenth century, however, also saw the Arts and Crafts movement taking hold on both sides of the Irish Sea. In Ireland the Arts and Crafts Society was founded in 1894, and held its first exhibition in 1896. Many of the products were monotonous copies of Celtic brooches similar to those made by Waterhouse and Co., though new to the range were copies of *methers*, old Irish drinking cups.

The second Exhibition in 1899 was little better, but in 1904 there were important innovations. The Roman Catholic Church had

agreed to employ Irish rather than foreign artists to adorn its places of worship, and Loughrea Cathedral was one of the first to receive native embellishment. A series of twenty-four embroidered banners were commissioned for Loughrea Cathedral from the Dun Emer Guild, and were worked in silk and wool on linen, in the tradition of William Morris, by Lily Yeats and her assistants. The designs were mainly by the artist Jack Yeats, based on Celtic patterns. The Dun Emer Guild was founded in order to 'find work for Irish hands in the making of beautiful things', using wherever possible Irish materials and traditional designs. For a while there was also a Dun Emer press, but it separated in 1908.

The Arts and Crafts movement continued to hold exhibitions until 1925, but by that time there was a reaction against Celtic motifs and an increasing feeling in Ireland that Irish art should be original and innovative, and not dependent on outworn motifs. The two last flowerings of the Celtic style in Ireland were a chapel decorated by Sister Concepta Lynch (1874–1939) at Dunlaoghaire, Co. Dublin, which was ornamented between 1920 and 1936, covering with stencilled designs the available surfaces. The second was a manuscript, The Book of Resurrection, commissioned by the Irish Government 212 in 1922 as a Republican Memorial. This was intricately decorated by Art O'Murnaghan.

O'Murnaghan was the last 'Celtic' artist who actually understood his models and was able to 'think' in their vocabulary. He began the illumination of the book in 1924, and by 1928 nine-and-a-half pages were completed. He did not copy the ancient models, he assimilated them in a new style, without artificiality and in excellent taste. Work was suspended on the book in 1928, following a dispute, and was resumed between 1943 and 1951 when sixteen more pages were executed, more confident and more original than those done in the 1920s. O'Murnaghan died in 1954, the book unfinished. With him ended nearly two thousand years of Celtic art.

Yet there are still shadows of a Celtic tradition. From an unknown date in the past some parts of Britain have retained a lingering tradition of carving stone heads. Some have been fashioned to adorn gateposts, some to set high up on the walls of barns. They are seen as 'lucky', or as 'warding off evil'. They are particularly common in Yorkshire, but the tradition seems to persist in other areas of northern and western Britain as well. Sometimes their recent date is betrayed by an anachronistic detail, sometimes by the method by which they have been carved. Most, however, are quite simply undatable. With

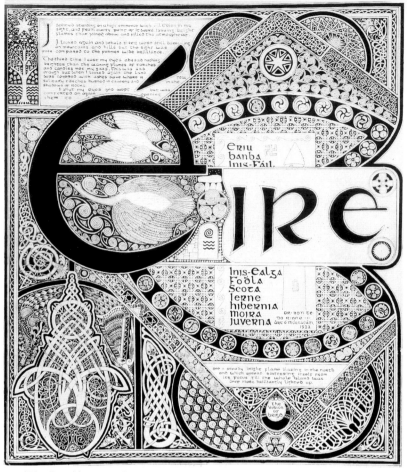

212 'Eire Page' by Art O'Murnaghan, illuminated as part of a never-realised project for a book that would have been an Irish Republican memorial

almond-shaped eyes and baleful expressions, they could be pre-Roman Iron Age, Romano-British, medieval or twentieth century. Archaeologists have sometimes been rash enough to pronounce on the antiquity of one, only to be told that someone remembers it being carved by a relative fifty years ago. They constitute a surviving link with the heads which can be ascribed with certainty to the pre-Roman Iron Age, and possibly provide a clue as to how their remote forerunners were viewed. Was the Mšecké-Žehrovice head carved to placate evil forces? The traditions of Celtic art run deep, and must surely run on into future generations.

acanthus A broad-leafed Mediterranean plant, stylized leaves of which were used in Antique and Carolingian art and taken up in some Celtic work.

billet Billetting in metalwork is the process of hatching a border into even segments (each segment constituting a billet). It is used on metalwork of the Early Christian period.

basket pattern A method of infilling a void with groups of lines set at different angles. It was particularly used on Iron Age mirrors in Britain.

carpet page A page of ornament usually incorporating a cross which prefaces each Gospel in some insular manuscripts.

codex A folded, gathered and bound book, successor to the manuscript book as scroll.

champlevé A method of enamelling in which the ground is cut away and infilled with enamel (see below), leaving the design in reserve against the enamelled field.

chip carving A technique of cutting metal into facetted surfaces, to reflect light, often in the form of reversed 'pyramids'. True chip *carving* is rare; pseudo-chip carving, produced by casting, is more usual.

die A metal stamp used to emboss designs on a thin piece of metal. Die stamping is not common in Celtic art, but was used for 'casket ornament' in Early Iron Age Britain and on occasion in the Early Christian period.

Durrow spiral A spiral of two or more lines with a looped centre, encountered in the Book of Durrow and widely employed on hanging bowl escutcheons.

egg-and-dart A type of ornament used in Early Christian metalwork of the ninth century which employs crescentic swags divided by oval 'leaves'. Its origin is probably Carolingian.

enamel Inlay made from glass, normally opaque.

filigree Very fine twisted gold wire.

folio The page of a manuscript. A page of vellum has two sides, recto (the smooth side) and verso (rough, where the hair was).

granular work Goldwork involving beads or droplets of gold soldered to a base-plate.

guilloche Symmetrical cable ornament.

lappet An ornamental extension of an animal's lip or hair into a tendril.

lotus bud A motif of Eastern origin, used in Egypt and taken up in orientalizing Greek art. It formed the basis of a design in early Celtic art.

lyre-scroll A design found in Early Style Celtic art employing two s-shapes back to back. It was derived from a classical prototype.

millefiori Literally, 'thousand flowers'. Glass threads of different colours fused together, pulled out and sliced across, used for patterned inlays. It is most commonly found in flower patterns.

niello A black paste of silver sulphide, sometimes combined with copper, used as a metal inlay.

palmette A motif of oriental origin representing a palm frond, imitated in early Celtic art. Also used of a simpler motif in Christian Celtic art, more commonly called a 'pelta' (see below).

pelta A motif found in Celtic art which looks like a section through a mushroom with thin stem and curling cap. It is possibly inspired by a shield design in Roman art called a pelta.

penannular (brooch) The term, meaning 'an almost complete ring', used for circular brooches with a break in the hoop. However, the heavy terminals of so-called penannulars were sometimes fused, i.e. the hoop was made as an unbroken circle. Such brooches are

referred to in the text as 'pseudo-penannular'.

pressblech Die-stamped metal sheets.

repoussé A metalwork design hammered into relief from the back.

running-dog pattern A design of hooked wave pattern, used in Early Style Celtic art.

scorper An implement to cut grooves on metal.

situla A bronze bucket, or its pottery copy.

swash-N A design reminiscent of a compressed, reversed N, found in Celtic art of the first century AD.

tracer An implement, used along with a scorper (which cuts grooves), to cut fine lines

on metal. Used in Sword Style and Mirror Style Iron Age metalwork.

triskele A three-legged pattern, frequently made of trumpet patterns.

trumpet pattern A design reminiscent of a trumpet. Two trumpets are frequently set facing, wide end to wide end, with a lentoid (almond-shaped) void between. This is termed confronted trumpet pattern.

yin-yang A circle containing two comma-scrolls.

zoomorphic ornament Literally, 'of animal form'. In Celtic art the term is most often used to describe the terminals of penannular brooches.

Motifs in early Celtic art. Top: lyre-scroll; above: running-dog pattern.

Motifs in later Celtic art. Above, from the left: running scroll, *triskele*, yin-yang, 'spherical triangle', swash-N.

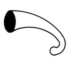

Above, from the left: trumpet, confronted trumpets, ring-and-dot, Durrow or *triskele* spiral, pelta, egg-and-dart as border pattern and as roundel (an adaptation for use on metalwork in which the 'darts' have become leaf-shaped, and the 'eggs' contained in the swags of the classical prototype have disappeared).

Most books dealing with Celtic art confine themselves to either La Tène art or Early Christian art. One book which attempts to span the whole of Celtic art is I. Finlay, **Celtic Art**, London (1973), though the emphasis is on the British Isles. For La Tène art on the continent, the 'standard' account is now R. and V. Megaw, **Celtic Art**, London (1989), though no serious student can fail to consult P. Jacobsthal, **Early Celtic Art** Oxford, 2 vols (1944). The magnificent, lavishly illustrated catalogue of the exhibition **The Celts, the Origins of Europe** (Venice, March–Dec. 1991) is essential reading for the subject; it is published as **The Celts** (eds. V. Kruta, O.H. Frey, B. Raftay, M. Szabó), London (1991). A sensitive account of La Tène art in the wider context of prehistoric European art is N. Sandars, **Prehistoric Art in Europe**, Harmondsworth (2nd ed. 1985); somewhat briefer but still perceptive is T.G.E. Powell, **Prehistoric Art**, London (1966). J.V.S. Megaw, **Art of the European Iron Age**, Bath (1970), is an illustrated catalogue with very detailed notes and references, with a useful introduction. Of the exhibition catalogues, S. Piggott with D.F. Allen, **Early Celtic Art**, Edinburgh (1971), may be singled out. In addition to these monographs, two collections of essays are of primary importance, P.M. Duval and C.F.C. Hawkes (eds.), **Celtic Art in Ancient Europe: Five Protohistoric Centuries** (1976), and P.M. Duval and V. Kruta (eds.), **L'Art celtique de la période d'expansion: IV**ᵉ **et III**ᵉ **siècles avant notre ère**, Geneva/Paris (1982). An interesting view of La Tène art is also provided by P.M. Duval in **Les Celtes**, Paris (1977). For symbolism and the importance of religion in Celtic art, M. Green, **Symbol and Image in Celtic Religious Art**, London (1989), is essential reading as is her **The Gods of the Celts**, London (1986). For coins and cult symbolism, P.M. Duval, **Monnaies gauloises et mythes celtiques**, Paris (1987), is invaluable, and for coinage as a whole there is L. Lengyel, **L'art celtique dans les**

medailles, Paris (1954) and D.F. Allen and D. Nash, **The Coins of the Ancient Celts**, Edinburgh (1980). For the archaeological context of La Tène art in Europe, readers may consult J. Collis, **The European Iron Age**, London (1984), (though this extends beyond Celtic lands to include the East Mediterranean), J. Filip, **Celtic Civilization and its Heritage**, Prague (2nd ed. 1976), (which is particularly good for central Europe), and T.G.E. Powell, **The Celts**, London (new ed. 1980, but the text as published in 1958) (this is particularly useful for Celtic institutions). The Venice exhibition catalogue (see above) is the most up-to-date survey.

La Tène art in Britain is dealt with in passing in some of the above books. The classic study (though its framework has been superseded) is C. Fox, **Pattern and Purpose, Early Celtic Art in Britain**, Cardiff (1958). An extremely good account can be found in I. Stead, **Celtic Art**, London (1985), while select items are discussed in J. Brailsford, **Early Celtic Masterpieces in the British Museum**, London (1975), and I. Stead, **The Battersea Shield**, London (1985), which deals exhaustively with one work but has wider implications. The art of northern Britain is covered (with an accompanying catalogue) in M. Macgregor, **Early Celtic Art in North Britain**, 2 vols, Leicester (1976). A concise and useful survey can be found in R. and V. Megaw, **Early Celtic Art in Britain and Ireland**, Princes Risborough (1986). Idiosyncratic but still useful is H.E. Kilbride-Jones, **Celtic Craftsmanship in Bronze**, London (1980). Irish La Tène art is well served by B. Raftery, **La Tène in Ireland**, Marburg (1984). E.T. Leeds, **Celtic Ornament in the British Isles down to AD 700**, Oxford (1933), has some interesting observations despite its date. For the archaeological background of Iron Age Britain, see B. Cunliffe, **Iron Age Communities in Britain**, London (2nd ed. 1978) and D.W. Harding, **The Iron Age in Lowland Britain**, London (1974). L. Laing, **Celtic**

Britain, London (1979), gives a more superficial account which carries the narrative into the Early Christian period. A useful summary appears in chapter 7 of J.V.S. Megaw and D.D.A. Simpson (eds.), **Introduction to British Prehistory**, Leicester (1979).

Books on the art of the Early Christian Celts have tended to concentrate on Ireland. The classic catalogue is A. Mahr and B. Raftery, **Christian Art in Ancient Ireland**, 2 vols, Dublin (1932 and 1941). A one-volume survey by F. Henry, **Irish Art in the Early Christian Period**, London (1940), was expanded into F. Henry, **Irish Art in the Early Christian Period to AD 800**, London (1965), **Irish Art during the Viking Invasions, 800–1020**, London (1967), and **Irish Art during the Romanesque Period, 1020–1170**, London (1970). M. Ryan (ed.), **Treasures of Ireland, Irish art 3000 BC– 1500 AD**, Dublin (1983), is a useful exhibition catalogue which extends beyond the Early Christian period. B. Arnold, **A Concise History of Irish Art**, London (rev. ed. 1977), sets Celtic Irish art in a wider perspective of Irish art as a whole, as does the more comprehensive P. Harbison and H. Potterton, **Irish Art and Architecture from Prehistory to the Present**, London (1978) – Harbison's discussion of Early Christian sculpture is particularly illuminating. A sound outline of Celtic Christian art in Ireland can be found in N. Edwards, **The Archaeology of Early Medieval Ireland**, London (1990). L. Laing, **Later Celtic Art in Britain and Ireland**, Princes Risborough (1987), is a concise account, largely ignoring sculpture. For this see M. Seaborne, **Celtic Crosses of Britain and Ireland**, Princes Risborough (1989). For a major hoard, M. Ryan (ed.), **The Derrynaflan Hoard I: a Preliminary Account**, Dublin (1983), should be consulted.

Manuscript art is covered in C. Nordenfalk, **Celtic and Anglo-Saxon Painting**, London (1977), and G. Henderson, **From Durrow to Kells: The Insular Gospelbooks 650–800**, London (1987). A catalogue with detailed bibliographical references and good plates is provided by J.J.G. Alexander, **A Survey of Manuscripts Illuminated in the British Isles 6; 6th to 9th century**, London (1978). The most useful account of the Book of Kells is provided by F. Henry, **The Book of Kells**, London (1974).

A collection of essays of major importance on all aspects of Early Christian Celtic art is found in M. Ryan (ed.), **Ireland and Insular Art, AD 500–1200**, Dublin (1987). An introduction to the beginnings of Early Christian art is provided by chapters 9 and 10 of L. and J. Laing, **Celtic Britain and Ireland, AD 200– 800**, Dublin (1990). Of more specialist interest is U. O'Meadhra, **Early Christian, Viking and Romanesque Art: Motif pieces from Ireland**, Stockholm (1979). Pictish art has been treated in two books on the Picts, I. Henderson, **The Picts**, London (1967), and F.T. Wainwright (ed.), **The Problem of the Picts**, London (1955). Also useful is A. Ritchie, **Picts**, Edinburgh (1989). For a study of a particular hoard, D. Wilson, A. Small and A.C. Thomas, **St Ninian's Isle and its Treasure**, Aberdeen (1973), is essential. For the background archaeology, L. Laing, **The Archaeology of Late Celtic Britain and Ireland c.400–1200 AD**, London (1975), may be found useful.

For the Celtic revival, the best discussion is J. Sheehy, **The Rediscovery of Ireland's Past: The Celtic Revival 1830–1930**, London (1980).

Location of objects and acknowledgments

Numbers refer to illustration captions. For locations of monuments still in situ, see also captions.

Avignon: Musée Calvet 71. **Bedford**: Bedford Museum 4. **Belfast**: Ulster Museum 9, 96, 211. **Berlin**: Museum für Vor und Frühgeschichte 43 (object now lost, photo Dr O. Doppelfeld), 54 (photo E. Neuffer, courtesy Römisch-Germanische Kommission). **Bonn**: Rheinisches Landesmuseum 30 (photo J.V.S. Megaw), 45 (photo L'Univers des Formes-La Photothèque), 30 (photo J.V.S. Megaw), 48, 52, 56. **Bratislava**: Slovenske Narodne Muzeum 84–85. **Brescia**: Museo Civico 2. **Brno**: Moravian Museum 60, 61, (photo J.V.S. Megaw). **Brussels**: Musées Royaux d'Art et d'Histoire 59. **Budapest**: Magyar Nemzeti Muzeum 7, 12, 81 (photo Kalmar Konya, Budapest). **Cambridge**: Cambridge University Museum of Archaeology and Anthropology 99. **Cardiff**: National Museum of Wales 91, 116, 118, 133,

134, 195. **Châlons-sur-Marne**: Châlons-sur-Marne Museum 63 (photo L'Univers des Formes-La Photothèque). **Châtillon-sur-Seine**: Musée Archéologique 22 (photo Giraudon), 23. **Clonfert, Galway**: Cathedral 204 (photo Belzeaux-Zodiaque). **Copenhagen**: National Museum 14, 58, 75, 76, 77, 78. **Corbridge**: Corbridge Museums 136. **Devizes**: Devizes Museum: 117 (photo courtesy Wiltshire Archaeology and Natural History Society). **Dijon**: Musée Archéologique 74 (photo R. Rémy, Dijon). **Dublin**: photos Bord Fáilte 177, 179, 181, 189, 190; photos Commissioners of Public Works in Ireland 164–167, 173, 180, 202, 203; National Museum of Ireland 143 (photo Belzeaux-Zodiaque), 144, 145, 159, 160–162, 163–167, 168, 170, 178, 187, 197, 198, 199–201, 212; Royal Irish Academy 155; Trinity College Dublin 146, 148, 150, 156, 184, 185, 196, 205, 208, 209 (photos courtesy the Board of Trinity College Dublin). **Edinburgh**: photos courtesy of Historic Scotland 152, 182, 183, 192–194; Royal Commission on the Ancient and Historic Monuments in Scotland 176; National Museums of Scotland 89, 100, 151, 153, 154, 169, 171, 172, 191. **Glasgow**: Hunter Coin Cabinet, Hunterian Museum, University of Glasgow 79, 80. **Graz**: Steiermarkisches Landesmuseum Joanneum 27. **Hull**: Kingston-upon-Hull Transport and Archaeology Museum 131 (photo British Museum). **Courtesy Lloyd Laing** 128, 129. **Liverpool**: National Museums and Galleries on Merseyside 112, 122, 123. **London**: British Library 158, 206; British Museum 1 (photo L'Univers des Formes-La Photothèque), 15, 24, 51 (photo Erich Lessing), 55, 92–94, 98, 101–104, 105 (photo J.V.S. Megaw), 106–108, 110, 111, 113–115, 119, 120, 121 (photo L'Univers des Formes-La Photothèque), 124 (photo L'Univers des Formes-La Photothèque), 125, 127, 130, 138–140, 186, 188. **Marseilles**: Musée Borély 69, 70 (photo Erich Lessing). **Monasterboice, Co. Louth**: 3 (photo Edwin Smith). **Munich**: Prähistorische Staatssammlung 8 (photo L'Univers des Formes-La Photothèque), 39 (photo Dr Carl

Albiker). **Neuchâtel**: Musée Cantonal d'Archéologie 65 (photo L'Univers des Formes-La Photothèque). **Newcastle-upon-Tyne**: Museum of Antiquities of the University and Society of Antiquaries of Newcastle-upon-Tyne 132, 135. **Nürnberg**: Germanisches Nationalmuseum 44. **Orléans**: Musée Archéologique d'Orléanais 88 (photo Jean Roubier). **Oxford**: Ashmolean Museum 95. **Paris**: Bibliothèque Nationale 157; Bibliothèque Nationale, Cabinet des Médailles 32, 57 (photo L'Univers des Formes-La Photothèque), 82, 83, 86. **Prague**: Národní Muzeum 68 (photo L'Univers des Formes-La Photothèque). **Rheims**: Musée Historique et Lapidaire 87. **Rhode Island**: Museum of Art, Rhode Island School of Design, Mary B. Jackson Fund 29. **Saarbrucken**: Landesmuseum für Vor-und Frühgeschichte 46, 47 (photo L'Univers des Formes-La Photothèque). **Saint-Germain-en-Laye**: Musée des Antiquités Nationales 35, 53 (photo L'Univers des Formes-La Photothèque); 5 (photo RMN), 36 (photo RMN), 40 (photo RMN); 56 (photo Inge Kitlitschka-Strempel), 72–73 (photo Giraudon). **Salzburg**: Museum Carolino-Augusteum 42 (photo Erich Lessing), 49, 50 (photo J.V.S. Megaw). **Sheffield**: Sheffield City Museum 141, 142. **Speyer**: Historisches Museum der Pfalz 41. **Stuttgart**: Württembergisches Landesmuseum 18, 19, 20, 21, 37, 62, 67. **Trier**: Rheinisches Landesmuseum 38. **Vienna**: Naturhistorisches Museum 11, 16, 17, 28. **Winchester**: Winchester Museum 137. **Zagreb**: Archaeological Museum 25, 26.

Maps and drawings

MAPS: S.S. Driver after P.-M. Duval 10. Annick Petersen 13, 33, 90, 147.

DRAWINGS: After Frey, *Hamburger Beitrage zur Archaeologie* (1971 edition, Band 1 & 2) 31, (1972 edition) 35 below. After Jacobsthal, *Early Celtic Art* (1944) 54. After I.M. Stead, *Celtic Art* (1985) 97, 109.

Index

Numbers in *italic* refer to captions

214